e/w

VUILLARD
HIS LIFE AND WORK

AMS PRESS

NEW YORK

VUILLARD
HIS LIFE AND WORK

BY

CLAUDE ROGER MARX

PAUL ELEK

THIRTY EIGHT HATTON GARDEN

LONDON

Library of Congress Cataloging in Publication Data

Roger-Marx, Claude, 1888-
 Vuillard, his life and work.

 Translation of Vuillard et son temps.
 Reprint of the 1946 ed. published by P. Elek,
London.
 Bibliography: p.
 1. Vuillard, Edouard, 1868-1940. 2. Painters—
France—Biography.
ND553.V9R62 1977 759.4 [B] 75-41229
ISBN 0-404-14718-6

Reprinted from the edition of 1946, London
First AMS edition published in 1977
Manufactured in the United States of America

AMS PRESS INC.
NEW YORK, N.Y.

LIST OF CHAPTERS

The numbers in brackets, e. g. (12) occurring in the text, refer to notes at the end of book.

To you, Denis, my son, my friend, struck down by German brutality; to you who sustained us so valiantly in our darkest hours; to you who were so much us that my sorrow was lightened on seeing you absorb the best of what I had inherited :

I dedicate this book with which you were so tenderly associated, which was written so close to you and to little Anne-Marie, also now but a shade.

Sustain us, smile on us, until we are reunited in calm and silence.

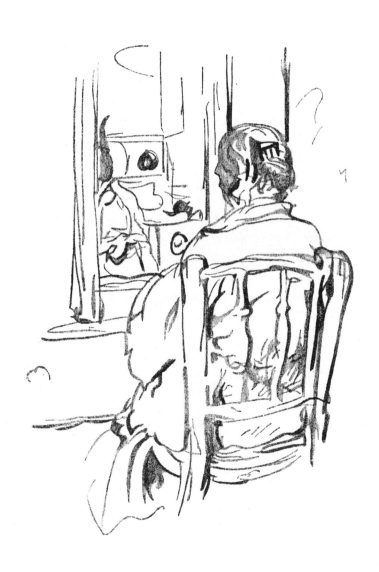

LIFE

AND

CHARACTER

OF

VUILLARD

Ancestral traits — The Workroom — Julian's — The Nabis and the Revue Blanche — Mother and son — Portraits of Vuillard — Old and new friends — The " walls " — Maurice Denis and the revival of the classic — Vuillard and Society — The exhibition of 1938 — Unsought glory.

The life of Edouard Vuillard, like his work, is barren of dramatic incident and unmarked by extraneous accident. His father, a retired colonial officer, traced his origin to the regions of the Jura and Savoy. He married Marie Michaud, the daughter of a textile manufacturer of the Aisne, a Parisian much younger than himself, and had by her three children — Marie, born in 1861, Alexandre born in 1864 (died 1928), and Édouard, the Benjamin, born at Cuiseaux, Saône-et-Loire, Nov. 11th, 1868. Mme Vuillard settled in Paris and upon the death of her husband in 1883 went into business as a corset-maker, first in the Rue Daunou, then in the Rue Marché-Saint-Honoré. In the industrious atmosphere of this home, the future painter grew up. At Cuiseaux, he had been taught to read by his sister (afterwards Mme K. X. Roussel). His early education he received from the Marist Brothers, then he passed on to the École Rocroy, thence to the Lycée Condorcet, where he became the friend of Roussel (1884).

While very young, he showed an inclination towards design. He collected pictures and coloured boxes. Not impossibly, he inherited this taste from his mother's father. The textile manufacturer, who had his mill at Fresnay-le-Grand and a showroom in the Rue Montmartre, designed patterns for his figured tissues. His uncle Sorel made designs for Cashmere shawls.

9

But what first fascinated the young Vuillard were the satins, the ribbons, the pieces and the threads in his mother's workroom where she stitched away with one or two helpers. There under his eye, all sorts of affinities and contrasts asserted themselves. There he imagined a colour-box long ere he dreamed of the purpose to which he would put oil or distemper. It is easy to realize the effect produced on the child by these multi-coloured samples, these silent symphonies, the precursors of the pots filled with pigment which were one day to constitute the principal ornament of his studio. In the home on the lower floor in the Rue du Marché-Saint-Honoré, divided into a series of little rooms, they spoke in low tones, they took measurements, they cut patterns. Everyone's back was bent over the work. The only rhythm perceived beside the whirring of the sewing-machine was that of the old wall-paper repeating the same motif like a refrain. Breakfast — household chores — washing time — the daily domestic events succeeded each other. In this serene world the three children grew up; it continued to be the world most loved by Vuillard. The chair, the armchair, the folding-bed, the carpet, the flooring, the check table-cloth, the hanging lamp — these were its essential features. To this modest dwelling, the chiaroscuro, multiplying invisible links, sanctifying the humblest object and differentiating values, imparted a monastic calm. There reigned not the atmosphere of poverty but the atmosphere of frugality; not the atmosphere of weariness but the atmosphere of daily duty. Ruling her small domain, a beloved shade came and went between kitchen and workroom; she was more often bent over her work than standing upright, this devoted mother, brave and cheerful as she seemed to all the admirers of Vuillard, who felt they knew and loved her, so much her son resembled her, so much does she enter into his work.

Pierre Veber writes: "Hers was a figure of extraordinary purity and nobility. Marvellous was her tenderness for our friend. She believed in his mission and consecrated herself to it with a conscientiousness and self-denial almost without precedent. It was thanks to her that Edouard Vuillard became the perfect artist whom we know and the man of loyal intelligence, the frank and simple character, who has won our sympathies. To her this powerful artist owes the inviolable modesty which he evinced even in the face of unhoped-for triumphs." Vuillard never had but one great love — his mother. Her hair might turn from chestnut to grey, she remained his inspiration. She never ceased to share his life. Even when she had passed on, she continued to counsel and protect him.

Some good fairy, aware of his native modesty, brushed aside all obstacles and took care of his development. Three of his schoolfellows were destined to play an important part in his life — Ker-Xavier Roussel, Maurice Denis, Lugné-Poe. Pierre Veber tells us, "Fifty-three years ago (writing in 1938) the Lycée Condorcet boasted two ministers and one emperor to be.

The two future ministers were Klotz and Lucien Capus. The future emperor of the Sahara was a self-contained lad named Jacques Lebaudy. With them were a future deputy, a composer, two dramatists, and the three leaders of the coming school of painting — Edouard Vuillard, Maurice Denis, and K. X. Roussel. One might believe that some providence brought these three together in the same class and the same college... We were seldom apart. Vuillard, I ought to add, spoke little about his projects for the future. "

Moved by the example of his father, he had first turned his eyes towards Saint-Cyr. But for Roussel, his future brother-in-law, a youth of generous, effervescent nature, he might not have discovered his vocation. All his life, Vuillard had to be spurred on by spirits bolder or more practical than himself. Among these was Lugné, a young man abounding in social dexterity and enterprise and guided always by a sure instinct. The future director of the *Œuvre*, in the *Nouvelles Littéraires* and the *Acrobaties*, conjures up the forms of the Condorcet, on which sat also Marcel Proust and Jacques Émile Blanche. It was Lugné, ironically enough, who won the prize for drawing. The friendship formed in youth ripened with the years. Vuillard, Bonnard and Lugné presently established themselves together on the sixth floor, at number 28 Rue Pigalle.

Roussel, the first to pass out of the Lycée, studied under Maillard, where his friends were Mouclier and Charles Cottet who made Puvis known to him. Vuillard and Denis followed Roussel and tried for the École des Beaux Arts. Vuillard failed twice. They continued there two years, but spent more and more time (1888) at the Académie Julian, then situated in the Faubourg Saint-Denis. It was not that the visiting masters there — Bouguereau and Tony Robert Fleury — were superior to those of the Beaux-Arts (two nudes in charcoal, forming part of the Roussel bequest. unite Gérôme's name with these) — but Vuillard was " terrified " by the coarse barrack-like atmosphere of the latter. Before three months had passed, he and Roussel resolved to attend only the evening classes.

" *Faites bêtement ce que vous voyez* " said Jules Lefebvre to Gauguin; who made answer, " *Un peintre peut tout faire pourvu qu'il ne soit pas bête.* " But let us be grateful to the Académie Julian since it was there that Vuillard fell in with Bonnard, Vallotton, Ibels, Ranson, Sérusier — with Sérusier " who discharged the functions of *massier* with startling whimsicality", Sérusier the soul of dissent, whose fate it was to constitute the link between the insurgents of the Beaux Arts and the School of Pont Aven.

Let us try to picture Vuillard just escaped from scholastic discipline and delivered over to the esotericism of Sérusier. He was, says Veber, " a young man of medium height, grave, speaking little and slowly, as though he was at pains to find exactly the right word, and in a gentle voice, rarely

interrupted by an ingenuous laugh. " This laugh, contrasting with his habitual gravity, also struck Lugné : " Vuillard laughs rubbing his nose, his beard in his hand... he has a child's laugh." He has drawn us his own portrait of himself at the opening of his career : an unkempt *barbiche* (whence his nickname " the Zouave ") frames a face lit up with a look of extraordinary intensity, a peculiar anxious look directed inwards. It is a look which belies the fresh complexion of his twenty years (1). Whence came this precocious gravity which inspired all who approached him with such respect? First of all, from his origin.

Romain Coolus, whom Vuillard met at the beginnings of the *Revue Blanche*, has sketched a faithful, lifelike portrait in one of the few studies published during his lifetime. " Vuillard, a native of the Jura, belongs to that ancient French province which has very marked characteristics, especially mental concentration. The men of these parts are not voluble. They do not spend their lives in public places, they have not the southerner's passion for the forum. Nor are their minds clouded, like the Breton's, with melancholy. As far removed from the petulant optimism of the one as from the pessimistic resignation of the other, they have inherited a disposition to survey life with gravity, to weigh their judgments long before pronouncing them, to do or to make nothing hastily. I have often been struck with the importance Vuillard attached to the word *importance*. Things that Parisian scepticism would have cheerfully dismissed as secondary were treasured in his mind and subjected to special consideration. " In the eyes of Coolus, who tends perhaps to overlook characteristics inherited from the mother, Vuillard's daily life was not other than a succession of cases of conscience, sentimental, artistic, social or professional. He sprang from the bourgeoisie and was in the habit of examining his conscience. Jansenist in spirit, made for meditation and solitude, he often found it necessary, as he himself put it, to play the Jesuit, since instead of fleeing from the world and dismissing painting as mere vanity, he had to come to terms with the world and the passions, to love a sensual pleasure and make it beloved.

The first doubt to trouble him, according to Coolus, was whether it was right to use his art to make a living. It was not without hesitation that he yielded to the inevitability of his gift. (This remark is rigorously exact. I still can hear him say, " I am more interested in the art of painting than in making my living as a painter. ") That other problem, the significance of the painter's art, had no less importance in his eyes. Independent of the constraint of time, essentially arbitrary, painting demands a high degree of intellect and a choice of conventions so happily concerted and co-ordinated that they impress themselves on the mind. " Strive to imagine " goes on Coolus, " between what contradictions a painter, if he is wedded to logic and concerned to be intelligible must struggle, in order

to accept a discipline which has no meaning for anyone but himself. We are not too indiscreet in maintaining that this struggle concerning the form and the formula of his art was for Vuillard a continual torment. An artist so thoroughly convinced of the logic of his art and of the exceptional methods to which he had recourse, must be perpetually putting their application in question, and seeking wearily for *illusions* in order to *allude* to realities, the appearances only of which he can fix and translate in their fugitive aspects according to conventional language. "

These problems were never tackled by the professors at Julian's and the Quai Malaquais. Vuillard by a happy chance found among his friends, the support and stimulus necessary. At a given moment, in that sad academy where he expected neither light nor direction, he was saved from discouragement by the fraternal exaltation of K.X. Roussel, the insight of Maurice Denis (so much at home among abstract ideas), and the daring of Bonnard, ready to run all risks. Miraculously, he recovered a doctrine, certainties, a contact with tradition — the true one.

The episode of the little cigar-box lid, the talisman, brought in 1888 from Pont Aven by Sérusier, who painted it under Gauguin's direction, is too well known to be repeated here. It may be found, told at length, by Denis in his *Théories*. The event was capital. Our painters at that epoch had witnessed the revelation of Degas and the impressionist landscapes — Monet's great exhibition opened in 1889 — but they little dreamed to what discipline, Cézanne on one side, and Seurat on the other, had subjected themselves. By the medium of Sérusier, they received from Gauguin, the leaven, the principles and the methods of liberation which their generation demanded. Side by side with Albert Aurier, who vanished all too soon, Maurice Denis became the propagator and exegetist of the new truths. He clarified what was too mystical and nebulous in the spirit of Sérusier, that great admirer of Plotinus, who had read too much. Denis excelled in forging definitions, in steering a course among apparent contradictions, in giving practical applications to the abstract. The Nabi group, baptized by the poet Cazalis, came into being. To it belonged Sérusier, Ranson, Denis, Vuillard, Roussel, Ibels, Lacombe the sculptor, Pierre Hermant the musician, Lugné-Poe, Seguin, Percheron, René Piot, Verkade, Vallotton, finally, Maillol. These " prophets ", " on fire with the spirit ", however seriously they took life, were capable of laughing a little at themselves. A good deal of boyishness was mixed with their fervour. They gave each other nicknames — Sérusier was the Nabi of the Sandy Beard, Verkade, the Monumental Nabi (because of his height), Bonnard, the Jap Nabi, Vuillard, the Zouave. Sérusier painted Roussel in a sacerdotal costume made of all sorts of pieces. Rising from their dinner in the Passage Brady, leaving the Café Voltaire or Henri Lerolle's or Ranson's, they went on talking. They hooted Meissonier beneath his windows. In the silli-

nesses of the evening, their overstrained minds found relaxation. Valéry said of the Symbolists, " Rarely have more fervour, more daring, more theoretical research, more knowledge, more pious attention, more argument been devoted in so few years to the problem of pure beauty. " And this was as true of the Nabis as of their poet friends.

Thadée Natanson recalls the discussions, prolonged sometimes into the small hours, which went on from 1891 onwards in the offices of the *Revue Blanche*. The talk was as intoxicating as alcohol. " Sérusier struggled wildly in search of words which could convey even a part of his ideas. Vallotton's anger and sarcasm were deep and biting as his woodcuts. Roussel swam out into such deep waters that not only his listeners lost their footing. Contrasted with these, Vuillard and Bonnard were reserved. Distrusting anybody's influence, including his own, over other people, Bonnard loved to contradict. Vuillard apprehended everything and maintained his good humour, but he could at rare intervals break out into a rage which shook him and made his face as red as his beard. "

These two, Vuillard and Bonnard, together with Roussel, formed a group within the group. Bonnard pictures them striding arm in arm across the Place Clichy. Vuillard wears the traditional cape and slouched hat, Bonnard a bowler, Roussel a silk hat; Denis hurries past, his portfolio under his arm; Lautrec goes by, overshadowed by Tapié de Céleyran. In other sketches, Bonnard shows us the offices of the *Revue Blanche*, the Natansons in the editorial chair, Mirbeau arguing with Henri de Régnier, Fénéon bent in two over his desk. Elsewhere we are admitted to Vollard's "cave", animated by the profiles of Degas, Renoir and Pissarro. These *petites images de la vie d'un peintre* assist us to reconstitute the atmosphere surrounding the Neo-Traditionalists during the feverish years when they were finding themselves. In company they traversed the museums and galleries. They discovered Van Gogh at Goupil's, Cézanne, at old Tanguy's in the Rue Clauzel.

Three portraits of Vuillard by Vallotton (*Vuillard de face*, 1897, *Les Cinq*, 1903, *Vuillard au bord de la mer*, 1902) and the *Hommage à Cézanne* by Maurice Denis confirm this character of gravity which was already manifest in Vuillard's impressions of himself. Any trace of the boyish that lingered in the look of his comrades — even of Odilon Redon, who presides with so debonair an authority over the *Hommage* — has long vanished from his countenance. He is pondering his responsibilities. Alone in the midst of others, he is debating with himself.

It has been said that Vuillard's life was destitute of incident. The only events that marked these years of apprenticeship were meetings and decisive revelations — the meetings with Denis, Roussel, Bonnard and Sérusier, the revelation of Rembrandt, Chardin, Monet, Puvis, Gauguin, Cézanne, the meeting with the brothers Natanson, his earliest devotees,

who brought him in touch with Lautrec, Stéphane Mallarmé, Louys, Mirbeau Jarry, Tristan Bernard. With critics (Gustave Geffroy, Arsène Alexandre), with actors (Coquelin Cadet) and with theatrical circles, he was brought in contact by Lugné.

✳

Very soon, the four friends realized that they had nothing to hope for from the École or official competitions. After sending a charcoal drawing of his grandmother to the Artistes Français (1889) and a rebuff before the jury of the Nationale (1890), Vuillard abandoned the salons to exhibit only in smaller galleries or at the Indépendants.

The present writer one day asked him in what manner he had discovered his vocation. He replied, " I should like to say as Degas did: on Sundays they took us to the Louvre — my brother made slides on the polished floor and I looked at the pictures. " His first still-lifes (1887-88) appear to owe everything to the examples of Corot, Chardin and Vermeer; they reveal his inborn qualities, his tact, his predilection for silence and subtle harmonies. They are the work of one untroubled by questions of technical order. But towards 1889-90, the influence first of the Impressionists, then of Gauguin produced a definite change. Vuillard has reached a crisis. Everything, once more, is in doubt. He is a prey to conflicting influences — Lautrec, Monet, Chéret, Degas, the Japanese, the Persians. From discussions engaged in by the artists who were bracketed together under the oddest labels — Synthetists, Idealists, Cloisonnists, Symbolists, Neo-Traditionalists, Neo-Impressionists (this last, a term more properly applied to Seurat and his imitators) — he retained the truths of technical order and these derive, nearly all of them, from the concise, impeccable formula enunciated in 1890 in *Art et Critique* by Maurice Denis, then not twenty years old : " Whether it is a nude or anything else, a picture is essentially a flat surface covered with colours assembled in a certain order. "

But whereas Denis, a conscientious painter haunted by Gauguin's harmonies, remained a disciple, Vuillard from the moment of his second debut (1890) escaped from any influence of a literary or sentimental order. He was determined, headstrong, in revolt against any domination, against passing fashions. He gave himself up to the most varied personal experiments and proceeded from elimination to elimination, from discovery to discovery, ever wary of his own preconceptions and drawing all from within. All testimony and his own work go to show that he was not intoxicated by the wine of theory or the powder of revolution, by the incense of the chancel, or the mists and mirages of the Symbolist era.

" For Edouard Vuillard " writes Maurice Denis, " the crisis brought about by the ideas of Gauguin was of brief duration. " Alexandre Hepp makes the same judicious observation on a page of the *Divan*, inspired by a

confidence from the painter himself : " Vuillard resisted Sérusier's theories proportionately as they ran counter to his natural inclinations, of which he was conscious. Vuillard wished to be entirely free, to refuse all help from outside. His was one of those growing spirits which are necessarily the enemies of dogma and scholasticism. If he listened to Sérusier, it was not as a dumb catechumen. Every pedagogic authority filled him with the same horror of absolute certainties which he had acquired at the École des Beaux Arts. "

He did not waver long. Prudence and modesty restrained him, and if at moments he gave evidence of a taste for experiment or daring, it was only when spurred on by Roussel or Vallotton or more often by the sprightly, fantastic and intuitive genius of Pierre Bonnard. Vuillard and Bonnard, in fact, came under each other's influence. Not for nothing did they share the same studio, inhabit the same district, visit and comment upon the same exhibitions. Both sprang from the lower middle-class, both were of retired habit, needing little but liberty, indifferent to money, honours and fame, severe with themselves, sparing of words, vibrating within... Yet they differed in more than one respect. At twenty-five, Vuillard kept his purity of soul and his laugh, but he had lost, I will not say, his gaiety but his lightness of heart. He was stable, logical and rigidly self-controlled. Sensuality never obsessed him, imagination never led him astray. Bonnard remained a child. His eyes ever discovered new wonders. In his work persists a strain of mobility and contradiction always foreign to Vuillard, who remained as faithful to his habits as Lesueur or Chardin and to the environment and the past which were his foundations.

When in 1890, he again took up his brushes, armed with new ambitions he did not make his appeal to exterior themes, to mystical subjects, to personages withered by the flight of time, to fanciful backgrounds or landscapes, but to the old ancestral repertory, to gestures and souvenirs of childhood, to his native milieu. A Symbolist like Bonnard and much more so than he, he remained attached to the ordinary, to the things of everyday, and far from losing himself in the ill-defined, the vague and the unstable, he limited his horizon and cloistered himself within walls. A painter of the intimate he went back, as if it was being done for a wager, to the inconsiderable objects which were despised because so many mediocrities had made them their speciality. But to the task he brought such a concentration and tenseness, so much emotion, such detachment, so much respect for the object loved and rediscovered, such contempt for artifice, that he found quite naturally within his hand, his heart and his memory, that mystery and silence which the Symbolists pursued desperately through time and space. By this sense of mystery, the everyday mystery, he held communion with his epoch, compelling it to love and reverence a likeness to realism which it would otherwise have condemned.

16

On opposite page : Woman with a bowl (About 1897)

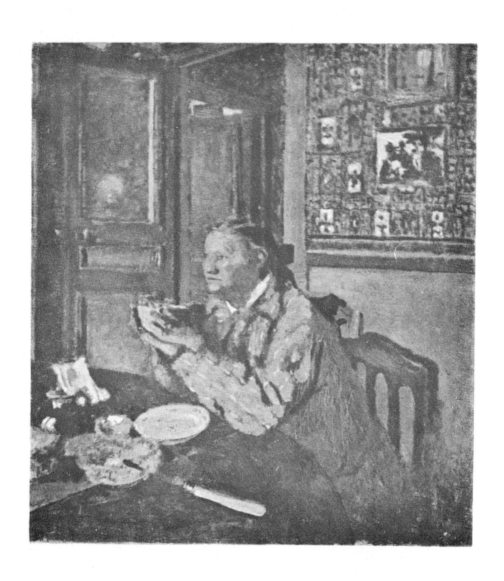

Doubtless, he made, unsuspecting and provisionally, some concessions to the conventions and exigencies of the moment. When we analyse the little " intimates " of the Le Barc de Boutteville and *Revue Blanche* period, we shall see to what extent outside influence and conformity enter into this or that bungling, into such and such eliminations, foreshortenings, extensions, ambiguities, and mistakes, and how marvellously he turned them to account. But these were slight concessions. He does not cease, he never ceases, to be in contact with himself, with himself alone, with all that goes to make him, morally and physically; he is conscious of his possibilities, his preferences and his limitations. Therein lies his virtue.

<div align="center">✳</div>

Vuillard's success, rapid enough, is a matter for surprise. He never desired it. He was frightened when his faithful manager, Lugné, placed one of his pictures. " I must look out " he said, " These well-meaning patrons may disturb my routine. As yet I am not formed — at least, I hope not. And here they are accepting things done anyhow as finished work. True I am compelled to earn my living, but one must be strong not to lose oneself in the process... "

He never ceased to be tormented by scruples; scruples about exhibiting, scruples about selling, about his patrons, about himself. At a time when the young men had little chance of asserting themselves outside the official salons, Gauguin, Émile Bernard, Daniel de Monfreid, Anquetin, Schuffeneker, Roy, Laval and others of the Pont Aven group, held out a helping hand to the Nabis. Vuillard was able to exhibit alongside of them on five occasions, between 1891 and 1894, at Le Barc's. It was there, in a narrow, badly lighted room, that he and his friends were discovered by Gustave Geffroy, Arsène Alexandre, Roger-Marx and Albert Aurier. They were to renew their acquaintance with him in the offices of the *Revue Blanche*, in the Rue des Martyrs (1891), at the exhibitions at St. Germain-en-Laye (1891-92), at the Toulouse *Depêche* (1894), at the *Figaro*, at Bing's, and at Vollard's, in the Rue Laffitte.

Thanks again to Lugné, the manager of the *Théâtre Libre*, unexpected temptations, of material importance to his development, were placed in his way. In 1890, he was entrusted with the ornamentation of a programme. The Nabis worked in collaboration at Paul Fort's *Théâtre d'Art* and at the *Théâtre des Marionnettes*. In 1893, the *Œuvre* was started. The name was chosen, Lugné tells us, by Vuillard, who was " the most interested in the theatre and the best judge of these matters. " Programmes and scenery were the business of Sérusier and his friends, with whom Lautrec, Laprade, Henri Bataille, and others were presently associated. On the earthen floor of a workshop in the Rue de la Chapelle, open to every wind, Vuillard worked on the scenery for *Rosmersholm*, with the help of Roussel, Bonnard

and Ranson, who afterwards did the scenery for *Ubu*. " It was the scenery of the second act " writes Lugné, " which stamped the note of intimacy and distinction on our set. Vuillard surpassed himself in ingenuity and economic invention in creating atmosphere and scenic decoration ".

In those days, the younger men, chained to the easel, were clamouring frantically for walls. The war cry was heard (so says Verkade), " There are no pictures, there are only decorations. The painter's work begins where the architect's finishes. Give us walls to decorate. Down with perspective ! " Here now, was the chance for these aspirants to realize their dreams, to enlarge their vision, to learn the use of materials, by means of which, a quick hand assisted by memory and delivered from bondage to the model, may freely create a world anew.

Vuillard did not underestimate his good fortune. " At that time " he once said to me " I was ready for everything. I took on the oddest jobs, anything which presented itself. Like a schoolboy battling with the difficulties of a translation or a composition, I managed as best I could, or rather as least badly, by all sorts of dodges, working for love of the thing, and also to earn my living ". These jobs helped him to overcome his want of self-confidence. He was assisted, too, by the example of Sérusier, then busy with vast frescoes in the studio of Lacombe the sculptor, and of Bonnard, who was exhibiting several great panels at the Indépendants (1891). Having mastered, thanks to his theatrical experience, the use and the surprises of the " colle " (size), he felt he was able more calmly to apply himself to less perishable work. Patrons came to his aid, nearly all of them grouped about the *Revue Blanche* : Mme Desmarais, the Natansons, Jack Aghion, Dr. Vaquez, Antoine Bibesco, Claude Anet, and (later on) Henry Bernstein. These, with Roger-Marx, Coquelin Cadet, and Olivier Sainsère, were his earliest " fans ". He was thus enabled to escape from doubts, transient at most, but doubts with which an Émile Bernard, a Sérusier, a Ranson, despite their gifts, had to struggle — sorely embarrassed when they were called on to convert theory into practice and driven very often to expedients.

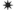

Very soon, Vuillard stood in need of no intermediary between himself and the masters of the past. He was not unfaithful to Monet and Degas, whose double influence so profoundly affected him, to Gauguin, Lautrec, Redon and Puvis (whose tributary he considered himself), or to Cézanne, Renoir and Seurat (all these discovered somewhat later and influencing him somewhat less) ; but he looked behind them, without losing touch with his early comrades, who remained always his confidants and support.

In his *Théories*, Maurice Denis has narrated his own evolution. Like the classic genius, André Gide, (I am quoting) he understood that Synthetism

might easily degenerate into manner- "Style presumes the renouncement of the individual fancy, of the pride of originality. It cannot be acquired but by a method... Our hope is that imitation by the general, by usual and common cognition, may replace impressionist subjectivism, and will offer a barrier of tradition, humanity and common sense to the excesses of the *Deformation* ".

To what extent were Vuillard and Denis in agreement? Nothing can be more significant than the correspondence between them, dating from 1898 (unpublished to this day). We see the influence indirectly exercised by André Gide on the evolution of pictorial ideas. Denis' first contact with Rome was disastrous. As much disappointed by the galleries as the landscape, he regretted Tuscany, which he had just left, and the skies of St. Germain. " We do not become any more accustomed to Rome. Gide tells me that it is always thus and that we shall love it in the long run " (1). Very soon, the painter in his turn yields to " the beauty of the gardens, the splendour of the fountains, the poetry of the ruins " as well as to the discovered Raphael.

Under date Feb 15, 1898, he writes to Vuillard : " I hold that we are wrong in asking from a work of art some immediate delight some outside pleasure, also to concern ourselves while working with that meticulous notation in which so many ephemeral modern works succeed... The value of a work of art lies in the plenitude of the artist's effort, in the force of his will. That is why one sees in Rome how all the painters of the Great Age and their admirable disciples, such as Poussin and Ingres, had in view only finished works. This is the very antipodes of impressionism... Here one feels one has the strength to embark on pictures which may take two years to paint, like the *Vœu de Louis XIII*, as I understand... Gide, to whom I have talked on this subject, feels as I do, and that is why he comes to Rome... " (2).

To these confidences, Vuillard's first reaction was defensive. As cautiously as he applied himself in 1890 to an investigation of the theories of Sérusier and the Nabis, distrustful of any slogan no matter whence it proceeded, he retracts. He is too profoundly empirical to admit that there can be recipes for the beautiful to be applied *à priori*. He pins his faith only to a few elementary truths which he has himself formulated and which he reserves for his own use. He does not believe in habitual and preconceived theories, but in certain flexible *principles* to be applied to each particular case and time.

" My dear Denis (he writes) I suffer too much in my life and my work from what you speak of, not to reply immediately... It is not while I am working that I think of the technique of picture making or of immediate satisfaction. To speak generally — it is not while I am doing this or that, that I consider the quality of my actions (you have only to think of my

19

diffidence and my character). Whatever I have the happiness to be working at, it is because there is an idea in me in which I have faith. As to the quality of the result, I do not worry myself... I conceive, but in fact I actually experience only very rarely, that will and effort of which you like to speak. You have so long been accustomed by nature, education and circumstances and in presence of certain results that please you, to give a particular sense to the word *will* that you attempt to explain others, me for instance, by your own logic. You may sometimes deceive yourself. The important thing is that my faith has produced works. And I admit that is work. In general, I have a horror or rather a blue funk of general ideas which I haven't discovered for myself, but I don't deny their value. I prefer to be humble rather than pretend to understanding ".

✳

In 1898, at the age of thirty, Vuillard was at the zenith of his art. He did not know it. He was more and more successful. His first publisher, Vollard, produced *Paysages et Intérieurs* in 1899. Next, he was invited by the Brothers Bernheim junior to exhibit by himself or with his comrades, annually (1903-14), at the Rue Laffitte and later at the Rue Richepanse. He showed very irregularly at the Indépendants, and with more assiduity, at the Autumn Salon (1903-11), of which he was one of the founders.

We have some portraits of him in his early thirties. He is seen, full face, standing, not wholly at his ease, in *Hommage à Cézanne* (1900), in company with Redon, Roussel, Denis, Vallotton, Bernard, Ranson, Sérusier, Vollard, and Mellerio. Vallotton in his group-picture of *the Five* (1903), shows him facing us, seated, his hands folded, his expression withdrawn, with that apologetic air his friends knew so well. (Roussel, always prolix, is seen talking with Cottet; Bonnard, in profile, is in the foreground; Maurice Denis, upright and slender, at the back).

An admirable lithograph by Redon (1900) suggests the profile of an apostle. No one has better expressed the secret life of the painter and his spirituality. Toulouse-Lautrec shows him under a very different aspect — angry, scornful, redbearded, seated with Thadée, Vallotton, and Missia. Bonnard has caught him, full face, his head slightly to one side, and with a becoming beard. This is Vuillard in a happy mood.

Faithful to his friends, but inveigled into fashionable and theatrical circles, Vuillard looked on, often amused but more often absently; it irked him to be torn from his meditations. Selling embarrassed him; exhibiting seemed to him to touch on indelicacy. He was as indifferent to praise as to blame. He did portraits now, not always to please himself as in the days when he drew inspiration only from the intimate, but in order to perfect his technique and to be freed from the petty tasks and repetitions which the dealers demanded from him in vain. They could not prevail

against his disinterestedness, against a wilfulness equal to Degas's, against his dissatisfaction with himself.

In 1909, in common with Denis, Roussel and Maillol, we find him correcting studies at Ranson's Academy, chiefly in memory of Ranson, and also because he remembered how much he had suffered for want of teachers and having to learn everything over again. The kindness with which Vuillard advised his pupils and described himself to them as eternally a student, is recalled by Christian Bérard. Half-humorously\he called himself the Intimist. None knew better than he his own limits. He was terrified by the multitude of abandoned works and by the gulf which separates the accomplished work from the work dreamed of.

Looking back through the years, I picture Vuillard. I see him seated on a divan or else, with me, following a path through the park. There is noise around us, the noise of conversation, the noise of the wind. Yet we are alone. Or, rather, he is alone. The dialogue is almost a monologue, for when he seems to be answering me, he could be more fairly described as answering himself. Words rise slowly out of the depths of his nature, painfully even, but they are the right ones. He regulates and explains them by gestures. His speech is broken by frequent intervals, so anxious is he to express his true meaning. There is a questioning charm in his regard and his melancholy smile. He twists his fingers nervously or raises his hand to his brow. Nothing passes within his consciousness which is without weight and significance. The atmosphere seems cleansed of every impurity and around us reign only calm and disinterestedness.

By a strange paradox, it was this man who was adopted by the circles most uncongenial to this temperament. We need not, like Carco, imagine him a man tortured by his mode of life, but we learn much from the notebooks to which, from his youth up and especially in his maturity, he confided his secret thoughts. Lucy Hessel's tender friendship, her vigilant devotion, secured his indulgence for many weaknesses. The fact remains that he was the spectator, in spite of himself, of ways of thought and life, of methods and habits, calculated to astonish and annoy him. There was a contrast, indeed, between his studios in the Rue de Calais or the Boulevard Malesherbes, which he left at dusk, and the Hessels' home in the Rue de Naples. There he found himself alongside High Finance and Big Business, the stage and politicians, an entirely mercenary and speculative *clientèle*. Value —the word was not used as Corot used it but in the Stock Exchange sense. Still, let it be said, at the Hessels', the artist's eyes were pleased by a display of luxury and living beauty and by a variety of masterpieces largely selected by himself.

In these surroundings, moreover, he rubbed shoulders with his friends of the *Revue Blanche*, the *Mercure* and Mallarmé's Tuesdays, with Tristan Bernard, the Natansons, Leon Blum, Savoir, Hermant the musician, and Prince Bibesco. They were the intermediaries between this retiring soul and the outside world. He confined himself almost exclusively to this adopted family, by whom he was introduced to undreamed-of spectacles. In his comrades he was able to admire the expansiveness which he lacked, their powers of repartee, their enterprize, in short, their *esprit*. They, on the other hand, respected his discretion, his reserve, and that charming saintliness which was his own way of being eloquent, forceful, and convincing.

This sober bachelor, who loved the society of women and for whom certain feminine friendships had meant much, beheld a panorama of flirtations, elegance, intrigues and love affairs, affairs often revealed to him and which left him wiser than before. He could fancy that it was for the entertainment of his eyes that he was diverted, almost against his will in the evening or at the week-end, from the stark austerity of his daily life, to these dinners, receptions, and country-house parties. But, unlike so many artists at the peak of success, he never allowed these distractions to interfere with his work. And even amid the fashionable whirl, thanks to a series of happy accidents and to Lucy Hessel's supple intelligence, he encountered an *élite*, cynical perhaps, but endowed with taste and vision.

Of these incursions into the world of fashion, this man of sedentary habits remarked " I have never been anything else than a spectator ". Much that he saw disgusted him. At the announcement of the prices his work had fetched at a public auction, he shuddered. " If it weren't for us, where would you painters be? " said a dealer. " Without us, you would be pork-butchers" replied Vuillard. He observed with dismay the corruption of taste by the spirit of speculation. The value of paintings went up steadily, but the standards of collectors went down. Hand in glove with the dealers, there were artists who succumbed to this moral contamination. Contemporaries were more highly prized than old masters. The present took its revenge in ugly fashion. Whatever the quality of the art, the culture of the public and the dealers was not sufficient to justify this infatuation, Society which used to be timid in such matters now piqued itself on being up to date, and rather than be suspected of not understanding, hastened to admit and to understand everything. The Modern was à la mode, but detached from the past. Vuillard listened, speechless and scandalised, to his admirer's talk.

To those who argue that his genius was affected by this promiscuity, we shall reply later on. But it must be said, here and now, that this lay monk, detached from the things of this world, preserved to his last day his passion for the true, his humility, his faith, his denial of compromise. He would have preferred his work not to be talked about. In 1914 he gave up

exhibiting at the Bernheims'. His contributions to the Indépendants and the Salon d'Automne became rarer. He refused all honours. Commissions for portraits by which he was overwhelmed, not altogether to his satisfaction, were never a pretext for self-advertisement. Vuillard played a game of hide-and-seek with fame. The younger men ignored him. There is hardly a mention of him in the pages devoted to the art of the time. That indeed was in accordance with his own wish.

Between 1912 and 1930 the reaction against impressionism was in full flood. It was good form to depreciate Degas, to ignore Puvis, to speak of Bonnard, Vuillard, and Roussel as facile painters and to contrast them with Matisse and Picasso. The aims of these latter were vehemently stressed. Innumerable imitators circulated their canvas manifestos. Vuillard for his part, replied to no enquiry, ceased to exhibit, endured in silence the misunderstandings which he knew were growing up between the public and his work. He was not moved to take a backseat by coyness or pretence but by the honest desire to resist a mass of prejudices, misrepresentations, and sheer ignorance. Inversely, some expressions of enthusiasm that come surprisingly from his lips, are accounted for by his need to re-establish a balance and to escape the prevailing fads and partialities. Simon Vouet, Lesueur, and Puvis, to name only three, were mentioned by him more often than Poussin, Ingres and Cézanne, not because he was lacking in fervour for these but because he felt their influence was abused.

<p style="text-align:center">✻</p>

Vanity stopped short at Vuillard's door. His studio in fact was just one of the rooms, without any particular appropriation, which he shared with his mother at their various addresses — Rue St Honoré, Rue Truffaut (1899), Rue de la Tour (1904), Rue de Calais (1908), Place Vintimille (1927). I can see in my mind's eye the frames piled up against the wall. Great rolls of paper — his schemes for decoration — lie on the floor. Bundles of sketches are stowed in a dusty cabinet. Terra-cottas by Maillol and the half of a life size plaster cast of the Venus de Milo, are the only ornaments on the commonplace chimneypiece. In an adjoining room are a few studies by Corot, Boudin, Renoir, Bonnard and Roussel. The man who lived here never had any possessive instinct. He could do without luxury and comfort. In the modern setting of the Place Vintimille, the old heterogeneous furniture, never renewed, seemed to mock the newly-built walls. The habitable disorder of the home was essentially middle-class. Many of those then living, Bonnard, for instance, and surprisingly, Proust, carried this contempt of luxury so far that they encamped like hotel guests in spacious rooms and strove to give their surroundings a personal note, spreading about them the dust of labour. Bonnard finds enchantment in a homely dressing-room or tiled bath-room. The vast studio of Les Ternes is as

barren of ornament as the Le Cannet pavillion furnished in white wood. But though Vuillard and his contemporaries were not seduced by luxury like so many painters of the 20th century, neither did they affect the Bohemian pose. The living room at the Place Vintimille with its tubes of pigment. charcoal stoves, saucepans and things required for mixing the size had rather the air of a kitchen. Outside was the little square on which one looked down from sedate facades between grey shutters. Vuillard, gazing out, must have thought of himself, twenty years before, looking out from the balcony in the Rue de Calais.

He was true to his own neighbourhood and landscape and saw no need to travel. In company with Bonnard, he visited London and Holland for the first time in 1913 and Spain with Prince Bibesco in 1930. He made several journeys to Italy. His last pilgrimage was to Geneva, to see once more the *chefs-d'œuvre* of the Prado. Between the years '97 and '99, he spent the summer with Thadée Natanson at Villeneuve-sur-Yonne. In 1900 he was staying at Romanel. From that year, when he discovered the south, onwards, he passed his summer in Brittany or in Normandy with the Hessels, Tristans, and Athis (*La Terrasse*, 1901 ; *Les Etincelles*, 1902 ; Vasouy, 1903-4; Amfreville, 1905-7; Criquebeuf, Loctudy, Le Pouliguen, St. Jacut, etc.) No sooner had he left Paris than he became homesick for his workroom. " The painter's instrument " he said, " is his armchair ".

At the gates of Paris, he found hospitality at the Clos Cézanne at Vaucresson (from 1917) and from 1924, at the château des Clayes at Villepreux, and thus was able to renew his provision of flowers and skies each season. His hair whitened, he became more and more sedentary in his habits, but he preserved intact his reserves of enthusiasm, his capacity for indignation and surprise. To the pure of soul, that privilege belongs. Life and men did not lose their power to amuse him. " What a singular person " he would often remark, on meeting new types at every step. With age, he lost few illusions. His notebooks, which are not to be opened till 1980, should throw much light on his character. He was led astray by no passion; hence his childlike physiognomy, enduring to the last, his expression grave and enraptured by turns, and the intensity of his presence. His countenance shown to us in a charming pastel of recent execution, is more serene than that which he wore in his twentieth year. The hair has receded from his temples; behind the glasses perched on the tip of his nose, his straight mild glance seems to dissipate the false. I seem to hear him say once more, " How pleasant it is to grow old! "

There was nothing of bitterness in him. Even the fits of temper which so rarely disturbed his natural blandness and discretion, were rightly inspired. No cunning entered into his discretion. It was born simply of a profound dislike of the nearly-true, the vague and the impulsive. It was a form of control which he strove to exercise over his words, his thoughts

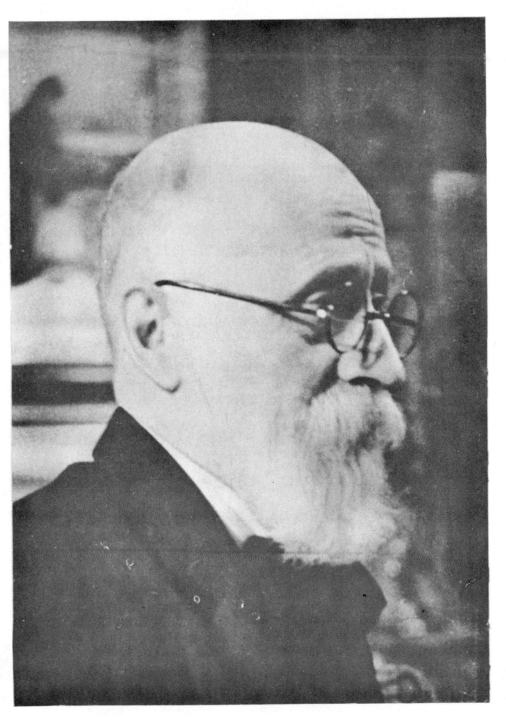

Edouard Vuillard — *Photograph*

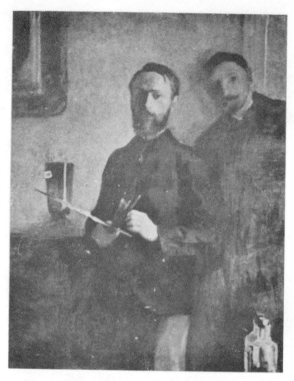

Vuillard with palette (About 1888)

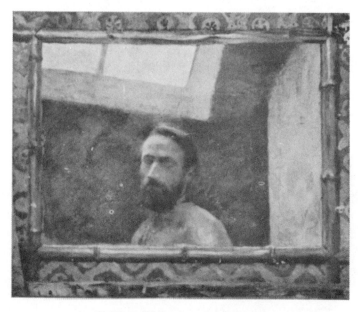

Vuillard in the attic (About 1888)

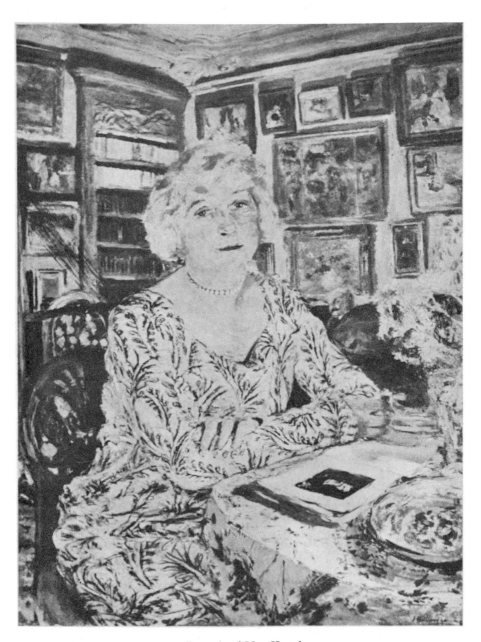

Portrait of M^{me} Hessel

27

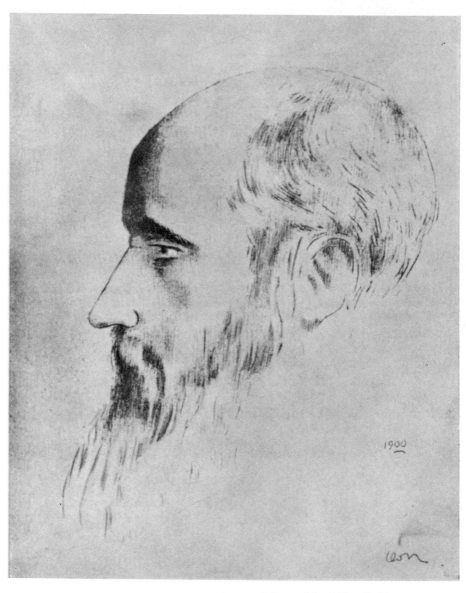

Edouard Vuillard (1900) — *From a lithograph by Odilon Redon*

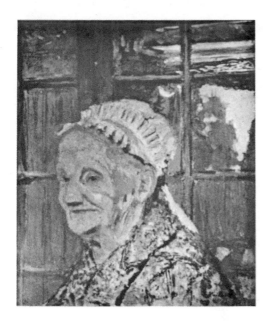

M^{me} Vuillard (1920)

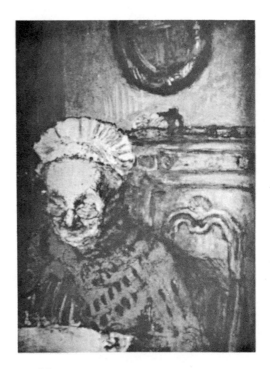

M^{me} Vuillard (About 1926)

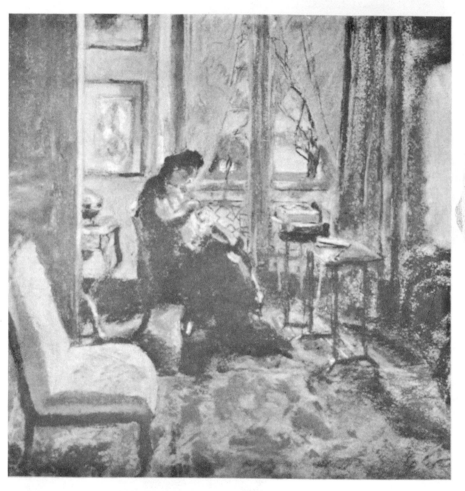

M^{me} Vuillard, sewing at her window (About 1923)

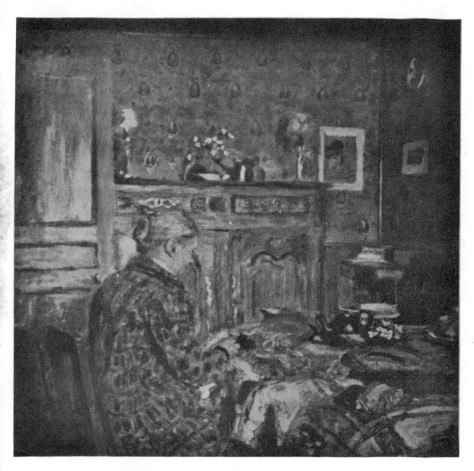

Luncheon (About 1900)

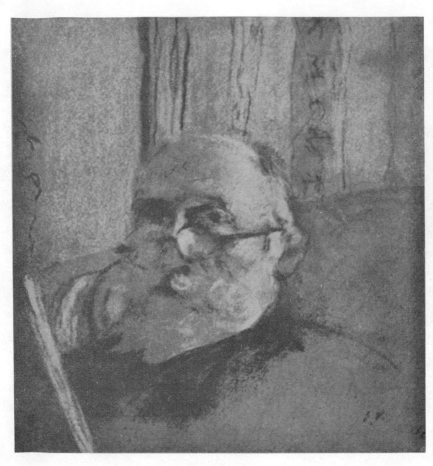

Vuillard by himself (About 1927) — *Pastel*

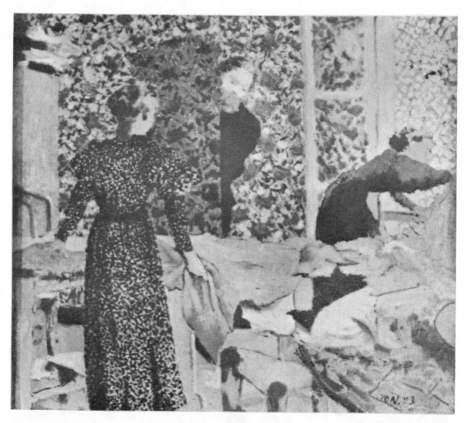

The Dressmakers (1893)

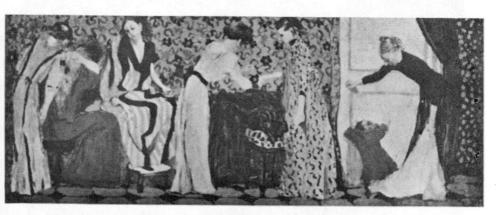

Sketch for design surmounting door (About 1893)

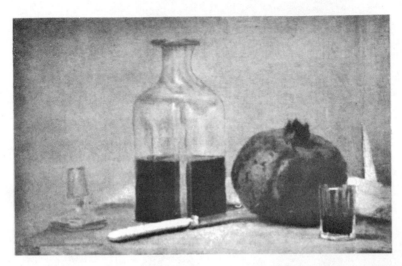

Pomegranate and still life (About 1881)

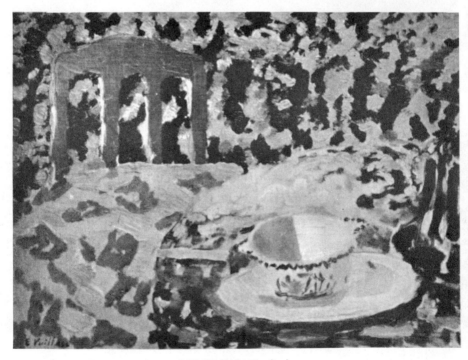

Still life. (About 1891)

34

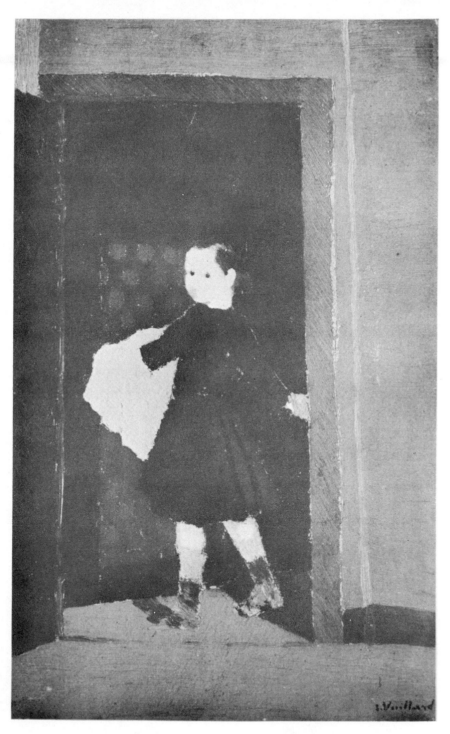

Child in a black blouse (About 1892)

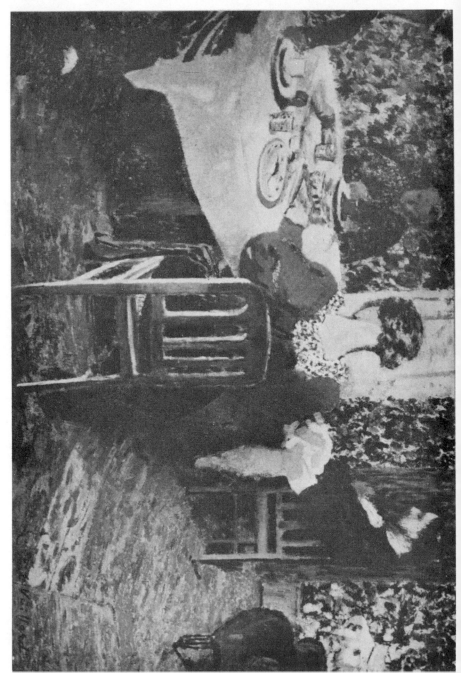

Family Life (About 1897)

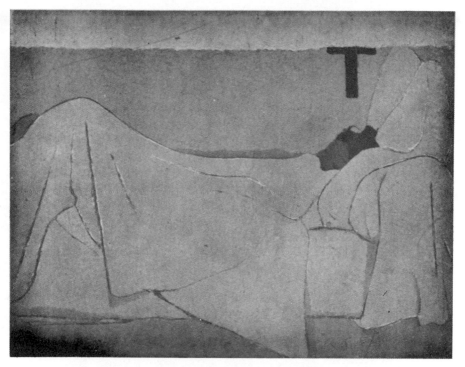

In bed (1891)

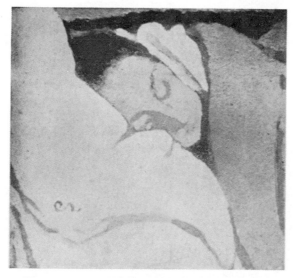

Sleeping woman (About 1891)

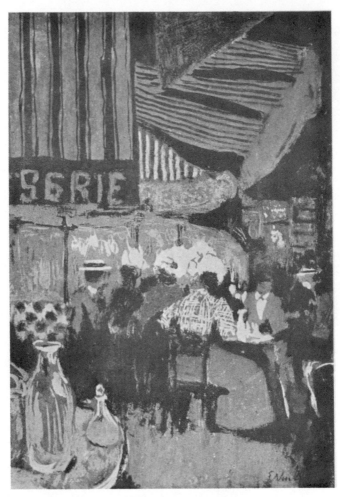

At the pastry cook's (About 1898)

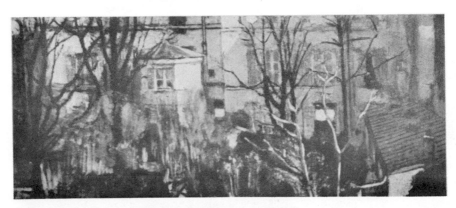

The courtyard in autumn (1898)

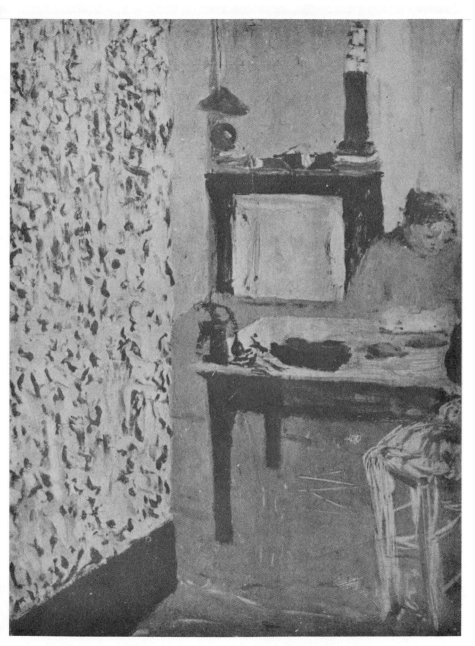

The corsetmaker's workroom (About 1891)

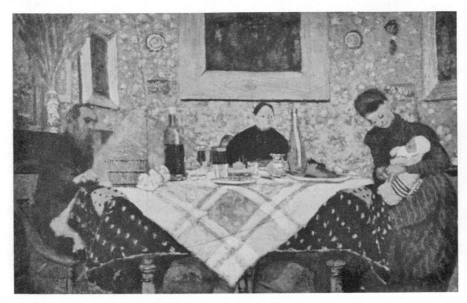

Family at lunch (1899)

his entire work. " Never did he express himself absolutely " declares Verkade in the *Tourment de Dieu*, " lest he should say what was not exactly true ".

His dread of risk, his slender appetite for adventure, barred the way, necessarily, to other discoveries. He penetrated ever deeper and deeper into his own being, always in the same direction. Resignation, this might be called — more truly, it might be recognized as his fidelity, a virtue illustrating his life as well as his art, his devotion to the same beings, the same objects, the same sites. This unswerving loyalty is to be wondered at in a time when the *Shock values*, denounced by Valéry, and the ambition laudable in itself and respected by him, to break with the already seen and the already known — to astonish oneself — had impelled so many artists along a perilous course. With an open mind, he studied their feats of strength and daring. Bonnard filled him with amazement. He was far from disputing the importance of Picasso's investigations or of those movements of discontent or destruction which took the shape of surrealism and cubism. Being anything but a revolutionary, as he chose to say of himself, he would not deny the benefits of revolutions. He had a great kindness for beginners. His two reports to the Academy on the award of the Prix de Rome, as well as his work at Ranson's, show how deeply he was interested in the formidable problem of the teaching of drawing and the technical and spiritual direction of a rudderless youth.

The delay in making a collection of his works which his admirers called for and which, in 1930, the Luxembourg did not succeed in doing, was due above all to the scruples of a painter who 'did not want to inconvenience his friends' *(sic)* and who regarded such a confrontation with his own works as downright painful. Bolette Natanson had to bring her charm and persistence to bear before he would consent to showing some forty small pictures at the exhibition of the *Peintres de la Revue Blanche* (1936), which coincided with the celebration of the Fiftieth Anniversary of Symbolism at the National Library. The unsystematic Bonnard-Vuillard collection at the exhibition of the *Maîtres de l'Art Indépendant*, so courageously organized by Raymond Escholier in 1937, made a more comprehensive collection a work of urgency. It was shown at last at the *Musée des Arts Décoratifs*, largely thanks to the initiative of A. S. Henraux and David Weill, and preceded at Bernheim's gallery, by an exhibition of admirably selected easel pictures dating prior to 1914.

Vuillard had already been elected to the Institute, an occasion of much misunderstanding. It was said that he had acted inconsistently when he, who till then, like Monet and Degas had refused all honours, accepted this one, upon the insistence of Maurice Denis, Desvallières, Blanche and Sabatte, after considerable hesitation, only with the desire to serve. " The

coat with palms " writes Veber, " is the only uniform which the perfect artist would ever wear. And I am sure he did so out of an excess of Christian humility. " He was elected on a second ballot (January 1938) by a majority of eighteen.

The admirable retrospective collection (1938) put together under the artist's supervision, included what was essential of his productions. The younger generation knew nothing of the mural work which occupied the central hall. In the first room, on the side of the gardens, were collected drawings, engravings and pastels; then came the little masterpieces of the Le Barc de Boutteville period, next, a complete collection of still life, interiors, landscapes and portraits — altogether three hundred pieces.

The exhibition proceeded without publicity or excitement, as Vuillard desired. It was the subject of comment at two meetings, one addressed by Gérard Bauer on *Vuillard and his times*, the other by the present writer on *Vuillard ou la féerie bourgeoise*. During the exhibition, from May to July, a half respectful silence was maintained by the critics. In general they seemed loth to discuss the work of the past fifteen years. Since the Academy election, the " advanced " press had been unfavourable as a matter of principle. Vuillard, however, who looked in only on varnishing day, was pleased that nothing troubled the religious calm of this gallery which contained the balance sheet of fifty years labour and conflict. He was the one person, it seemed to him, to whom this confrontation could be of interest. He little dreamed that he had only two more years to live and that this retrospect was in the nature of an adieu.

In the years '38 and '39, he was able to finish and to witness the installation of the only two decorative pieces which the state had commissioned from him — *Comedy*, a great square panel for the Théâtre de Chaillot, and *Peace protecting the Muses* for the Palace of the League of Nations at Geneva. The winter of 1939-40, he was engaged on some portraits, pastels, and charcoal drawings of the beautiful trees of Les Clayes. He complained more than once of pain in his chest, but he was more distressed by events in the world outside and the terrible confusion in the public mind. Already in very poor health at the moment of the German advance, he was persuaded by his friends to leave Paris. He stayed for a while in Burgundy. Thence he was taken to La Baule, to die there at eight o'clock in the morning June 21 st, 1940.

His ashes were not brought back to Paris till a year had passed. There were few of us to follow them to the little suburban cemetery of Montmartre. Nearly all his friends had been forced to flee. Evil forces were abroad. Death reigned in the galleries. Betrayed and without confidence in herself, France knew not whom to blame and impotently beat her breast.

What was to become of Vuillard's studio? Deeply disgusted by the remorseless sales following on the death of Degas, the painter had not thought of his own work or left any written instructions. His sister and her husband, opposed to any sale by auction, generously presented fifty-five drawings, paintings and pastels to the galleries, under what was called the Vuillard (more correctly, the Roussel) bequest. These were shown at the Orangerie in the course of the winter 1941-42. Some are of real importance. The full value of the others will not be seen until they are placed in juxta-position with definitely completed works, first, at the Musée d'Art Moderne, next at the Louvre. The desire of perfection, which was always Vuillard's will be frustrated, his survival menaced, by exposing too many sketches, full of charm, no doubt, but preserved only for himself and interesting to him only in so far as he had discovered " why they fell short ".

A Calatogue is in preparation which will track down forgeries and de-scribe the complete work, including the considerable remnant found at the Place Vintimille.

The purpose of the present work, begun in Vuillard's lifetime and with his consent, is to state his intentions and to attempt for the first time, a close analysis of his character and his work.

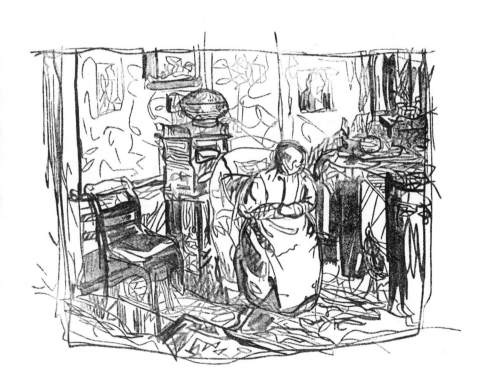

THE INTIMIST

*The first still lifes. — The crisis of 1800. — Syntheses and deforma-
tions. — Vuillard and the Symbolists. — Entresols and attics. — Equili-
brium recovered. — The Woman with the Bowl. — Family Meals. — The
Social Kaleidoscope. — Nudes and still lifes. — The exterior world. —
Permanence of the exquisite.*

Vuillard began by painting those small subjects which have always
illustrated the qualities, the grace and prestige, of the French School. By
his search for values and undertones, by the importance he attached to
grey, by his horror of rhetorical dispersion, he stands revealed at twenty as
the descendant of the Maître de Moulins, Lesueur, Chardin and Puvis. The
seed of all that he was to express later on with more strength is to be found
in the still lifes executed in the course of 1887 and 1888, which were to
remain unnoticed for half a century — in that cultivation of the intimate
in its simplest and most mysterious form — the love of an order which far
from excluding the natural finds room for the accidental—a predilection for
the subjects which, even in the absence of man, are always impregnated
with a human essence.

*Potatoes and kettle, Glass of water and lemon, Glass and cheese, Cup
and orange, The jar of pickles, Cabbage and still life, The copper candlestick,
Wild rabbit, Greengages, Bouquet of violets in a pot* it may have been one of
these little canvases that was rejected by the National jury in 1890, with
the result that the artist never again took part in official competitions.

These works are not original in aspect. Their unpretentiousness, their
finesse, alone renders them exceptional. Skied on the wall of a Salon,
probably they would never have been noticed. Yet how masterly is the
treatment in *The Wild Rabbit! (Lapin de garenne)*. Here the artist brings
out the play of the brown on the wall and the little body, so docile in its
erect position, free from fear and agitation, while the colour repeats
itself in the fur streaked with the hues of ploughed land. Vuillard
even before he re-examined his artistic conscience, as he was soon to do,
understood grouping and harmony. It may be said that the composition
lacks originality, that submission to the real is too abject, that these are after
all, timid experiments. But we cannot be unconscious of the artist's
wonderful faculty of *taming* the subject, the subject which by its hermetic,
brilliant or frozen quality eludes so many others, remaining the non-Ego

and the Thing Represented. Even in these earlier *intimates*, intimacy is established between the bouquet and the vase, between the glass of water and the lemon, the waterjug and the glass, the sugar-basin and the cigarettes, between the several companions placed on the table. Equally is it established between the painter and this little universe, the character and qualities of which he has been able to verify by daily use.

Still life with salad (Nature-morte à la salade) is somewhat crowded, it is true. A directive rhythm is wanting on this culinary field of battle where an army of table-knives is deployed or plates piled near the water-jug, and the camembert cheese near the bottle, the water jug and the plates, awaits its hour. Yet these objects have the air of presiding at some domestic festival or at some unsolemn rites. We know beforehand, the company will not be merry. The light is not the light of an orgy. Only faint shadows rest on the table-cloth. Only a few leaves on a salad bowl strike a sharp note in this symphony.

Together with these, we have some half-length portraits by the painter who at twenty was not yet acquainted with Manet or Pissarro. We have his own (with several variants), showing him calm and grave, like a Fantin We have his sister's, which might have been the work of the youthful Degas, and more exaggerated, his aunt Sorel's. What strikes us here is the naturalness and the authority of the tone. A rare combination! At the outset of their career, diffident workers express themselves hesitatingly with shaking brushes; others are over-confident in their skill. But Vuillard's suavity and serenity make us forget his age, still more that he is on the eve of a crisis.

✻

Under the indirect influence of Gauguin, his world was shattered. Everything had to be re-considered — line and colour, subject and material, the construction and dimensions of the work. The year 1890 marks, apparently at least, a total break with the past, a break which may be compared with what happens to the youth on leaving the Upper Fifth. The superficial dissolves and an interior revolution upsets the materials of knowledge.

The works of this period were preserved by the artist. They exhibit so much disorder and daring and so much of the arbitrary that they might have been executed fifteen years later at the height of *fauvism*. There is no little incoherence in these studies. Vuillard, suddenly released, abandons himself to febrile sallies, in full agreement with his comrades' slogan, " Amplify the form, exalt the tone ". Even when the Nabis were working separately, they worked in collaboration, so close was their communion. United by their participation at the Indépendants show and at small exhibitions, Vuillard, Bonnard, Roussel, and Denis form a group within the group. Captivated by the same subjects, Bonnard and Vuillard

continue to fraternize so as easily to be confounded, one with the other. They remain attached to the background of the *petite bourgeoisie*, to the same districts, to the same rooms, to what they may learn from the Japanese, from Lautrec and Degas. They listen, moreover, to whispers of childhood and the familiar.

For economic reasons, but chiefly out of sentiment, Vuillard draws inspiration from *the near* — beings or objects — from what is within reach of his heart and hand. His models vary little. But from 1890 onwards, his method undergoes a radical change. Far apart from the actual thing, he no longer reconstructs tangible shapes but what he remembers of them. There was nothing in this contrary to his talent. No violent debate arose between his sensibility and his reason. That Symbolism which led so many weaker souls into mannerism, troubled hardly at all this balanced temperament. He leaves escapes, pilgrimages, journeys in space and time, to others. No phantoms will lure him from the world of his choice— the everyday table, the bed, chair and door. More than ever, he feels the need of something real to hold on to, of walls to enclose the rediscovered objects.

One of the first intimates is entitled *Woman in a check dress darning a stocking in a room hung with red paper with yellow flowers (Femme en robe à carreaux ravaudant un bas dans une pièce tendue de papier rouge à fleurs jaunes* (1891). This might well be the title of a Pieter de Hoogh or a Metsu. But no picture is less realist. Vuillard's interiors are now peopled with elliptical figures, often seen against the light, at once strange and familiar, vague and precise, singular, charming and fraught with a mysteriousness which is the more unexpected, since they wear modern dress and are engaged in the most commonplace tasks (sweeping, cooking, dressmaking). Violent effects of chiaroscuro help to create the warm, velvety, subdued atmosphere common to many of the small pictures which Bolette Natanson brought together in 1936. For the most part, they are inspired by family life. The characters, for all their out-of-fashion garments, achieve, like Seurat's, a touching picturesqueness. They are not models but the real inhabitants of these interiors — the painter's mother, his grandmother, his uncle, his aunts, his sister. This intimacy is shared by the friends and the modest collaborators who divide the day into a series of little pictures, like the scenes of a play. The intrusion of what is called the anecdote never disturbs the daily round by a factitious picturesqueness. Only the ordinary, I might say, the *lived-before*, has charm. The secret force of these intimate studies resides in the fidelity of the painter to such attitudes, such lights and such rites as are repeated like the hours and the seasons. Thus these actions, stripped of all solemnity (many of which can scarcely be called actions, since they are concerned with people at table, or reading, chatting or sleeping) are invested with more

general importance and gravity than the trivial events described — sometimes very happily — by the lesser Dutch masters and their French, English and Flemish emulators of the 18th and 19th centuries, with the aim of entertaining or bringing out the aptitudes of the moralist or the chronicler.

Never does Vuillard, like Steen or Hogarth, invent a scenario or incline towards the genre picture. As we shall presently see, his essential interest is less in the individual in action or at play than his relation to his surroundings or, rather, in his ordinary frame. At this period of his beginnings, he incorporates the persons with the setting to such a degree that one gets the impression that by some law of mimetism, setting and person make only one. A dress appears to be composed of the same material as the wall-paper. A profile seems to be woven. Wall-paper to which Degas assigned so much importance (cf. the great *Portrait de famille* of 1860, the *Violoncelliste Pillet*, etc.) takes on hallucinatory powers. The background wedges into the foreground. Shadows are denser than solids. Objects have, nearly all of them, more weight and more movement than the living. The perspective seen through a doorway, the hanging lamp, the table laid, become spectacles, I might even say, events, more notable than a company of persons reduced to the rank of dummies little better than still-lifes.

I recall Vuillard at the Place Vintimille, as he opened as a special favour, a cupboard containing a hundred or so studies covered with dust. As I took them out, one by one, he looked at them anxiously. Raising his arms, he exclaimed " It's dreadful, revealing all these secrets! " It might have been thought he was about to disclose shameful thoughts, or some crime long since forgotten. I remembered the words of Degas, " A picture is an artificial work, outside nature. It calls for as much cunning as the commission of a crime. " Now and then he asked me to hand him some little panel which he appeared stupefied to find was his own work. More often he would bow his head with an unhappy expression before some exquisite sketch which he deemed monstrous. There were faces that detached themselves sharply against green, yellow or pure red backgrounds, febrile spectres from the Grand Guignol, raucous cries, muffled cries, proceeding from some being in a frenzy. Vuillard appeared quite flurried by this tumult.

From the years 1891-92 dates a series of very small pictures painted in oils on cardboard, entitled *Woman in yellow, Woman in black, Woman by an open door, Woman in black and beige seated near a table*. What characterizes them is the total absence of modelling. Lines, some horizontal, some vertical, determine the frankly schematic architecture; the faces are indicated summarily; there is no interior detail. A palette of blacks, browns, ochres and whites, suffices the artist. But in spite of so

On opposite page : Bouquet of Pansies, Forget-me-nots, and Daisies (About 1900)

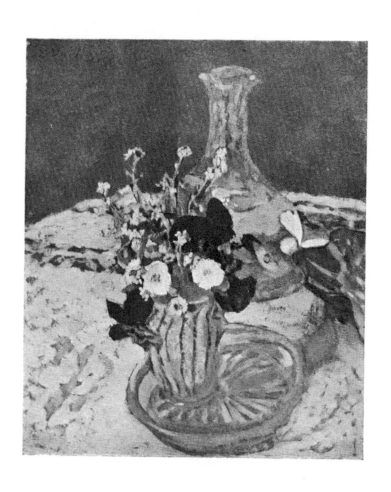

much abstraction and deliberate austerity, however elliptical the outlines, they are living and seem to move.

Au lit (Roussel bequest), done in *camaïeu*, shows a long form lying under the sheets, the tousled head emerging against the light on the coverings. This sort of construction anticipates some of Braque's or LaFresnaye's works by fifteen years. The rigorous stressing of certain angles and contours is allied to the most sensitive observation and an exquisite discrimination of values. Not less typical is *l'Enfant debout en blouse noire (Child in black blouse standing)* (Hessel collection); as in Dutch pictures, a perspective of doors creates different areas of light. It has a dark muffled effect, but it charms by the naturalness of the attitude and the harmony of its lines.

Elsewhere, under the influence of Gauguin and the Japanese, too marked an anxiety to refresh the production has led to eliminations and sometimes to forced contrasts. Faults of youth! — the painter, we must remember, was only twenty-three. " At that time " Vuillard said to me, " I was hunting in all directions. I hardly knew what I was aiming at. I worked alone. I stood in need of advice and encouragement ".

As a change from canvases which were almost monochromes, the artist, dazzled by Chéret's enchanting wall paintings, and the flat sonorous posters of Toulouse-Lautrec, sometimes abandoned himself to the joy of the pure colour squeezed from the tube. He touched up the vivid yellows and vermillions of his *Coquelin Cadet (Diafoirus, Basile)* and *Biana Duhamel* water-colours with almost a grotesque effect (4).

The Family after the meal (Famille après le repas) with the remains of the supper still upon the table, is one of the first collective " intimates ", one of the first *cènes* (using the word in the biblical sense — signifying the last supper of Christ or by extension, Holy Communion. *Translator's Note*, painted by Vuillard. His mother and grandmother occupy the flanks of this little canvas. Their profiles, highly pronounced, stand out against a background tinted amber and green by the hanging-lamp. In the centre, the uncle draws at his pipe; a young woman, turning sideways, in a tigerstriped dress, her head thrown back, rests her elbow on the table; two black bottles stand out sharply against the light in the middle of folded napkins, plates and bread. The work is highly characteristic, the more so for its tempering — it has a grace which Vallotton never achieves, a gravity foreign to Bonnard, a love of those little profane solemnities which distinguishes it at all points from Maurice Denis. It is one of the earliest Vuillards inspired by artificial light. Others are the *Lampe à pétrole (Oil lamp)* and the *Dîner à la bougie (Dinner by candle-light)*, in which the blended influence of Gauguin and Cottet is shown in the curious effect produced by the back-lighting.

The projection of shadows is, in fact, a conspicuous element in many

pictures left as mere sketches. We see the white or blue enamel of the stove, loaded with kitchen utensils, glittering in the chiaroscuro. The active shadow is the painter's mother, sometimes brandishing a saucepan, sometimes tying on her apron. Girls spread out cloth gilded by the old oil lamp; they read or sew under the green shade; groups project strange outlines. A few still-lifes *(Bouillotte et casserole, l'Encrier, le Pain)* also date from this period.

A notable economy and a strict choice of material governs the organization of these canvases. Only the purple, yellow, blue or white of a skirt, bodice, stool, carpet, or curtain, strikes a lively note amid the subdued tones and contrasts with the severity of opaque blacks and cold greys. The title *Femme en noir (Woman in black)* applies to most of these studies. One feels that at this stage, Vuillard has been looking more closely at Degas than at the impressionists. Everything shows it — choice of the subject, methods of composition by stages, the downward design, the startling bisection of objects, everything except the sentiment.

✳

For with Vuillard, Vuillard the contemplative, despite some angles and jarring notes here and there, the exquisite already has the mastery and insinuates itself everywhere. About the work of Degas, on the contrary, remarks Paul Jamot, one observes nearly always a struggle, some latent hostility, even if it be between the objects. In the bosom of the intimate, Degas holds back or refuses himself. But Vuillard, once he is sure of himself and sure of others, gives himself freely. He seems to have understood early in the day that the field of his discoveries would be limited and that he would find happiness only in a sheltered world. But his innate sense of harmony was not enough for him. He wanted to demonstrate the perfect accord between the setting and the objects within it. It is this concern for internal geometry which distinguishes the interiors of 1891 from the still-lifes of 1889. Vuillard imposes on himself, at moments even brutally, *methods of composition*. He sacrifices in the cruel sense of the word. He spurs himself and wrenches out a reply to problems. (See his *fauve* portraits).

These were years of ferment. Influences from without were effective only so far as they helped him to discover himself, to gain confidence and to recover, far from the professional teachers who taught him so little, and in concord with his true companions, the great rules, elementary truths and forgotten discipline.

The other Nabis generally showed more diversity in the choice of subjects. They ransacked the streets and the country. Vuillard shut himself up. To enlarge his horizon or to commune with vaster distances, he opened or half-opened a door giving on to other rooms or a corridor.

A table, an ordinary chair, a folding bed, a carpet, linoleum — he required no other subjects for meditation, for his was a plastic meditation which was qualified by the reflective, demonstrative character of these spiritual exercises. They were unpretentious — a thing uncommon with painters who so soon as they acquire a method, independently of their instinct, are inclined too often to lay stress on their intentions and to proclaim their intellectual merits on the house-top.

In Vuillard's first " intimates ", what there is of the schematic is corrected by an exquisite tact. To this contrast or more exactly this mixture of suavity and violence, the natural and the arbitrary, is undoubtedly due the peculiar appeal, for instance, of the *Atelier de la corsetière (Corsetmaker's workroom)* (1890 or 1891). Behind a table which divides the canvas into halves, the artist's mother is bent over her work. The clear vibrations of a piece of fabric are in contrast with the nudity of the floor and the walls. An active silence fills the void. In *l'Essayage (The fitting)* are gathered several young women whose faces we shall recognize again in many a sketch and notably in a series of lithographs : *Pliage du linge, L'intérieur aux cinq poses, L'Atelier* (1893). Belonging to about the same time is *La Femme balayant près d'un poêle (Woman sweeping round a stove)*. In the foreground, on the right, is a chair; on the left, the sombre column of the stove. The napkin drying on the chairback, and the canvas stretcher against the wall are indicative of a room which serves as kitchen and studio. We note the order which presides over this disorder and in the background, the importance of the vertical lines of the door and cupboard cut halfway across. From this picture proceeds a quiet poetry which makes one think of François Coppée (the Coppée akin to Verlaine who gives promise of Francis Jammes).

How would a modern Steen have treated the same scene? The dust would have been floating about, a child would have been lighting the fire, the mistress of the house would have been finishing her toilette, and through the door ajar, a servant would have been seen bringing the letters. But Vuillard, like Vermeer and even more so than he, has simplified action, costumes and framework. Here are no velvets, pearls, furs or smiles; every trace of opulence, even of modest wealth, has disappeared. Poorly dressed in a house-jacket, the woman of the house, like the walls, is no longer young. The broom is worn-out, the napkin wearing into threads. Yet there is here no appeal to sentiment nor the moral intentions which Diderot encouraged in Greuze. And there is no sadness, either. It is of Le Nain, of Chardin, of Corot, that we think. A Chardin detached from reflexes and the polished, a Le Nain not quite so austere, a Corot inveigled in his childhood into a network of habit and spells. The blond and tender colouring, which Edmond de Goncourt, admired in the *Blanchisseuses* of Degas, inevitably recalls him; but the woman sweeping appears neither

overtired nor bound to her task — she is not a hireling, she is in her home, and happy, which is better than resigned.

L'intérieur au paravent (Interior with screen) or *Les Couturières (Dressmakers)* is premonitory (1893). In the foreground, a girl standing spreads out her work; in the background, another girl, bending so that her body forms almost a right angle, projects her fine profile against the shutter and sky. In the centre, the head and shoulders of a young man appear from behind a screen, as he looks wonderingly at this scene of animation, at the stuffs and scattered lights. All those methods of colour orchestration used by Vuillard three years later in the Vaquez panels, are here shadowed forth : movement without dispersion, a light chiaroscuro, brevity with feeling, the leaving some of the zones vague in order to emphasize an inspiring detail. The conscious and unconscious here combined to upset values and the hierarchical order. These discoveries were such as the poet makes — the play of elisions, alliterations, assonance, pauses, lines running on. It is not so much the ostensible subject which occupies us as the material of the picture —the subtle relation of tones, values and rhythms (the back of a neck, for instance, is as charming as one of Watteau's and reminds one also of Seurat). Here, as in other contemporary canvases, the contrasts of the full and the empty, heat and cold, are established with so much freshness and novelty that such commonplace themes as a youth lying on an old mattress, a grandam watching over a new-born child, or someone reading on a balcony or by lamplight, combining precision with the vagueness of a dream, are delivered from all realism.

Vuillard, it is essential to remember, from this moment had discovered his method. He was not to paint the object as it first struck him but to postpone his response to the excitations of the exterior world; avoiding all impulse and the automatic action of eye and hand. It is a difficult method which calls for no little prudence. In the years of transition, an excess of logic and arbitrariness urged Vuillard to some insolence in colour or contour. This moderated; the *détente* was near.

A specially fruitful year, 1893, witnessed the production of many small pictures which were shown at various group exhibitions organized between 1891 and 1894 by the *Dépêche de Toulouse* news paper and the *Revue Blanche*. Thus they came to the notice of Roger-Marx, Gustave Geffroy, Albert Aurier and the Brothers Natanson, who wrote enthusiastically about them in the *Dépêche*, the *Voltaire*, the *Revue Encyclopédique* and the *Revue Blanche*.

I, the writer, passed my childhood in the society of these little masterpieces. My father chose that the Nabis should continue to fraternize on the same wall where their affinities were more conspicuous than their divergencies. *Le Fiacre (the cab), le Trottoir à l'orgue de Barbarie (Pavement and barrel organ), Les Coqs* and *La Tasse de café (Coffee-cup)* by

THE INTIMIST

Bonnard alternated with *l'Enfant à la chaise (Child in a chair)*, *la Nappe à carreaux (Check tablecloth)*, the *Repas de famille (Family meal)* and the *Pot de fleurs (Pot of flowers)* by Vuillard. The *Étang à la barque (Boat on the lake)* and the *Procession* by Maurice Denis, obviously deriving from Gauguin, made me understand why the new school appealed so much to poets. I was led to enjoy these pictures by the mystical freshness of the tones and the protraction of the forms. Captivated, and for other reasons, by the picturesque compact of a group by Vallotton *(Les Passantes) (The Passers-by)* and by Roussel's *Leda*, I was too young to perceive the perfection achieved by Seurat in a tiny panel *(Tour Eiffel)*, which my father had deliberately placed beside the quartet. The pictures of Vuillard and Bonnard being treated in the same subdued tone, it was easy to confound them. Vuillard's deformations gave the impression of a prankish and off-hand attitude which I afterwards learnt was very foreign to his temperament.

In this year, 1893, Vuillard who had hitherto often signed his name in capitals, adopted, like Bonnard and Lautrec, a monogram composed of his initials. The *Intérieur* of the Pierre Goujon collection, the *Dame âgée examinant son ouvrage (Old lady examining her work)*, the *Café au Bois de Boulogne*, *Maternité*, the *Lit-cage (The Folding-bed)*, and the *Petit Restaurant (Little Restaurant)* (with the bare marble top of a table cutting across the seated persons, as in Degas), date from this time.

It was in the course of 1894 that Vuillard in the *Jardins de Paris (Gardens of Paris)* attempted mural decoration for the first time, using distemper, with which medium he had familiarized himself in painting the scenery of the *Œuvre*. The two panels. *Dans les Fleurs (Among the flowers)* and *Conversation*, commissioned by Thadée, derive by their proportions from easel painting, but in them we see, implicit, the series executed for Dr. Vaquez and Claude Anet. They possess the sonority of lacquer; chestnut-brown, warm reds, vermillions, yellows and prune-violets are wedded to blacks. Perhaps because they were painted not on cardboard but on canvas, the colour appears denser and its sombre glow reminds one of certain Bonnards. Like him, Vuillard has drawn inspiration from the surprising proportions taken on by persons and things in false lights and protected from the darkness by lamps, candles, and other artificial means of illumination.

Conversation and *Dans les Fleurs* participate in an atmosphere which is neither broad daylight nor evening. At the bottom of both pictures, the dominance of a long horizontal zone is assured by a dark loaded table, while, hardly distinct from the walls, young creatures, seated or upright, are *vaguely* engaged in different ways. The deliberate avoidance of precision contributes greatly to the evocation of the faces and to the mystery

which the painter achieves by following in some measure the methods of Denis. These phantoms, which we recognize as living beings in their striped and spotted bodices, these little bourgeois sisters busy with cutting and darning. (as a work-box or an unfolded cloth lets us know), are soaked in symbolism. It is impossible to discover to what family belong the bouquets, half hortensias, half chrysanthemums, that spangle the spaces with their whites and greens and contrast with the flowers on the wallpaper, turning the persons into something like ghosts. On these offertory tables many objects more or less distinct are seen — fallen petals, boxes, books. The spell resides in these vaguely sketched gestures, embryonic states of mind and the correspondences invented between objects, faces and environment. It is born of declared or latent sympathies between tones as difficult to define as the names of the flowers. Amber, tortoise-shell, onyx, ebony, have composed this double symphony of their rare substance and muffled note. To this one, we may approximate several contemporary panels. A sufficiently different canvas presents a bearded youth (perhaps Bonnard) conversing with a woman in a white collar. The work is done in matt blacks, grey, sombre browns, reds and ochres which give us the date, near enough.

*

The capital year, 1896, was in great part consecrated to the Vaquez panels, to the importance of which we shall refer when studying mural work. Vuillard, in the neighbourhood of his thirtieth year, discovered his equilibrium. The era of his tentatives had closed. Master of his methods, he was prepared to execute the masterpieces of the years 1897 and 1898.

Henceforward, a hierarchy came to be established among the plastic elements, a revolt against that jumble of forms and subjects, reminiscent of Jules Renard, and against what had been too deliberate in this or that naïveté or distortion. Unlike Bonnard, Vuillard was already very serious for his age. He did not, like his friend, continue to play with appearances, forgetful of the traditional aspect of things, their use, and even their names, nor dream of a whimsical world on the margin of the real. Vuillard very soon remembered his logic and took himself seriously. For that matter, he never was adventurous. The crisis on which he entered in 1890 hardly lasted more than five or six years.

From 1897 onwards, the portraits of Cipa Godebski, Lautrec, Coolus, and Missia, as well as the *Cour en automne* and the two marvellous panels now in the Bibesco collection, show us Vuillard delivered from theory and the risk (as Gide was to say of Cocteau) of being disconcerted in the long run through being too much concerted. Henceforward we shall find him avoiding those incoherences, pallors, and protractions dear to the mystics, as he avoided the spirit of caprice and evasion which he so much admired

in Bonnard. The extravagant, the obscure and the nebulous, were to him merely the formulas, the nervous twitchings of an epoch. He longed even before Denis had discovered Rome, to renew his ties with a tradition. *En famille (The family circle)* (1897) determines the series of *Déjeuners* which so genuinely inspired him. The downward design cuts [doors and wallpaper at a quarter of their height. In the foreground, with her back turned, is seen the artist's sister, wearing a dress with puffed sleeves; to the right, in profile, K. X. Roussel; in the background, full face, the grandmother. The half-light falls caressingly on the lightly sketched faces, on the table-cloth, a corner of which makes an acute angle, and on the vibrant collection of objects upon the table.

Two years later, the *Déjeuner en famille* (late of the Hessel collection) enables us to measure the progress made since the first repast painted in 1890. The characters are no longer in a solid block but separated from each other, with air enough to breathe. A softened light, no longer artificial, plays upon the flowered wallpaper, shapes without hollowing out the faces, and brings out in strong relief in the form of a triangle, the checked table-cloth, the apex of which descends to the bottom of the picture. To the right, Roussel, side-face, grips a newspaper. To the left, his wife, thin and pale, forms the arc of a circle as she bends over her baby. In the background, between the wine-bottle and the jug, is seen the grandmother, watchful, dressed in black and head-bands. Why does this picture, essentially simple, strike us at once by its profundity and solemnity? Is this due to the static character of the persons at table or to the still atmosphere? What distinguishes this picture from innumerable genre paintings inspired by the same subject, is the silence and isolation of these three beings united by the same cloth charged with offerings, by the communion of bread, wine and water.

The year of liberation, 1897, is signalized by a masterpiece. *La femme au bol (Woman with a bowl)*. This is a portrait, but in virtue of the title chosen by the artist, it may be classed among the *intimates*. We recognize the beloved features which never ceased to inspire the painter. The work is immediately impressive thanks to the balance, and to the happy disposition in the centre of this woman, seated with her face sideways to us, in her morning gown, her elbows resting on a round table. One wonders by what miracle, by what combination of virtues, at once plastic and domestic, a scene barren of mystery, should become invested with solemnity, instead of remaining merely anecdotic. The collected attitude of this mother about to begin her day, who lifts the earthenware bowl to her lips, is suggestive of the Elevation (*). The comparison might shock, did it not emanate from the gravity of the expression and the religious calm of the atmosphere.

(*) The Elevation of the Host is meant. *Translator's note.*

We wonder what sort of preoccupations are those of this woman who preserves so much charm although the hair is receding from her brows. In the carriage of the head there is so much uprightness, so much faith in the open look, so beautiful a light on the forehead, hands and shoulders... This is nothing less than a revelation coming to us from the bosom of ordinary family life. As in the *Pèlerins d'Emmaüs (Pilgrims of Emmaüs)* the only furniture is a common table on which are placed the coffee-pot, the plate, the rustic butter-dish and a knife with a white handle, reminding us of Manet's knives. The back of a chair is seen against the wall. It is a humble room, like hundreds of others, with its square-patterned paper beginning halfway up, and a wide open door, beyond which we picture a dim corridor and other rooms as banal. And in spite of that, and without doubt, because of that, some supernatural presence — it may be the light — consecrates the objects, lends a venerable softness to the shaggy old gown, lights up the shabby walls, emphasizes with a ray the door space, leaves a reflection on the table, on an ear or a cheek, irradiates the wallpaper and brings into communion the walls and the person in a perceptible silence.

Only Péguy has succeeded in defining the spiritual qualities at the base of such a portrait and the ideal which it consecrates. Vuillard's original environment, as well as his moral formation and his entire work, are manifested in these lines *(l'Argent)* " The home and the studio were one, and the honour of the home and the honour of the studio the same honour. What resulted? Everything was a rhythm, a rite and a ceremony from the moment of rising. Everything was a sacred event. In all was a tradition and a lesson, everything was inherited, everything was a pious habit, everything was a prayer going up all day — sleeping and waking, work and the brief repose, the bed and the table, the soup and the meat, the house and the garden, the yard and the doorstep, the plates on the table ".

There is in the *Femme au bol* a tenderness which has little to equal it in nineteenth century painting. Tenderness? — friendship would be a better word. With whom can we compare the artist? Not with Vermeer, who was after all, too brilliant, too easily carried away even in the midst of the daily round, by the richness and sensuality of outside things. Vuillard reminds us, rather, of Fantin-Latour in his picture of his sisters' embroidering. But for all his charm, Fantin is far from having Vuillard's power of command — his spirit falters or his hand trembles. But in this picture, everything is expressed with a decision, surprising indeed in one just emerged from a series of painful technical crises and who is only thirty-two.

An artful geometry is concealed in the picture. Among the fine vertical lines of the door, chair, etc. may be traced two decided curves : the semi-circular circumference of the table at the bottom of the picture, and the shaded back, lightly bent, leading upwards to the centre of the canvas, which is also spiritsitual centre, since it is occupied by the fine head, the

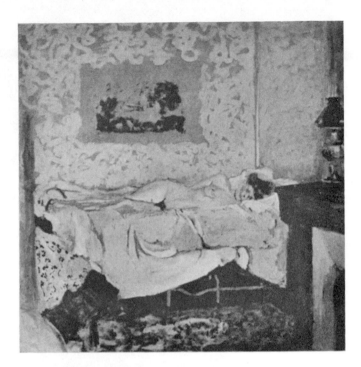

The Folding
Bedstead (1903)

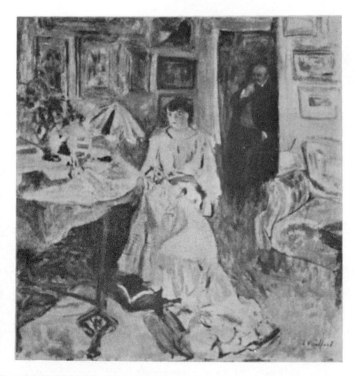

M^{me} Hessel, Rue de
Rivoli (About 1901)

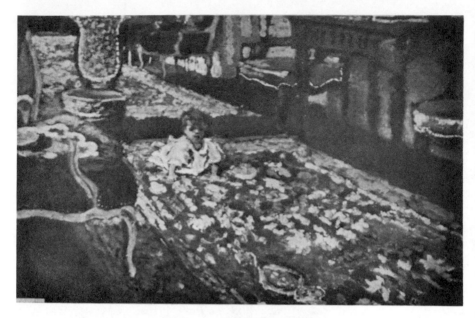

Child on carpet (About 1905)

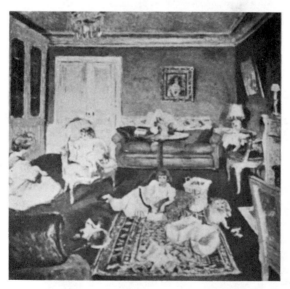

Children playing in a room with red carpet
(About 1905)

58

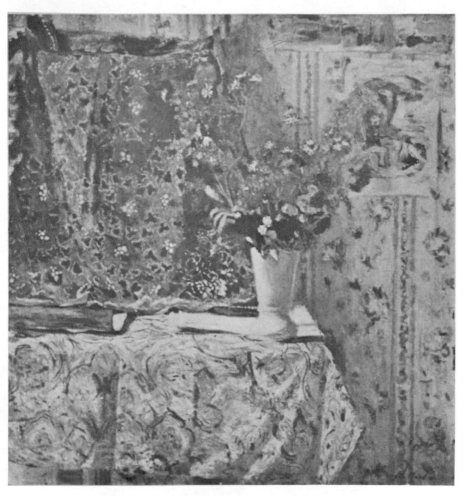

Vase with flowers (About 1904)

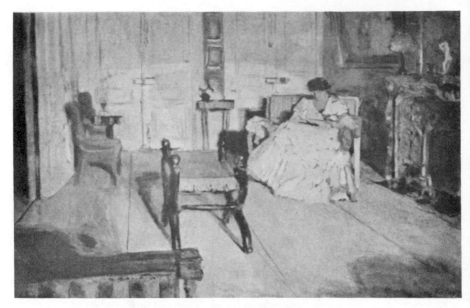

The white drawing-room (1904)

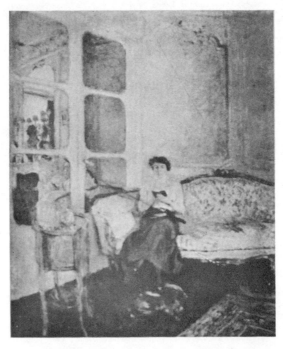

Woman in black on a sofa (1911)

culmination of the chiaroscuro. Maroon, beige, grey and lilac compose the space and enshrine the precious dress of a duller blue than Vermeer's. The papered, upper part of the wall, contrasts with the cold bareness of the skirting. It has the mysterious opulence of work by Odilon Redon. Our admiration is awakened by the distribution and the marvellous economy of the high lights. Vuillard does not resort like the wizard of Delft to the sheen of a pearl in order to bring out the value of a face. He finds the radiance of the pearl in a simple ivory knife handle or in any old bowl.

La femme vue de face, le visage éclairé par en dessous (Woman, full face, lit from below), a portrait contemporary with that just described, is a masterpiece close enough to Rembrandt and Fabricius. In this very small picture, Vuillard has once again found inspiration in his mother. From the same year date the decorative pictures done for Claude Anet, to the importance of which reference will be made later on.

There are, on the other hand, canvases where the artist sinks below his best and loses his design —as happened often enough to Bonnard. There exist three versions of the *Après déjeuner à Valvins (After lunch at Valvins)* : in the foreground, Cipa Godebski, wearing a soft hat which lends a waggish air to his profile, is seen looking at his sister, Missia, who is dozing in an armchair, her elbows sticking out of her puffed sleeves.

This much admitted, Vuillard's mastery proclaims itself in every direction. Never perhaps had he painted landscapes as complete as the *Cour en automne* (1898). With a precision that recalls the still-lifes of 1888, he has juxtaposed greys on a succession of small buildings, notably on a little polygonal pavilion, the panes of which reflect the sunlight. The base of the facades is half hidden by trees. Their bare branches are outlined against the stone. Autumn, in the absence of green, displays here her softest tints. This is an exquisite slate-coloured symphony a rich monochrome in greys. The structure of these modest dwellings, in Paris, indeed, but brooding in a provincial quiet, is reproduced in the smallest details but without harshness. To express the density of solids and the resistance of stone is a gift lacking to nearly all the Impressionists, with the exception of Jongkind. The *Cour en automne* in virtue of its unity, its light and its structure, must rank as a classic. It would hold its own beside a Corot. It is spoiled by no trace of sentimentality, no mannerism, no professional device, no singularity — the painter effaces himself.

✳

Vuillard had now reached the zenith of his art. He was unaware of it. He was shielded in various ways. He belonged to a very small circle of friends. He was privileged to work only for himself and without spectators. The bourgeoisie's lofty indifference to all good painting safeguarded him from material success and the importunities of the dealers. And from

moral success, likewise. They are happy times when the problems of art are not discussed in the market-place and the most intimate talk in the studios is not distorted by the journalists and the art reviews. Apart from the *Revue Encyclopédique*, the *Voltaire* (Roger-Marx), the *Justice* (Geffroy), the *Revue Blanche* (Maurice Denis, Thadée Natanson), and a few devotees, like Olivier Sainsère, there was no one to harass Vuillard. Who could foresee that *La Femme au bol, La femme lisant dans un jardin, Le Repas de famille*, or the *Cour en Automne*, would one day be hailed as masterpieces? Nor was it these pieces, apart in private collections, which were to make his reputation. That reputation which he never desired, grew at the turn of the century when he was discovered by the dealers and committed to periodical exhibitions. Reluctantly, he found himself among the stars of contemporary painting.

For Vuillard, the year 1900, when the Centennial Exhibition afforded a magnificent display of the continuity of French art, was fruitful in portraits, decorations, landscapes, and intimates. We will glance at three of these last which deserve to be placed beside some of the above-mentioned works in that room in the Louvre which we hope soon to see allotted him.

Le Bouquet de pensées, de myosotis et de pâquerettes (Bouquet of pansies, forget-me-nots and daisies) is a very small canvas (25×24 ⅝), the greatness of which resides in its hidden merits. To flowers, Vuillard has consecrated a number of studies. I know none with more emotion in it than this. The explanation, perhaps, lies in its simplicity. It is with flowers as with persons — the humbler they are, the more surely Vuillard understands them. The flower plucked in the fields or the Curé's garden attracts him far more than the rarer species, because it does not seek to shine or to eclipse its companions. The deep velvet of the pansy agrees with the ingenuous look of the forget-me-not and the daisy's fresh enamel. For this modest gathering, there is no call for an ornate receptacle — a transparent glass is enough. The iridescence of the crystal saucer on which the glass stands, harmonizes with the milky smoothness of the jug which stand out clear against the table. Here again the work owes its power not to contrasts but to the affinity of tones and values. *Le Bouquet de pensées*, like *La Cour en Automne*, is painted in oil on millboard, but it might be mistaken for a distemper work or fresco, for even the lights are matt, suitable to the sobriety of the subject.

Another study of simple things is *Femme en rouge et enfant (Woman in red with a child)* (1900), from the G. de Villiers collection, which might as well be entitled *At tea*. This is a masterly little picture, in the line of the twelve coloured lithographs which Vuillard, without much success, had lately produced. Its value lies in the perspective of worn flooring and the sadness of the wall paper faded by the sunlight. The adroit rendering of the wall with its walnut skirting, the commonplace chimneypiece seen

slantwise, and the reflected mirror, justify us in describing the left portion of the picture as a tour de force, or rather as a *tour de finesse*, of which Degas alone might have been capable. The outstanding figure of the mother in a long red overall (which contrasts with the orange red of the hearth) overtops the child in a white pinafore and funny little shoes, who bends over the fruit in his hand. The tonality is that of a novel by Chekov or Katherine Mansfield. Here again the painter excels in extracting the suavest harmonies from the humblest forms or subjects. For this room without furniture, which nothing, not even a look, lights up, is, notwithstanding, inhabited. The latent emotion resides in the relations of the ample maternal silhouette and the tiny childish mass, of brown neck and fair neck, of a great protecting arm and nervous little hands. It resides in the balance of the composition assured by the arrangement of vertical lines and by a construction, at once simple and skilful, unknown to so many victims of " the subject " and so many virtuosi carried away by literal imitation.

Paradoxical as it may seem, a work by Vuillard, it must be insisted, is a work willed and directed at every point from end to end. Meditation plays as great a part in it as in any by Degas or Seurat. It is therefore wrong to assimilate it with works such as Ernest Laurent's or Aman Jean's, which are of undeniable merit, but wherein space lacks density, planes dissolve and, wishful to create a poetical world, the artist is often entrapped by mere artifice. Even when Vuillard had introduced more *brio* on to his palette and more animation into his subjects, even when he had overcome the *jansenism* of his beginnings, he always preserved, thanks to the crises he had gone through, those qualities of organization, those virtues of order and foresight, the more precious for being hidden.

The *Femme en noir tenant un bébé sur les genoux (Woman in black holding a baby on her kness)* is also of the year 1900. In the centre, the bed in charming disorder, with a coverlet striped pink and blue and parti-coloured cushions, stands out against a background of ochre, brown and lilac. The ample protective form of the grey-haired grandmother clutches to her breast a little bundle which is animated by the bloom of the face and the white bib.

*

Le Déjeuner (Lunch), which Roger-Marx acquired for the Luxembourg (Chronique des Arts, 1903) has also for its subject the artist's mother seated at table. Full of charm, it does not possess the resonance and concentration of *La Femme au bol*. It is a transitional work, existing in several versions, which announces an approaching evolution. The details are more clamant; the light is somewhat dispersed and wavering. A major harmony succeeds to the chiaroscuro. The background is the same; but it gives promise of

luxury and crowding in compositions. Not that we need here bid goodbye to the simple life. The Rue de la Tour, as later on, the Rue de Calais, will continue to inspire the painter.

In the course of this same year he signed the *Vieille dame en gris remplissant une carafe (Old lady in grey filling a jug)* (Laroche collection) as well as the *Femme en noir assise près d'une cheminée noire (Woman in black seated by a black fireplace)*. But a wider livelier world seems to have been discovered. Vuillard goes out of his home. He goes on his travels. Literally so; this habitual stay-at-home makes the acquaintance of the lands of the sun *(Terrasse au bord de la mer à Cannes, le Toit, Jardin au bord de la Méditerranée)* whereas two vast green landscapes, inspired by the Ile-de-France only a few months earlier, look as if they had been painted during an eclipse. He seems to have lost a little of his gravity and tempted by new delights, to be getting nearer to Renoir. The shutters are thrown back and a more sensuous atmosphere pervades the home.

This change coincides with a notable alteration, if not in the rhythm of his life, at least in his outside relations. In 1903 we find him associated with Vallotton in a general exhibition of his work at the Bernheims'. He consents to exhibit at the Salon d'Automne. Already, Jacques-Emile Blanche had taken alarm lest this least vain of painters should descend to become the portraitist of a society or an epoch. To change his line, to abandon his garrets, the coarse wine and the rough cloth, to grope after fine manners and elegant subjects, to venture into the world of riches and fashion — this would be a betrayal of himself, indeed! That this spiteful colleague was not altogether wrong, we must acknowledge.

Should we attribute Vuillard's evolution to the circumstances which led him into a new environment? Rather, I conclude, he had begun to wonder whether he was right in limiting the field of his discoveries by his preoccupation with his immediate circle and modest surroundings. He may well have asked himself whether he was doomed to repeat the same little scenes indefinitely, to use the same undertones, to remain the captive of the same family of persons and of harmonies. In the *Divan* (1908), Pierre Hepp has very well portrayed a state of mind which had endured several years : " Having attained in depth as much as he deems himself capable, M. Vuillard yearns now towards expanse, in the representative and the concrete sense. He aims at emancipating himself from the indoor school and from the Japanese tradition at the other end of the scale, at broadening his field of vision and working on a larger canvas. This calls for an immense effort from a painter accustomed to summarize his intentions within the least possible space ". These words, used of design and proportions, can be justly applied even to the colour.

For Vuillard, from 1900 upwards, returns little by little to the optical tradition. He pays more attention to imitation and attempts colour

schemes hitherto shunned by him. The very titles are coloured. *Femme en rose assise dans un intérieur à tapis bleu-clair (Woman in pink seated in a room with a light-blue carpet).* *Enfant jouant dans une chambre à tapis rouge tendue de vert (Child playing in a room with a red carpet, hung with green), Femme en rose devant une fenêtre donnant sur la mer (Woman in pink at a window looking on the sea)* etc... The scenery undergoes a transformation like the actors. It is also possible that the artist, like Renoir, was giving thought to the chemical alterations which might be effected by the passage of time in studies on millboard, dark enough in the beginning. Moreover, he may have been weighing new tendencies at work. Under the influence of Van Gogh, stronger even than Cézanne's or Gauguin's, the *Fauves* were brandishing revolutionary flags, rioting in pure tones, splashing crimson on the oaks and red on the ships and the sea, gilding everything with the rays of the sun. Dazzled by so much noise and glitter and deafened by the roarings of Matisse, Vlaminck, and Derain, the public might find Vuillard's chamber music all too dull. Close at hand he saw Odilon Redon freed from his nightmares and revelling in all the vibrations of the prism — Degas himself outrivalling Redon's splendour with his passionately striped pastels — his own friends coming out of the shadow, heightening their tones, seeking to infuse at once more transparency and brightness into matter — Renoir, finally, lighting the fires of his magnificent autumn.

Nor could this observer remain insensible to the evolution going on in bourgeois settings, lighting and furniture. The old wall-paper had given place to lacquered surfaces, small window-panes were coming in, pendant lamps and illuminators superseded the old oil lamps. Notions of hygiene and comfort were transforming the most modest homes. Every room was a piece of scenery. A new poetry of apparatus outmoded the unconscious poetry of the old-fashioned *appartement*. Dust, lumber, shadows, were driven out. Everywhere exhaled the odour of the new. It might be that, in contrast, Vuillard's intimate little studies smelt the kitchen, the offices, the shut-in. He must occasionally have asked himself this. I say *occasionally*, for how could this man, so much at one with his past, with his habits, renounce what he liked best, what he would always like best —the atmosphere of his youth and the things which gravitated around that beloved being who, for all her whitened hair and wrinkled brow, seemed not to him to grow old ?

Portraits of Mme Vuillard succeed each other without a break. We see her darning a stocking (1904), reading her paper, sewing with a green plant beside her (1908), or by a window, through which the snow is seen glistening (1917). The *déjeuners* and the *goûters* are repeated without monotony. From 1920, we have the beautiful little portrait in the Lyons museum; from 1922, the breakfast at Vaucresson; there is Mme Vuillard watering her hyacinths, there is *la Ménagère (the housewife)* (1925). Vuil-

lard proclaims his devotion to the one great lifelong friend simultaneously with his love for calm and silence, to the monochromes which he always returns to when painting only for his own delectation.

Nevertheless, it cannot be disputed, he is seeking a new direction. This is the creator's saddest problem. To keep on for ever at the same subjects and the same treatments is a confession of indolence. On the other hand, to forswear one's own temperament and change one's manner is to court disaster. Delacroix was not the only man of talent who feared to aim too high; but many more have come to grief by failing to recognize their own limitations. Wherein lies real weakness? — in running a risk or avoiding it?

Writing of the *Salon Blanc* (Autumn Salon, 1904), Roger-Marx defines the painter's development : " The boundary crossed by Vuillard is decisive. The elect are not alone in proclaiming the subtle quality of his art. We perceive continuity in the refinement of his vision and the enrichment of his technique. We hear an unknown language expressing with singularly persuasive eloquence the quietude of the modern home, with its cheerful panellings shutting in the solitary dreamer or reader ". Yet, while admitting the distinction and charm of the young woman seated in the middle of a room like a jewel-case, can we be sure, now that time permits a general appreciation of the whole, that this picture marks any advance on the *Femme au bol* or the Vaquez panels? About these latter, Gide writes with marvellous lucidity : " I know few works which enable us to converse more directly with the author... We do so because he speaks with us in the low tone reserved for confidences ". The tone in the *Salon Blanc* and the works that followed it being less confidential, the conversation has no longer the same charm and secrecy. For one thing, the painter is himself less interested and, nextly, because strangers — I mean, his sitters — are becoming more and more frequently, the occasion or the witnesses of the conversation.

Two years later (1906) Paul Jamot reviewing the autumn salon in the Gazette des Beaux-Arts, pays tribute to Vuillard, as well as to Bonnard and Roussel, and describes one of his exhibits : " A small boy with dark curls, is sitting on an Aubusson sofa and looks upwards at his mother... The fascination exercised by the harmonizing of the amber-pink of the *peignoir*, the white of the child's costume, and the creamy greys of the sofa, which has a flowery pattern of the liveliest tones, is irresistible. " Here is proof to what an extent, the artist's palette and his methods of composition have been modified.

We may pause to consider a number of scintillating works painted between 1903 and 1914, which were shown first in the Rue Laffitte and later, in the Rue Richepanse. A quick, nervous, silky touch is at work on a new world of lamp-shades, cushions, carpets, gowns and furs. Under

the artificial light, all sorts of colours are displayed — carmines, madder, orange, lemon, cream, sometimes even shades of pistachio, duck-blue, — gooseberry-red, or crude violet. The occupations of the inhabitants have changed — now they are having tea, playing bridge, presently they will be listening to the gramophone or the wireless. Housekeepers and butlers seem to have been at work. So has the Hoover. Carpets have taken the place of linoleum and rugs, the folding bed has made way for the divan. Brooms and dusters have gone their way, pictures don't lie on the floor nor loaves on the chairs. The children don't carry the satchels of the Ecole communale; dresses are not being cut out or darned at home; preparations for the meal are being made off-stage. If tea is served, it is on a sumptuous table or a low occasional table.

In painting these upper middle-class interiors *(La femme en rose — The woman in pink), (La chambre bleue — The blue room), (Femme en blanc dans un jardin ensoleillé — Woman in white in a sunlit garden), (La dame au chien étendue sur un divan — Lady with dog lying on a divan)*, etc., Vuillard has not parted with his qualities. He has even acquired others. Ravished by the enchantment of these scenes where happiness seems to flourish, it is happiness that he attempts to portray. He is animated by manifest sympathy and even by a kind of tenderness for his subjects and the gilded peace he saw there, especially when he found himself among people who liked him, such as the *appartement* in the Rue de Naples where Jos is smoking, playing cards or dozing in the midst of his collections, the Bernheim's house in the Avenue Henri-Martin, Tristan's in the Rue Edouard-Detaille, Lerolle's or Arthur Fontaine's, the Villa des Etincelles at Villerville or Bois-Lurette at Villers.

The contrast no doubt is striking enough between these interiors or exteriors and the place where the artist worked and meditated. But he found a stimulus in reconstituting among his familiar surroundings, as one might think out a comic interlude or a ballet, these scenes, with their charmingly-presented children, dogs and gilded idols — offering a palette, almost Venetian, ready to his hand but which he had feared till now to use. He was tempted, fiercely tempted, this monk suddenly transported to a garden of women. His work is warmed by a new splendour. He feels the joy of being and of assisting at every manifestation of life. The austere air breathed in by Vuillard in his youth while under the influence of his chosen masters, Degas and Puvis, reflects now some glints of the sensuality of the Impressionists and of Renoir. This has happened to Bonnard. A less reticent communication with the universe is manifested by the colours of flesh and flowers, triumphant greens and whites and blues which are not now " half sad ". But in spite of the irruption of " objects ", the calm rhythm of these compositions is maintained, and we continue to perceive, even in the midst of tumult and profusion, those marvellous

qualities of silence and economy without which Vuillard would cease to be Vuillard.

✻

La partie de dames à Amfreville (Playing draughts at Amfreville) (1906) renews the subject of one of the most celebrated plates in the Vollard album. Seen from a first floor and crammed together by the perspective, the diminutive persons, seen back or front — André Picard, Hessel, Tristan Bernard and their friends — are joined with the deck-chairs and furnishings of the beach, with the sand all round them; they are seated, as it were, in an open air room, at the foot of a villa which is suggested only by the oblique line of the back-thrown shutter.

It was in the course of the years 1908 and 1909 that several large landscapes were painted at Le Pouliguen and St. Jacut. Their iridescent milky sheen reminds us of Berthe Morisot. They are contemporary with the *Paysages de Paris (Paris Scenes)* executed for Henry Bernstein, the Square Vintimille panels, and the portrait of M. and Mme Natanson in a garden.

In 1910, Vuillard was busy with portraits and decorative works. His intimate studies took the second place. Lucy Hessel and her women friends offered the artist a variety of attitudes, stuffs and colours. But these were only preparatory exercises or holiday work. The painter realized that knotty problems remained to be solved, as a consequence of researches too little co-ordinated. And it was at this moment that he was urged to increase his output. His success was assured, more so now that his " intimities " in the opinion of the dealers had become more agreeable and intelligible. But he stoutly resisted the temptation of pleasing to sell.

Among the easel pictures executed between 1908 and 1914, we must put in the first rank the *Modèle assis devant un paravent japonais (Model seated before a Japanese screen)* (1912). Vuillard had painted only a few nudes. Ill at ease in presence of professional models, he preferred to glimpse the body through the folds of a dress. Even then, he used his eyes very modestly. He very seldom let himself follow a leg or an arm to the more secret places or allowed himself to impart anything like a perfume to his canvas. His mouths smile hardly at all, and not with pleasure. His torsos are chaste and he never painted a hand which gave the impression of being naked.

Nevertheless, from time to time, we find him communing in the confessional of the studio with " the most intimate of the intimates ", reduced to its simplest terms, divested of all parasitical ornament, and quite alone. Towards the year 1895, he had executed a series of synthetic nudes reminding one of some of La Fresnaye's or Segonzac's. Bodies of clay lie flat against dull white sheets or an earthy or red ochre background.

68

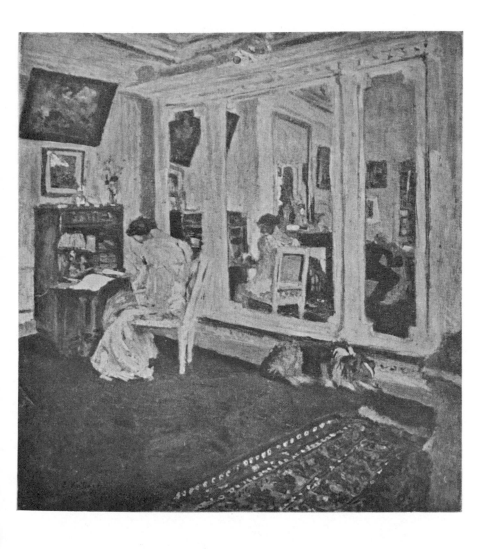

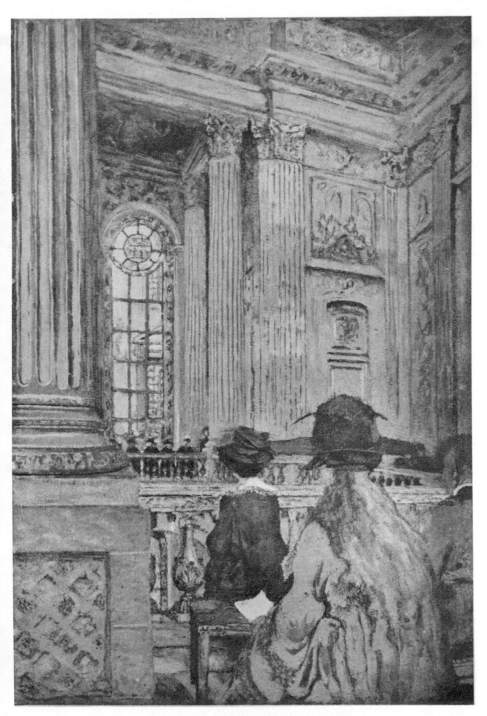

The chapel in the Palace of Versailles (1918)

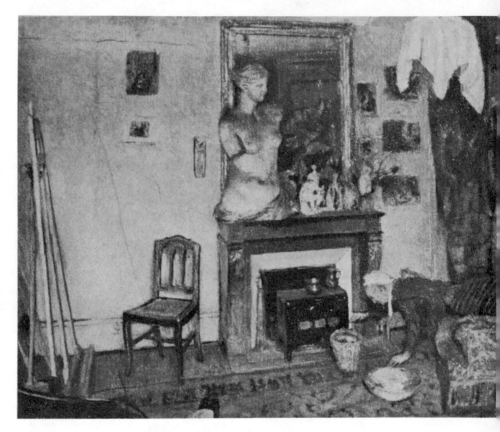

Woman kindling a stove in a studio (1925)

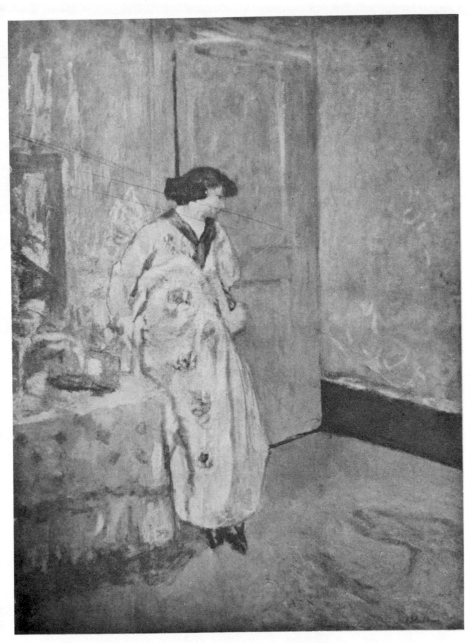

Woman at her dressing-table (About 1907)

71

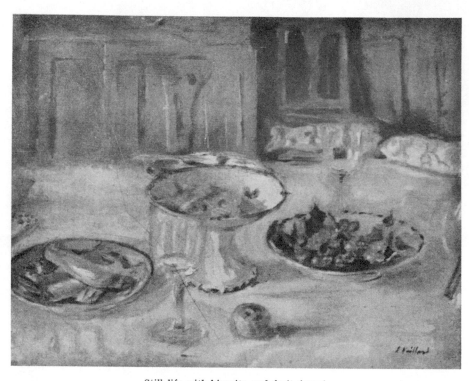

Still life with biscuits and fruit (1922)

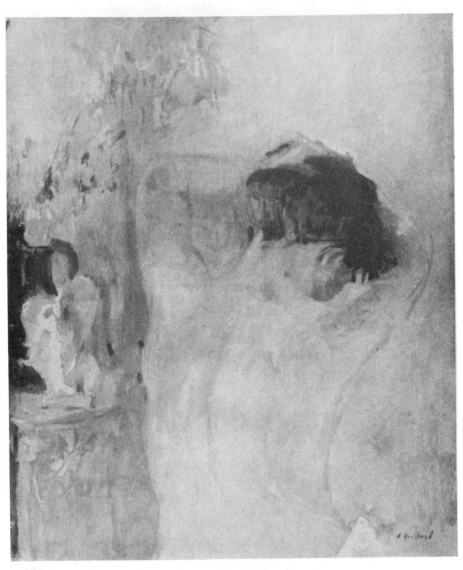

Woman doing her hair (About 1908)

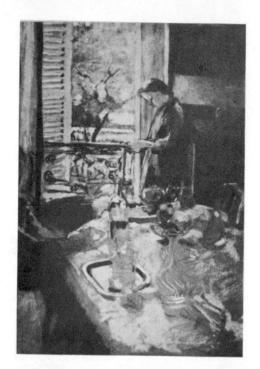

Dining-room,
Place Vintimille
(1915) *Pastel*

Mᵐᵉ Vuillard watering her hyacinths

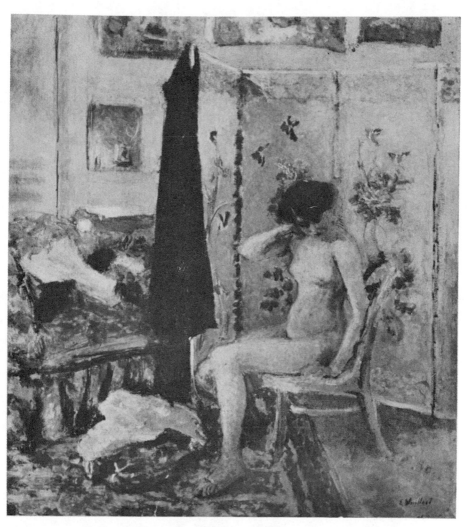

Nude woman with her back to a Japanese screen (About 1912)

Playing draughts at Amfrevile (1906)

There is little interior modelling; only a search for rhythm. *La femme nue debout devant une cheminée (Woman, nude, standing before a fireplace)* (1898), *Modèle se déshabillant (Model undressing)*, *La coiffure (Doing the hair)*, *la Femme en chemise raccommodant (Woman in a chemise mending)* and the *Femme assise devant un paravent japonais (Woman seated in front of a Japanese screen)* (1912) have lost all abstract character. In the last picture, the long streak of a dark skirt hanging on the corner of the screen, combined with the woman's dark hair, serves to emphasize the whiteness of her young breasts and the freshness of this statuette in flesh and blood, obviously unaware she is being looked at.

But Vuillard's most beautiful nudes are perhaps those painted from a lifesize fragment of the Venus de Milo. This piece of statuary recurs in many of his compositions. It presides over the collection of Maillol's terra cottas on the chimneypiece in the Rue de Calais. As he grew older, our artist had less and less use for professional models, but he never let his eyes stray for long from these exquisite figures which had become part of his life. He put his heart into copying them and penetrating their hidden lessons. He showed them full of movement in their immobility and shining with a beauty purer and more absolute than that of any ephemeral passer-by.

<p align="center">✳</p>

He enjoyed the simplicity of his lodgings during the summer vacations. Long windows gave on to the garden or the sea, the furniture was of bamboo, wicker or cane, the bare boards were partially hidden by rush mats. Napkins are drying in front of the fire, two rocking-chairs seem to be talking together, a little girl in a romper is playing in the summer light which is filtered through the blinds — elsewhere, we catch the tender vitality of a little maid in a big flowered hat. The years 1902-3 are specially rich in scenes of this kind. In the course of his vileggiatures, Vuillard discovered pleasures which were not the privilege of a caste and an odour which did not reek of the new. To these intervals of tranquillity, also belong a considerable number of still lifes. The French word *nature morte (dead nature)* is singularly inappropriate to his works of this kind. He wove, as has seldom been done, the subtlest links between the things called dead and their place in everyday life. He shows us objects as the friends and equals of the living, so that we might allude, in an almost mystical sense, to the presence of such a piece of wallpaper, armchair, fireplace or assortment of books and flowers. That sense of *communion* in his pictures of family meals is helped by the presence of the table-cloth, the napkin, the bread-basket, the bottle and the glass which possess the importance and solemnity of ritual instruments.

More than once, Vuillard chose to paint a fragment of reality and to isolate this or that object, as he had done in his early days. From the

years 1898-99 date the *Bouquet de geraniums et de fleurs blanches (Bouquet of geraniums and white flowers)*, the *Compotier d'oranges (Dish of oranges)* and the *Vase de fleurs près d'une statuette de Maillol (Vase of flowers and statuette by Maillol)* The *Bouquet de pensées* dates from 1900.

The *Vase de fleurs*, exhibited in 1904 at the Automn Salon and acquired for the Luxembourg in 1932 at the Pacquement sale, is wrongly dated 1906 in the catalogue of the retrospective exhibition of 1938. In it we find, gathered together, all the mauves and violets in the world. The iris, lilac, Parma violet, wistaria, scabius and heliotrope are blended insensibly before our eyes as in the sky. Although these flowers are more or less effaced in this nosegay by the garden aster, they impregnate with their emanations and perfume the opaline vase that contains them as well as the shawl behind them, the embroidered cloth on the table and the flower-patterned screen. It's a triumph of subtlety, recalling those preludes of Debussy which are governed by the same mauves and the same dominants. Kinship with the wizard of the London bridges, Venice and the water-lilies nowhere appears more pronounced than in this work to which all the colours have contributed; the very space is set with stars and all is flowers and perfume. However faithful Vuillard may have been to Monet, even at hours of the most violent reactions, he was unfailingly conscious of the perils run by abandoning oneself to a mirage. He knew that a firm framework must sustain the form and safeguard it against destructive charm. All those qualities which we have so much admired in *Conversation* and *Dans les fleurs* are visible here. But a great work of purification has been accomplished. There may be less of the unexpected in the design, no phantoms mingling with the flowers, no idle spaces and no indescribable objects, but the mystery remains in spite of the light, the logic and the tranquillity.

A large picture executed about 1904 and subsequently cut up, came as a variation from the studies of nudes, flowers and persons. Later on, Vuillard was painting roses, peonies and anemones, to be seen in the Laroche, Chausson, Robert de Rothschild, and S. Berriau collections. Especially after the war of 1914 and in his declining years when his friends provided him with geraniums, gladioli and sprays of apple-blossom from their gardens, he multiplied his flower pictures. (Magnificent bouquets were made up for him at the château des Clayes). But he liked best the rustic sorts in a plain glass or a stone jar. In the fascinating *nature-morte* of Renand's collection a small bunch of nasturtiums neighbours the jug and the loaf on a cloth of pale saffron tinted with pink (1925). Greys and silvery whites triumph in *Marguerites et tasse à vin (Daisies and a cup for wine)*, a small masterpiece. Vuillard liked the narcissus, hyacinth and anemone. He cared less for dull mauves, acid greens and chattering reds. Fleshy and over-scented kinds repelled him. In the plant world as in this he was attracted neither by courtesans nor princesses. In a flower, he

could dread opulence and boldness. His nosegays are not like Delacroix's, Van Gogh's and Redon's, firework displays, battle-fields or fairy-scenes, nor pleasances like Renoir's. More restrained even than Fantin, he would isolate one or two stalks as he isolated his models. Using pastels, he avoided turbulence and riot.

With the exception of the *Lapin de garenne* (1888) and the *Faisan posé sur une chaise* (1926) *(Pheasant on a chair)*, which are of the same family as certain early Monets, he painted very little game. He fled from every allusion to blood and death. From 1922, a year almost entirely devoted to portraits, dates the *Compotier de biscuits, verres et fruits sur une table (Dish of biscuits, glasses and fruit on a table)*, a canvas, amber and pink, neither tame nor insipid. The *Table servie (Table laid)* which belonged to Armand Derville, is like a flowery parterre.

As a matter of fact, his best still-lifes are displayed on tables in *En famille (The family circle)*, the *Déjeuner de famille, Lucy étendue dans une pièce au papier rayé (Lucy at full length in a room with striped paper)*, the *Petit déjeuner à Bois-Lurette*, and the portrait of Mme Vaquez. We may instance the dressing-tables and their accessories or the desks on which the blotting-pad, the inkpot, the letter-file, the magnifying glass and the letter-scales engage in whispered colloquies; or the accumulation of tools in the studios of Roussel and Bonnard or the surgical instruments in *Gosset opérant* or of the *Dr. Viau*.

With the " intimates " may be numbered various compositions dating from before the war of 1914-1918. Two panels in iron grey are evocative of life in the factory, inspired by a visit to Lyons (1916). *L'interrogatoire du prisonnier* is in the Musée de Vincennes. The change in the soldiers' uniform from red to blue-horizon brought the war within Vuillard's range of colour. The greenish discoloured spectre dragged into the sordid guard-house — the mean objects set out on a bench (poor relics stripped from the living and the dead) are full of misery. Not less commiseration is shown in *l'Aveugle de guerre (Blinded in the war)* — the father of little Lulu, who was adopted by Lucy Hessel.

With these scenes may be bracketed *La chapelle du Château de Versailles* (1918). The interior of the chapel is seen from the gallery. With their backs towards us and seated on forms are an officer in a blue tunic and a girl with her hat on; her abundant fair hair modulates with the yellow greys of the high spacing between the Corinthian columns. Vuillard has noted the smallest details of the balustrade, capitals, bas-reliefs and flutings with the same feeling that he put into the architecture of the *Cour en Automne* or the scenery of the *Petit Café*.

It was not till 1943 that the general public was allowed to see *La Réunion électorale (Election meeting)*, *Les Boulevards extérieurs (Outer boul-*

evards), *Voûte du Métropolitain (Metropolitan tunnel)*, *Concert à la Salle Gaveau*, and *Une Séance à l'Académie*. They were unfinished works but they reveal hitherto unsuspected aspects of Vuillard's genius. All sorts of difficulties of light and perspective are mastered with the virtuosity of a Degas in the wonderful view of the Villiers underground station.

The surprise of connoisseurs would have been still greater if they had seen a still more exceptional distemper — *Gosset opérant. (Gosset in the operation theatre)* (about 1912). In this modern Lesson in Anatomy, what most attracted Vuillard was the precious relations between so many shades of white — head-dresses, aprons, blouses, cloths, walls varnished with Ripolin, nickeled instruments; the lightness of the shadows, the character of hands and faces saturated with an aseptic atmosphere. Nurses, operator, and assistants are so many draped statues. A great white silence prevails, shot through with a sense of tragedy; but death and blood do not come into the picture, as they do in Rembrandt's. The patient disappears behind mask and cloths. Still-life is admirably represented by a trolley bearing metal boxes, cotton and compresses. Never in his observation of professional action had Vuillard shown so much of the pathetic. (With this picture should be compared, the celebrated panel by Lautrec — *Une opération par le Docteur Péan à l'Hôpital International* (1891).

The portrait of Dr. Vaquez (1921) is not so much an individual portrait as the presentation of a hospital ward. There, as in the Gosset picture, white is supreme. It bathes the group standing by the patient's pillow and forms a frame to the view of trees and houses which, seen through the window, dominates the whole. In a pastel, done on the morrow of a visit to Vaquez, the doctor is shown in a slightly different fashion effecting a blood-transfusion.

✳

These collective intimates are not numerous. It is a pity that Vuillard on escaping from bourgeois portraiture, should not have more often been tempted by other atmospheres and environments. What an enlargement his art might have known if he had been entrusted with the decoration of an institution, a college or a prefecture! The chiaroscuro of the Palais de Justice and the Houses of Parliament had no charm for this home-keeping genius, faithful to private homes, to his Lares and Penates, to confined spaces, to their special acoustics, and their limited audience. Believing his orchestration to be too subdued for any but chamber music — solo, duo or sonatina — Vuillard to his last hour found satisfaction in painting small scenes *La salle à manger au Clos Cézanne (Dining room at the Clos Cézanne)*, *la Partie de cartes à Vaucresson (Game of cards at Vaucresson)*, *La Leçon de reliure (instruction in book-binding)*, *La réussite (Patience)*, *Le coin de feu (The chimney corner)*, *La chambre rose*, *La cham-*

bre jaune, etc. The essentials of his work are not in these. These canvases and pastels, for the most part rather intense, even fiery *(Le Salon de Mme Gillou, Mme Jonas au divan rouge)* were for him just pleasant exercises. He was more deeply moved when fleeing from a society which meant his ruin, he took refuge in the forest, in green chambers and alleys open to the sky.

There is no room for doubt that the factitious aspect of various interiors, painted between 1920 and 1940, betrays uneasiness of a kind. In contact with pleasures without pleasure, a spurious intimacy, and a well-being inimical to a better-being, the painter, in spite of himself, reflects the impurity into which circumstances have plunged him. His entresols and attics expressed the sweetness of habit and age-long traditions, but now everything seems done to advertise his value, to distinguish himself, to inspire envy. But let him return to what André Fontaine called " the place of predilection ", leave him as in the days of his poverty, in the company of simple sentiments and objects, with all their greys, and the gilded social scene vanishes, the fashionable nightmare takes flight, calm reasserts itself and self-questioning begins.

All the qualities of the earlier works reappear in *la Femme allumant un poêle (Woman lighting a stove)* and above all in *la Ménagère (the housewife)*. The grey-haired housewife, with slippered feet, approaches the unmade bed, a cloth under her arm. It is the early morning, so she throws but a light shadow. This little masterpiece apparently contemporary with *la Femme au bol* and dating from 1925, must finally help to dissipate the absurd myth of a Vuillard, dried-up, drifting, ready for any concessions and turning back on himself.

We shall return to the gravity of a crisis beginning as far back, perhaps, as 1900, and reaching its climax about 1930. For a long time past, Vuillard had talked of nothing but executing a perfect work; of getting beyond the sketch stage, in fact, finishing. The further he goes, the stronger becomes his determination to eliminate the startling and the unsymmetrical, arbitrary bisections, and all the delight he once derived from the skilful juxtaposition of the finished and unfinished parts. These seemed to him now only ways of approach. He reacts contrariwise to Manet and Degas. Let us try to imagine Manet passing from *Le Linge* to *Le Fifre* and Degas from the last pastels to the *Foyer de la Danse*. He deems it facile and vain to give a room the depth of a valley, to split a profile or an object, to achieve the singular by artifices of design. That which fascinated him in a Japanese print seems to him now hardly bearable in a picture. As he restores the local colour, so he restores the local form. The widespread epidemic of deformations had disgusted him with deformations. One might say he wished to unlearn all he had been taught by Gauguin, the Impressionists and Degas; to resume his work where he had left it in 1889; and considering

himself sufficiently qualified, to recommence as though he was twenty. All he had given, all that we admire so much in the "intimates" of the Revue Blanche period, he looks on now as mere essays, approximations, preambles. We shall see, dealing with his portraits, how much such an attitude, at once proud and humble, contains of the noble and dangerous.

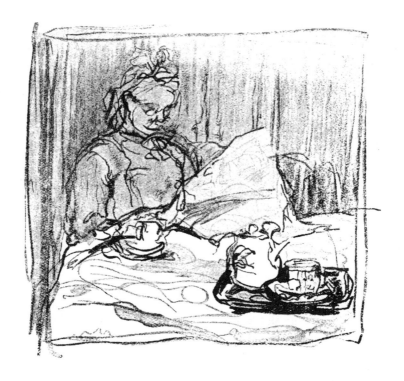

PORTRAITS

Vuillard, from the start, sought inspiration in his own face and the faces of his family and familiars. We see him standing, palette in hand; or in an attic, reflected in a wide mirror, framed in bamboo, in a half-light suggestive of Carrière. Elsewhere, with his face framed in a reddish beard, he turns his burning eyes upon us, conscious, though he is only twenty, of his gravity. Another portrait shows him in a straw hat. Repeatedly he draws his mother, his grandmother, his aunt Sorel. Severe in expression and concise in contour, his sister's protrait recalls in some ways, some early works of Degas. A discreet chiaroscuro subdues the colours and assigns their essential part to the greys.

In or about 1890, Vuillard, influenced by Gauguin and Sérusier, was lured by daring feats in colour and design and his love of synthesis into sacrificing the individual to general characters. *(Le chapeau à côtes, La Dame à la perle)*. In his portraits of himself, sharply outlined with eloquent flat strokes in pure colours (orange, lemon, or red on the hair, nose and beard) he did not shrink from extremes. The familiar characters that people his first domestic interiors, although recognizable, look like quaint phantoms. Those who figure in the *Jardins de Paris* and *Conversation* are stripped of any precise personality and are no more than the emanations of a particular age and environment.

But, very soon, from 1895 onwards, there came a revolt against this highly abstracted conception of the external world. In many small works *(Mme Godebski, La Femme au pince-nez, Mme Vuillard au corsage à pois, Fénéon, Thadée Natanson en buste)*, the rights of the individual are vindicated. *Cipa Godebski, Mme Vuillard éclairée par en-dessous, La Femme au bol, Toulouse-Lautrec, Coolus en chemise bleue*, are decisive landmarks in the years 1897-8. The third *Déjeuner en famille, Missia au piano*, and *Missia et Vallotton*, commemorate the year 1899. The affinities with Lautrec are striking. The two artists first became acquainted at the offices of the *Revue Blanche* and passed some time together at Thadée's

place at Villeneuve-sur-Yonne. They found inspiration in the same models, attitudes and backgrounds. They adopted the same simplifying conventions, underlining what was then called the arabesque. Vuillard like Lautrec, painted Missia at the piano. The *Femme buvant*, and the fine portrait of Cipa exhale that charm of the period present in Bruant and Jane Avril. But Vuillard's colour was more reticent. There was more of measure and caution in his design; it was more tender, less flighty and feverish.

In the *Femme au bol*, we saw him detach himself from Degas. The rigour which Degas inherited from Ingres and David was modified by doubts, reservations and a controlled emotion, not unlike Fantin-Latour's. I say Fantin rather than Whistler who is famous in France for a portrait, great indeed, but lacking the profound intimacy and plastic intensity of the *Femme au bol*. Whistler's mother is posed. Hardly at all is she in communication with surrounding space. Vuillard's mother, on the contrary, is at all points in touch with the air she breathes and the objects to her hand. The spectator, like the artist, regards her with something like veneration.

The Fantin of which Vuillard's work reminds us, is the Fantin of the *Brodeuses*, so chastely bent over their task, the Fantin of the *Coin de Table (The Table corner)* where Verlaine and Rimbaud sit dreaming. There is the same decency and restraint in both, the same caressing modulations, but the nervous force of Vuillard redeems the picture from any sort of flabbiness. From the *Femme au bol* and its divisionist treatment arises a subdued vibration reminiscent of Seurat. But in the little portrait in the Sainsère collection *(Mme Vuillard éclairée par en-dessous)* we look behind Fantin at Rembrandt.

A transitional picture of 1899 shows Felix Vallotton, slim and stern, standing upright with his arms folded, behind Missia Natanson who is seated at table in a check dress, wearing her hair like a helmet. To about the same period belong the profile of *Lautrec au feutre mou (Lautrec in a soft felt)* (Maurice Denis collection), *Lautrec en ciré faisant la cuisine (Lautrec in oilskins doing the cooking)* (Albi museum) and the *Romain Coolus reading at Villeneuve*.

Very often, the painter's favourite model, his mother, is not named. She is described simply as *Femme agée (Aged Woman)*. Inseparable from her son, we see her successively at the Rue de la Tour, the Rue de Calais, and at Vaucresson, getting the meals, doing her housework, sewing at the window, reading beside her *infusion*. He knows her face by heart, but his eyes are insatiable. Every look exchanged between them expresses a communion which not even death will dissolve. We have included most of her portraits among the " intimates " because this is the deepest of intimacies. The little head and shoulders portrait in the Lyons Gallery

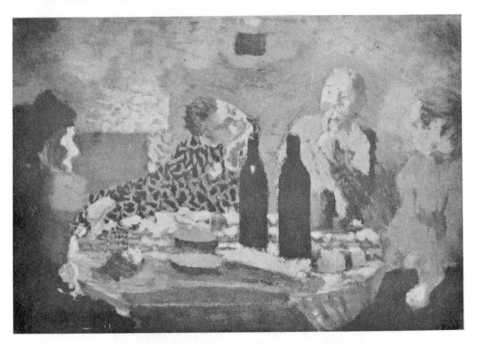

The painter's family at table (About 1892)

Woman with glasses reading (1896)

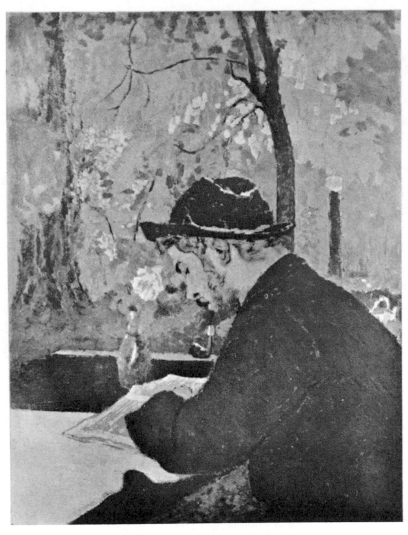

Cipa Godebsky (About 1897)

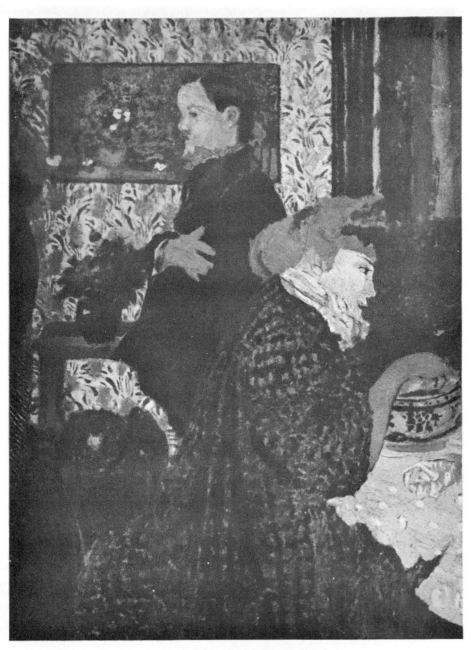

Vallotton and Missia Natanson (1899)

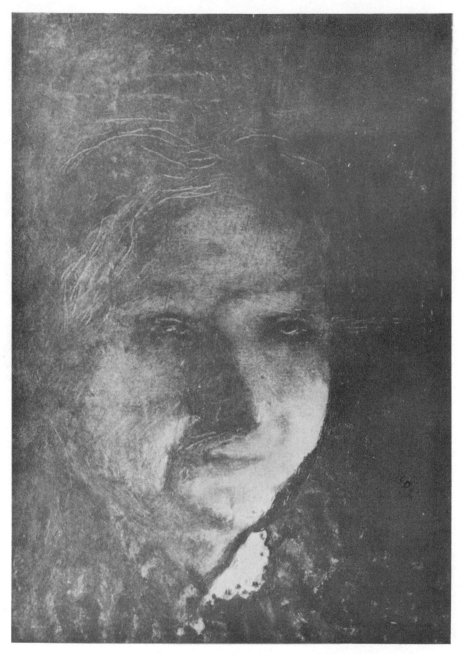

Portrait of a woman with her face lighted from below (1897)

(1920) and the *Déjeuner* at the Luxembourg summarize a considerable number of studies representing the painter's mother in her latter years. Her face has lost nothing of its *bonhomie*. The fine lips form a smile. The eyes reflect sweetness, experience and almost gaiety. She wears a frilled peasant's bonnet with a ribbon hanging down behind. High lights here and there, on the nose and cheek, and faint shadows boldly placed on the temples and throat accentuate the model's thinness.

✳

In the beginning, Vuillard painted only those persons who were known to him under all their aspects and whose synthesis he could attempt from memory. With the Hessels, Tristans and Fontaines he was at home. One of his first important portraits of men, later than those of Cipa, Lautrec and Arthur Fontaine (1901) is that of Jos Hessel. He faces us squarely, a cigar in his mouth, eyeing us keenly, with an unfolded newspaper held by his plump determined hands. He wears a well-fitting coat and starched cuffs. This is an evocation remorseless in its precision and accuracy.

The first study of the Brothers Bernheim borders on caricature (1908). A red carpet covers the floor. We are in the limelight, the stage is set! Gaston, all in angles, in a double-breasted waistcoat and pointed shoes, is perched like a great black bird on the arm of a chair. In the background is his brother Joss. They are expecting a customer. The final picture is quite different (1912). In the background, Gaston stands with folded hands in front of Monet's *Venice*; in the foreground, Joss is seated in a Maple armchair. All that remains of the first sketch is the echoing emptiness of the great commercial sanctuary and the attention called by means of some kind of varnish on their hair, cuffs and shoes, to these business men's sense of propriety in dress — which Sacha Guitry illustrated by his two top-hats. Bonnard, also, found inspiration in the Brothers Bernheim. But this time, it was in the work of Vuillard that irony, though light enough, showed through.

A big square canvas presents the guiding genius of the *Revue Blanche*: Thadée Natanson; one of Vuillard's most active and lucid champions (1908). Conscious of his worth and importance, he reads, lying back in a rocking-chair. On the right, the frame cuts across the figure of K. X. Roussel. By means of a small mirror, placed high up, the painter, like Velasquez in the *Meninas*, has introduced himself into the picture. Now we come to the first great open-air portrait, less severe and more iridescent in its harmonies — Alexandre Natanson and his wife at the tennis court. Vuillard was brightening his palette. It may have been due to the influence of the Impressionists or Renoir that a greater dispersion soon becomes noticeable in certain portraits in which the model instead of taking the first place, becomes merely an accessory.

Lucy Hessel from 1900 onwards is seen as the centre of innumerable interiors. Interested in life, greedy of confidences, devoted to her friends, and enterprising as Vuillard was not, she receives the painter every evening about six, does him the honours and keeps him to dinner. Vuillard has a refining influence on Jos Hessel and indirectly, on the customers who consult him. Fabre and Fayet discover Delacroix, Corot, Sisley, Cézanne and Renoir. Orosdi, the banker, goes over to the moderns and converts the Prince de Wagram. Auguste Pellerin transfers his obsession for Manet to Cézanne and gets Orosdi to sell him at ten times the original price, three chefs-d'œuvre by the master of Aix which the banker had won at the card table for five hundred francs the lot. When Hessel and Orosdi could not agree on a price, they played at écarté for the difference. Most of Hessel's customers, devoted to poker, racing and the Stock Exchange, staked their money on a painter as on a horse.

Practices of this sort, it need hardly be said, went far towards revolting Vuillard. Happily, Lucy by a thousand quasi-maternal attentions, knew how to protect him, amuse him, deaden the shocks, and initiate him into the underside of a society which, but for her, he would not have had the time or the inclination to study. Into his almost monastic life, she introduced the noise and dust of the world. He was as pleased as a child with the kaleidoscope of fashions, the hats and the dresses, which, thanks to her or rather thanks to him, were to illustrate half a century. It would be a long task to enumerate all the pictures in which the Egeria figures — standing, resting on her elbow, at table, lying down, reading by the window or lamplight, looking into her mirror or crouched over a log-fire, walking with her big dog or arranging flowers, in décolletée or holiday dress, with or without a hat, in brown or grey or white.

One of the largest, if not the most pleasing portraits, shows her stretched on a divan against a background divided by broad stripes; beside her is a low table with tea things (1906). In an earlier interior (1901), she wears a long evening gown; a rosy light softens the somewhat rugged counten-ance, pointed chin and aquiline nose; in the background the profile of Jos is framed by the doorway. Many of these pictures were painted in the Rue de Rivoli or the Rue de Naples. The walls are hung with master-pieces. The room is only a frame for the frames. Each year brings new gestures *(Lucy listening to the wireless)* and new settings *(le Clos Cézanne, le château des Clayes)*. The synthesis of these works appears in that portrait of the Friend in her lace-trimmed dress, embellished and one might say purified by her white hair; in her gravity, she resumes all the women of her class and generation who have reconciled the apparently irrecon-cilable, reaching the threshold of age without the least shadow shadowing their brightness.

The years from 1908 to 1914 were not signalized by any great portraits.

The picture of Jacqueline Fontaine standing before a bookshelf (1910) was followed by a full-length pastel of Charlotte Lysès. Wearing a hat, slim, sheathed in a tailor-made suit, with black gloves, she is seen in her sharp outline before a long mirror. One is reminded of Lautrec's Yvette Guilbert. This tall angular spectre is seen in artificial light.

A back view shows Mme Thadée Natanson, in an apricot dress graciously presiding over a brilliant crowd. The future Mme Marcelle Tristan Bernard, Lucy's great friend, gracefully inclined, sits musing in a conservatory beside her dog. Three portraits of men have more depth — Dr. Viau in his dental surgery, Arthur Fontaine in the evening in his library, and above all, a masterpiece, Théodore Duret (1912); this last is worthy of inclusion with the great portraits of writers at work — with the Zola of Manet, the Duranty of Degas, and the Gustave Geffroy of Cézanne. The dashing Duret, the early champion of the Impressionists (made famous by a full-length portrait by Manet), is now shown meagre and half-afraid, with his cat Lulu on his knee, overlooking from his great height a desk loaded with books and prints. Not a little mischievousness and boyishness haunts his face, but the passage of the years is revealed by the trembling hands and by the red rims round those eyes once so sparkling. The time has come when the man takes refuge in his past, when he does not fill much space and weighs only lightly on the earth. That at least is the thought skilfully suggested by the painter. The warmth of the setting contrasts with the frailty of this disembodied apparition. Whence does this portrait derive its intensity? From that store of observations, memories and experiences which form a part of his private life and which the artist recalls in the presence of an old man. Théodore Duret repeats the gestures and expressions and has that mildness and quiet slowness, which belong to those whose days are numbered and who are committed to the downward path. Vuillard is thinking of his mother as he watched her transformation, day by day, the curving of her back, the gradual whitening of her hair, the deepening of her wrinkles, and her increasing likeness to the grandmother of whom he had made a drawing when he was twenty years of age.

Vuillard and old men — this particular aspect of his work deserves study. We are aware of a livelier sympathy whenever the painter reconstitutes the likeness of a man or a woman delivered from the reactions, tumult and contradictions of youth, a sympathy apparent even for models not well known to him, such as Senator Rosen (1913), as we see him sitting back a little in an armchair, his hair *en brosse*, holding his eye-glass downward. Duret's portrait is anterior by seven years to another admirable likeness, yet more austere — *Mme Kapferer mère dans son intérieur (Mme Kapferer senior in her room)*.

Vuillard's work was interrupted by the invasion of 1914. To the period immediately succeeding belong the large distemper painting of a *Young*

Woman standing at her dressing-table (Jeune femme debout devant sa coiffeuse)
—which may be described as a sequel and enlargement of the portrait of
Charlotte Lysès — and a striking picture in pastel and distemper, *Jacques
Laroche enfant à sa table de travail (The child Jacques Laroche at his desk)*.
Both illustrate an increasing virtuosity in the evocation of a person presiding
over a number of commonplace objects. There is no suggestion of melan-
choly about the portrait of Mme Vaquez (1918), bequeathed to the nation.
The round pasty face, alive with good-nature, appears above a rather
lively mauve corsage. Tea served on a great table is again the pretext
for a scintillating display of covers and flowers. Relegated, as in the
Dame aux Chrysanthèmes of Degas, to the extreme edge of the composition,
the mistress of the house, relaxed, smiling, presides over the little feast.
It will be noticed that Vuillard has adopted a very much elongated *marine*
or oblong form (1 metre by 2). In fact, this interior is in its way a landscape,
with the snowy arc of the table-cloth as a foreground and the mountainous
blocks of the fireplace, dessert-table, buffet and green drapery closing
the horizon.

The years 1917-20, so rich in portraits of his mother, were marked by
Vuillard with a capital work — *Mme Kapferer mère* (1919). The design
and harmony are austere. In an armchair with a white antimacassar and
her feet on a blue cushion, a singular person, severe and wrinkled, sits
communing with herself. The illusion of unimpaired vigour is commun-
icated by the bony hands, the appearance of strength in the thin arm,
and the haughty poise of the head. Vuillard has not hesitated to leave
the sunken mouth its peevish curve. He has equipped the solid nose
with spectacles which like two tragic excavations reveal the skeleton of
the façade in its thin covering of flesh. This woman resembles a soldier
on the defensive. Her thoughts are directed towards the invisible enemy.
Unceasing vigilance is essential and an economy of gesture which is consis-
tent with the economy of the picture itself.

There is a total absence of exciting colours. Greys, the violet of a
shawl, jet blacks, the blue of a cushion — everything is as subdued as it
could well be. But in the posture, something of elegance, or at least of
correctness, lingers. Her reticule hangs from her arm. Every detail has
its meaning — the cushion at her back, another beneath her feet, the
teapot beside her, all these are comforts which she owes to herself. In
this world there is no place for the smiling otherwise than in the ornamen-
tation of the fireplace, the work-table, the lamp-shade, and the keepsakes
and knick-knacks discernible in the clear shadow. Vuillard understands
the precious character of the little usual things — the sugar-bowl, the little
clock, the candlesticks, the photographs in frames. To enumerate them
would be to traverse the stages of a life.

The portrait of Mme Bénard (1930) has not the same power of general-

ization, nor the same plastic feeling. The ordinariness of the design is, of course, deliberate. Still, it may be objected that there is something too textual in the description of this well-to-do room where the model, less solitary than the seventy-year old lady in the spectacles, while seated on the same kind of armchair and with her feet also raised above the floor, looks at us, full-face, a little as if posing for the photographer. That is not unnatural, for the face is full, the eyes have not lost their sparkle and the fine determined mouth is very French; the active hands have for a moment let go her work and everything is inspired with a sentiment of frankness and simplicity. Here age is much less apparent in the central personage than in the background, in the banality of the perspective and surroundings. Vuillard has amused himself, as the Dutch would have done, by describing (and perhaps with too much complaisance) the lace table-cloth and even the pleats of the lamp-shade. The light is scattered, and we would gladly sacrifice the right side of the picture in order to isolate the sculptural block formed by the woman in the armchair. She sits, an image of green old age, as opposed to age already entered into the shadow and left motionless at the post of command. With these portraits of those in ripe age, we must bracket the portrait of M. Bénac of which more will be said presently. We resume the chronological order.

The portraits of Philippe Berthelot and Mme Arthur Fontaine were painted between 1921 and 1924. The glowing picture of Mme Prosper-Emile Weil and her children has passed through many transformations. It began merely as a group of children. In the final version, the mother standing on the left, holds a green album, the hue of which fascinates a small boy in a white shirt perching on a chair. Close to him is his sister dressed in blue. An empty sofa occupies the right of the picture. This composition is a tribute to a friendship of rare quality which was to last till the death of the painter; but in it may be found too much dispersion and that seeking after polychromy and the picturesque *anecdote* which also characterize the portraits of Mme Jean Bloch and of Mme Wormser and her children.

Mme Val offered the artist a pert, laughing countenance, a blooming complexion, and an opulent bosom — all that would have tempted and inspired his master, Renoir. Vuillard puts the living woman side by side with the Grecian Venus in half-length, and succeeds by a charming invention in making the clothed goddess look like the other one's double. With similar allusiveness, in another picture, a young Parisienne in a hat is shown half recoiling as she gazes at the half-length Venus and her smaller sisters sculptured by Maillol.

At the first exhibition of the Collectionneurs (1925) was shown the portrait of Yvonne Printemps in an easy-chair. Her delicate face with its shadowed eyes is reduced to an impressive profile, set in gold. Fridette

Laroche, that charming little exotic bird, is imprisoned in a theatrical interior with magical perspectives, a scintillating cage. Jane Renouart in her dressing-room is all tinsel; a ballerina in grand décolleté, sister to Mistinguett, she seems with her animal bust, her dilated eyes, her fleshy elbows and outspread fingers, to have been made for Boldini. She reigns over a wide space covered with mirrors and draperies. This sumptuous being is seated and reflected in mirrors in the midst of a barbarous luxury made up of too much gold and too much dark red. The portraits of Germaine Saint-Granier and Mme Henri Baudoin have a more conventional aspect, perhaps because of the amiability of the sitters.

Mme Jean-Arthur Fontaine (1925) on the contrary turned a pathetic face, lit from the interior, towards the painter. Her faraway gaze, directed towards the heights, seems detached from the earth; her hand appears only to hover on the edge of the table. In these bourgeois surroundings, pinks, tender greys and pale golds contrive to create, as in the portrait of Mme J. Adam, an almost mystical atmosphere.

A year earlier (1924), Vuillard had painted a work of small size, which must be considered the most supremely successful of all the portraits executed within the previous twenty years of the woman, who next to his mother, had done most to inspire him. Perhaps because of the white dress, perhaps because of the brilliant lighting, which casts a radiance on the face itself, we are put in mind of Renoir, of Renoir of the *Grand Loge.* Yet we are looking at a white-haired woman nearly fifty years of age, who never possessed the sprightliness of Renoir's little model from Montmartre. We see a lady inseparable from the affluence and security which the canvas reflects as a jewelled setting.

Mme Hessel is shown presiding over the white smoking room in the Rue de Naples which is hung with works of art (a triptych of Paris by Bonnard, flowers by Redon and that *Salon de la Rue de Rivoli* in which Vuillard painted her twenty years previously). The glamour of fine painting warms the atmosphere. The parallels of the frames and the mixture of so many harmonies in no way depreciate the principal person seated in the foreground with her arms crossed on the edge of the table. I know few portraits in which Vuillard has expressed himself with more candour. The eyes brilliantly calm, the lips joined in a faint smile, diffuse unmistakable friendship. And, as if to dispel any misunderstanding on our part, Jos, recognizable by his bald head and the curve of his eyebrows, is shown on a divan in the far background, assisting at a dialogue which has been going on between his wife and the painter for a quarter of a century.

A nervous drawing (as seen in the hands, the arm, the bare shoulder) sustains the colour which in spite of its warmth is not dispersed. The

delicious still-life, constituted by the ceramic plate, the bunch of marguer-
ites or chrysanthemums and the book on the table, is sketched without
any excess of precision. It is a manner without minute detail which has
turned the ornamentation of the charming fabric to good account. The
spell cast by the evening light and diffused, one may guess, by reflection,
does not overstress salient points or dim them. As in Renoir's *Loge* the
light is not copied but transposed, evening is discovered in daylight.
Indeed, everything here is *re-found* in Proust's sense of the word — every-
thing is the issue of a memory, of a thousand memories amalgamated
about a beloved being and a chosen attitude.

We turn to the portraits of men friends. The four likenesses of
Roussel, Bonnard, Denis and Maillol, with sketches, have luckily been
secured for the Petit Palais. The sketches are of much interest, showing
how the portraits looked in 1925 before re-touching.

They are enriched by a sentimental and a documentary value. Here
we have Vuillard's companions from the start, his brothers in thought
and work, who, the first three particularly, were inseparable from his
own life. Here we have eminent artists analyzed by an artist of their
own standing. The same good fortune attended Vuillard when he was
painted by Lautrec, Redon, Denis and Vallotton.

What is rare and particular in these four compositions is that they
show us an artist in the midst of his work, immersed in those emanations
of himself which are his works and his doubles, in full evolution, and which
cannot be detached from him so much do they help us to define him.
Roussel is seated at his table; Bonnard, upright, studies a landscape;
Maillol is chiselling in the open air in his garden at Marly; Denis at Rouen,
is decorating a chapel.

The preference among these portraits must be given to Roussel's.
It could hardly be otherwise. Roussel was the confidant of Vuillard's
whole life and experience, brother more than brother-in-law, ebullient,
generous, often beside himself, a master endowed with prodigious gifts
of which he did not make the fullest use and which the future will discover.
It is thus that Vuillard pictured Roussel, an alchemist in his laboratory
at Etang-la-Ville, lost in a jungle of canvases, brushes, palettes and vessels.
The winter of his life is drawing near. Outside, through the tall window,
is the dull sky and against it, the leafless tree. This domain is filled with
crepuscular hues, a vapour emanating from violets and sombre browns,
amongst which a white, a yellow, a red and a blue here and there explode.
In the midst sits Xavier Roussel, a greying Faust, looking beyond all
external images and his piled canvases, at the people of his projected
creations. The high vertical lines of the window give the studio the propor-
tions of a church and almost dwarf the master on whose brow the light

lingers. The aged child, the prisoner of his imagination and of the chiaroscuro, is thrown into the background by the disordered foreground and the accumulation of the instruments of his magic.

Standing, in profile, thin, in neat morning dress, Bonnard inspects a large landscape pinned to the wall. In another minute one guesses, he will ransack the magic box — the box of colours before him on the table. Like a commander who searches the horizon, he stands, face to face with this picture which is a mirror, prepared to take a step backward. Wonderingly, his basset hound seated on a low divan contemplates with comic absorption his silent, transported, hallucinated master. The dialogue between the author and his work fills a world of enchantment. Yet this is only one of those undistinguished modern drawing-rooms with bare walls in which Bonnard chose to paint. All the golds, all the blond tints, all the rich colours which go to the composition of his works have transfigured, one might think, this room so paradoxically consecrated to the arts.

The Bonnard and the Roussel are complementary to each other. Roussel waits, absorbed in a preliminary meditation. Is he examining an invisible model or pondering one of his dreams? Bonnard is disputing with himself. He judges his work and his work judges him. The double action of the eye and the hand is so apparent that we seem to perceive the images passing through his vision and his hand about to move. All may not agree, but revelations of this kind belong to the pictorial art. They occur too seldom, even with Vuillard, not to be signalized. This profoundly faithful portrait, resuming the features, the rhythms and the interior life of Bonnard, is a portrait of all painters, as Mme Kapferer's is that of all the aged.

In the *Maillol sculptant à Marly*, the stage is held by the large figure of divine proportions, resplendent against the greensward and foliage — the recumbent nymph of the Cézanne monument, so much more alive than the little man, a comical figure in his straw hat and striped summer suit, who is working with a hammer. The nobleness of the statue lying on the ground under a penthouse, close to the studio, is in contrast with the commonplace setting. It might seem that by reducing the size of the sculptor, Vuillard aims at showing that the work is more important than the man and that a mortal may give birth to a goddess.

There is a little too much of the picturesque and surprising in the design of the *Maurice Denis*. We are at Rouen, inside a chapel converted into a decorator's studio. In the foreground, pails of distemper are carried on a long trestle-table. An assistant of the painter is perched on a ladder. Denis, full face, is dipping his brush in the dish. He has the air of an " old-fashioned " child, despite the keen and critical look on his chubby face. He is surrounded by his characters — a saint at prayer, a half-circle of Franciscans enclosed in a great medallion. Here, as in the preceding

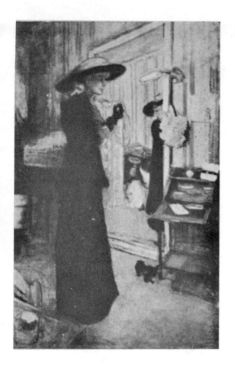

Charlotte Lysés (About 1912) — *Pastel*

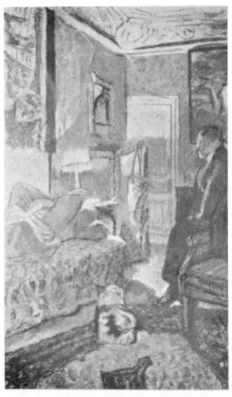

Romain Coolus

97

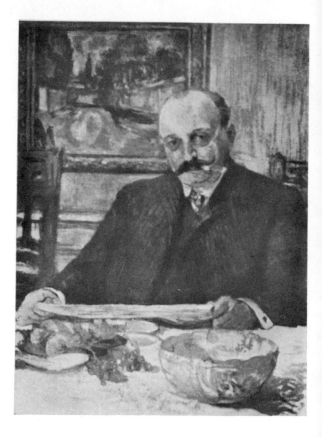

Jos Hessel (1905)

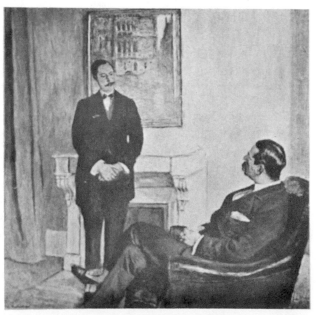

The brothers
Bernheim, junior (1912)

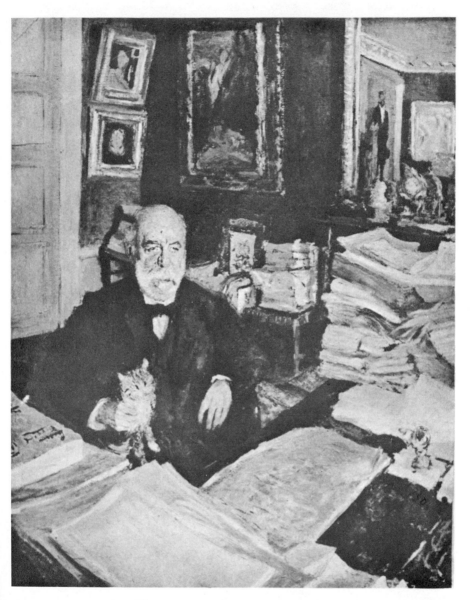

Theodore Duret in his study (1912)

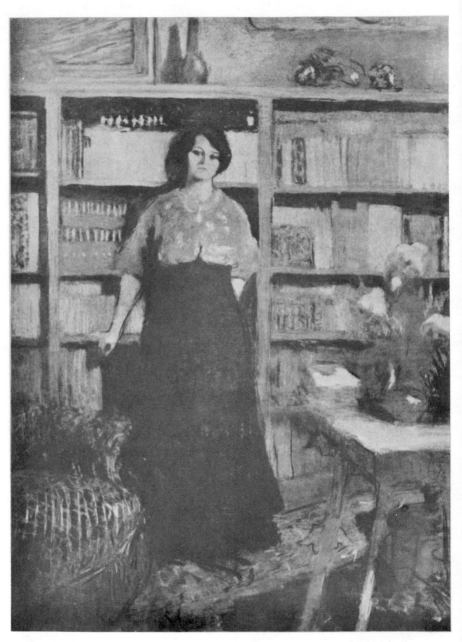

M^{lle} Jacqueline Fontaine (1910)

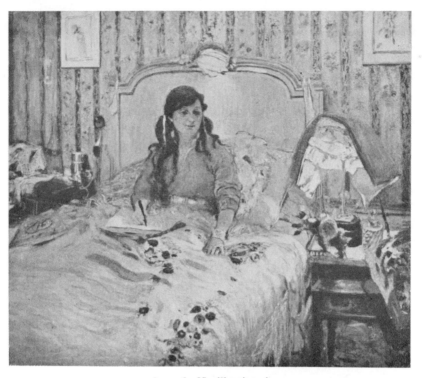

Anna de Noailles (1932)

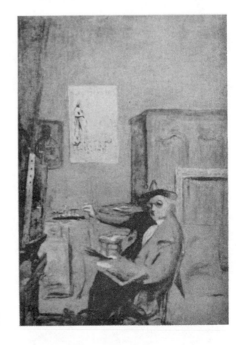

Forain in his studio (About 1928)

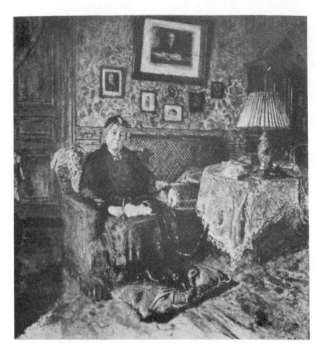

M^{me} Bénard (About 1930)

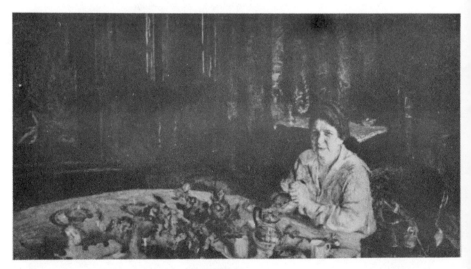

M^{me} Vaquez (1918)

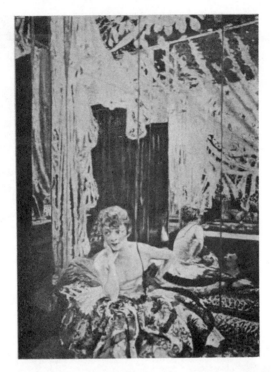

Jane Renouart
in her dressing-
room (1927)

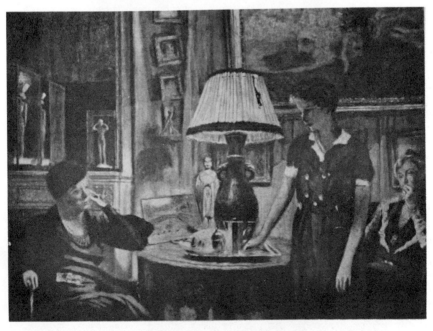

Mme Leopold Marchand (1931)

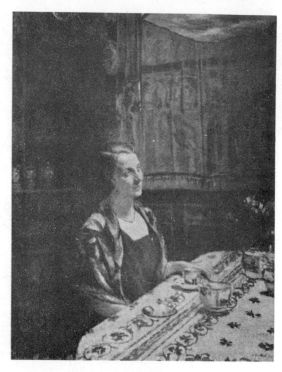

M^{me} Jean Arthur Fontaine (1925)

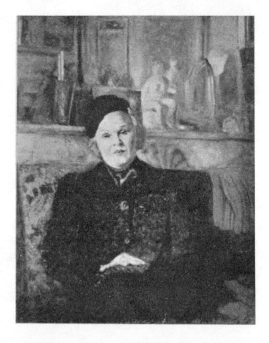

Elvire Popesco
(About 1938)

portraits, the artist reigns in the centre of his creatures. Nevertheless and strange to say although we find ourselves in the house of prayer and in spite of the sacred character of the frescoes, there is less of mystery in this portrait than in those just discussed. This is due, no doubt, to the contradictory rhythms of the composition and to a sharpness, here and there, which has been accentuated by retouching.

With these studies of painters at work, we may consider the *Souvenir d'une visite à Forain (Recollections of a last visit to Forain)*, in the Albi gallery, and the *Comtesse de Noailles*. Forain seated at his easel, turns his old roguish face towards us. Under the shadow of his felt hat, his gaze pierces his spectacles. His outstretched arm, somewhat weakly, holds a brush. A large empty frame leans against a massive wardrobe. It is a picture conventional enough, designed, perhaps, to imply that the master so hard on others has descended in the evening of his days to artifice.

Anna de Noailles was endowed with the tastes and qualities the most foreign to Vuillard. Hers were an overflowing lyricism, a sensuousness which gave colour and perfume to everything, a love of the piquant and exotic, an all-embracing heart. With her nothing at all was a matter of habit, not even the circumstance of her being alive. Vuillard's bewilderment on coming in contact with such a temperament may be imagined. It may be doubted whether any sympathy could exist between them. They knew each other only late in life when she who always imagined herself to be dying was drawing near, without suspecting it, the end she so much dreaded.

The canvas remains faithful to the preliminary sketch. The bed is covered by a large shawl embroidered with variegated floral devices. From it emerges an oriental idol, a strange little lady with an aquiline nose and heavy eyelids. Supported by pillows, her hair loose, she has the vague and at the same time fixed expression of writers at their work. In her pensive hand she holds a black fountain-pen; her left hand, short and sensual, and braceletted wrist, rest on a white surface made rosy by the light and strewn with flowers.

The disposition remains the same in a later version, except that the bedside lamp and the electric bulb fixed to the bedhead impart to this sanctuary a still greater warmth. Reds and golds of sunset light up the high spots and the trinkets of glass and metal. These were numerous. " Take away that tube of vaseline " cried the Countess when the painter was announced, " Monsieur Vuillard paints everything he sees! " At the same time, the face has become overshadowed. That Vuillard should have resorted to the subtleties of the psychologist by introducing this firework display and diffusing all the perfumes of Asia throughout the room (even to the length of putting in a red rose near the bed) may be admired;

notwithstanding, we must deplore a profusion of adjectives and an excess of enumeration. The poet has mastered the painter.

One version of the portrait of Anna de Noailles was exhibited at the Cinquantenaire des Indépendants in 1934, but Vuillard was dissatisfied with it, nor did he show it again in 1938, preferring a large preparatory study in addition to a pastel.

After 1925, commissions for portraits became numerous. We may instance those of David Weil, Marcel Gaboriau, Loucheur, Marcel Kapferer, Missia and her niece at tea, Mme Kapferer and her children, Mme Reichenbach and her children. The sitters were sometimes well known to him; more often, they were newcomers. It was of these that Vuillard was thinking when he said, "One begins a portrait without knowing the model. When one has finished, one knows the model but the portrait is no longer a resemblance." The painter found himself more and more at the service of a clientèle unconnected with his past. The physical and psychological construction of the new faces might well have seduced a painter of fashion, but certainly not this man of retired habits and tried attitudes.

How did he come to follow this path? He was led on, in the first instance, by the inevitability of his social relations. In his youth, Lugné had taken him behind the scenes. Visiting the Natansons, Tristans, Hessels, and Bibescos, he rubbed shoulders in the evening with a host of characters. He observed them with amusement, too tired however to analyse them. He went on accepting commissions from this sort of people rather as exercises, perhaps even as mortifications. At moments he may be suspected not of mere indifference but of something like contempt or aversion. Some of his encumbered interiors seem to call attention to the bad taste, vanity and discords of the inhabitants and to contain an irony already perceptible in certain early canvases. But Vuillard was far too prudent and had too little imagination to be satisfied with approximations or to adventure into regions little known to him. He had not the vehemence of a Goya or the universal curiosity of a Durer, a Raphael, a Velasquez or a Rembrandt. To express himself, he required a minimum at least of sympathy with his subject; and if he could not find this in his model, he strove to find it in the relations of the individual with his environment or in such harmonies as he could invent. To everyone it is given to console one self after one's own manner.

Drawing nervously and precisely, he was loth, it would seem, to amplify or to commit himself to judgment without appeal. He was far greater as a colourist than a psychologist, thus resembling Renoir and Cézanne. Like the latter, he watched himself, wishing to go beyond the harmonies which he could repeat indefinitely in the little intimates, now all the rage. His vision expanded. It had long been his ambition to compose a picture in the spirit of the seventeenth or eighteenth century. By a seeming

PORTRAITS

contradiction, at once technical and moral, this master of the exquisite began to talk in his declining years much less of Chardin, Vermeer or Corot than of Lebrun, Vouet or Boucher. He desired to rise above charm and distinction and to trust to style, at some violence to his nature and to something of the petty which there had always been in his inspiration. It is these efforts, often fortunate, sometimes despairing, which we are watching.

The evolution announced by the portraits of Jane Renouart, Germaine Saint-Granier, and Anna de Noailles, as also by those of Girardoux, David Weil, Loucheur and some other men, became more precise and pronounced in his portraits of Simone Berriau, Mme Freyssinet, Jeanne Lanvin and M. and Mme Bonn. Rosengart (1932) is a portrait characteristic of Vuillard's new manner, showing a manufacturer established in the centre of his office as at the centre of his business. The order and severity of the setting express the sitter's interior organization : lamp, inkstand, file, office clock, all have their practical functions, everything is precise, severe, anonymous. The face is suggestive of a safe which refuses to disclose its secret.

Accessories play also a very great part in the portrait of Simone Berriau. Conspicuous are the red bench contrasting with the blue dress, and the heavy tapestry, which the painter has dealt with the most tenderly. In a slightly conventional attitude, the actress, seated full face, leans on a piano of ebony. Notwithstanding, the beauty of the face, lit up by the splendid eyes, with its voluptuous mouth, the portrait is wanting in intensity, and the colouring borders on the trivial. This is unusual and may be intentional. Obviously Vuillard is not in his element. Mme Freyssinet, standing, in a red dress with a white belt, has more character, but is eclipsed by the background (a Buddha and a Chinese screen). Painting Jeanne Lanvin, the brush was used to describe with minute detail the table lighted from the side and this brings out too many ledgers, files and small articles of metal, wood and glass. Looking at this portrait (or that of Mme de Polignac), Bonnard exclaimed : "So Vuillard, you are going in for jewelry!" Formerly, there were few reflections and high lights — fewer still, the tactile values so dear to Berenson; everything calculated to deceive the eye was excluded. But now in the portrait of André Bénac (1936) we see a craftsman working with surprising skill. Light is thrown on the smallest details of clothing, on the smallest still-life, mostly dark red; it illuminates the coat and rosette, it does not spare us a pot of glue, a calendar, a pen, a blotting-pad or a telephone instrument. But the picture is miraculously redeemed by the painter's sympathy. This face of a French business-man, all the redder for its white hair and beard, is of the same descent as other revered countenances. We see in it kindness, penetration and something rather moving in the little blinking eyes, in the jowl, in the podgy hand

resting lightly on the desk. We forgive the solemnity of the background, we overlook the rich Renaissance chest and the framed photograph, in the delight of finding to the right, a glimpse of the winter landscape — slipping through the window and enveloping the slender branches outlined on the façades, the greys at last come unto their own!

Before condemning such a work *in toto*, we must not forget that time will dim its lustre and restore its unity. In its punctilious resemblance and technical perfection, we see a challenge thrown to the aesthetics and conventions of the day. The age of the painter, the model's environment, circumstances — none of these is at fault. Vuillard, that man so reflective, so disinterested and so little prone to impulsive movements, cannot be judged lightly. It is our business to understand and to state why Vuillard persevered in this path, deaf to objections, indifferent to the reprobation of which he had for some time been conscious even from his admirers.

He was in his sixties, but never was his mind clearer nor his brushes more obedient or steadier. He enjoyed good health, physical and moral, he was troubled by none of that decay which may manifest itself by vanity, greed or fatigue of the eye or hand. He sought not publicity or glory from his portraits, the majority of which will never be shown. He under-took them as so many exercises of patience and will-power. Far from yielding to routine or following the easier course he denied himself, in exe-cuting them, anything that appeared to be facility, the automatic application of methods and recipes, servility to the spirit of the age, or conformity.

What met his gaze when he looked round him in 1907 and the years that followed? Exhibitions of the *fauves*, a cubist sect, who seemed to be convulsed by the crises through which he had passed, but in silence, in the days when artistic debates still took place *in camera*. Now, of course, the whole world was brought into the discussion — dillettanti, dealers, brokers, waiters at the Rotonde, cheerfully babbled in an obscure jargon and proclaimed a philosophy of the market-place, where Sérusier, twenty years before, had talked of Plotinus and the Golden Section. Jackasses were disguised as philosophers, daubers as critics and the leaders of schools. The least justifiable extravagances were assimilated in the twinkling of an eye by a public which in obedience to a system of conformity upside down, proceeded to explain all things by principle, especially the incomprehensible, preferred the ugly and abstract, as it had formerly preferred the pretty and the delicately finished, believed that French art began with Cézanne, and was as proud to belong to the advanced guard as it had been yesterday to defend a false tradition. To idolatry of Cézanne succeeded the Matisse and Picasso obsession, men whose externals were plagiarized and who were admired for the wrong reasons. After 1918, the confusion was worse. Painting had reached the Age of Mammon. Prices went up, everything sold. The resistance put up by Vuillard and his friends to those facile

On opposite page : M^{me} Kapferer (1919)

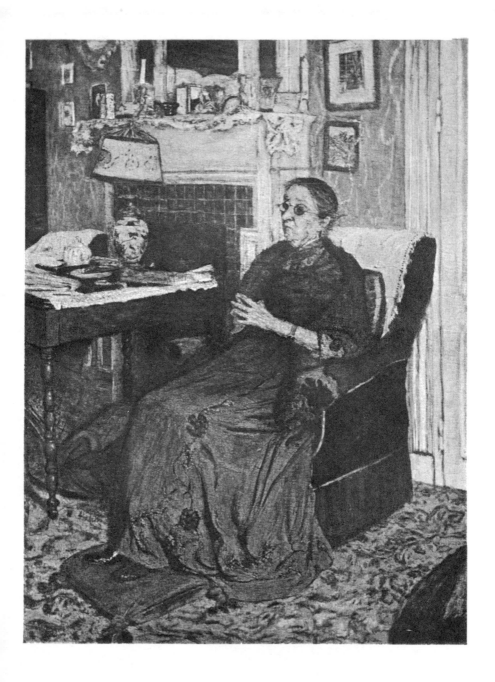

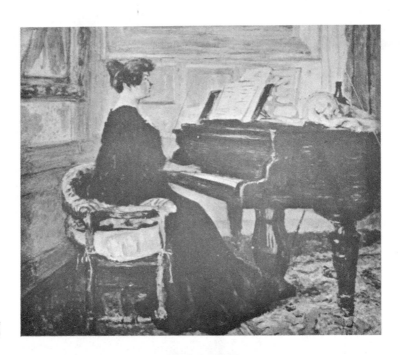

Missia at the
piano (1899)

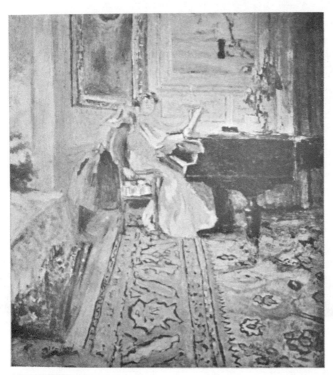

M^{me} Arthur Fontaine
and daughter (1905)

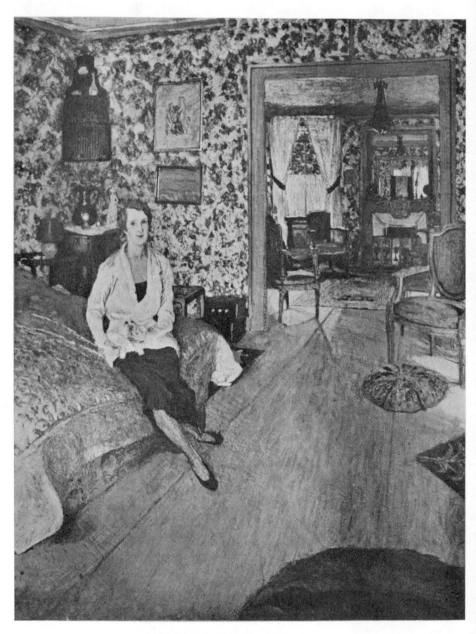

Countess J. de Polignac (About 1932)

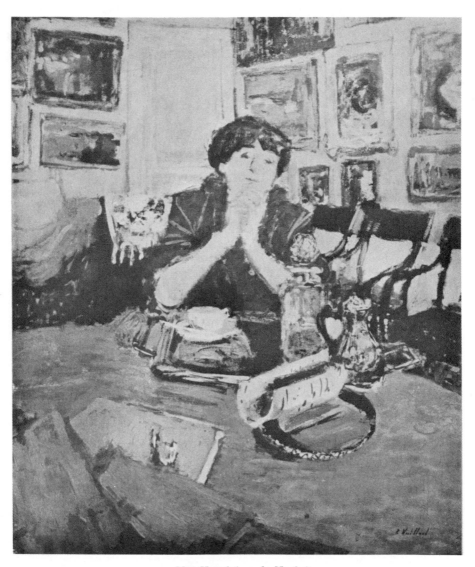

M^{me} Hessel (rue de Naples)

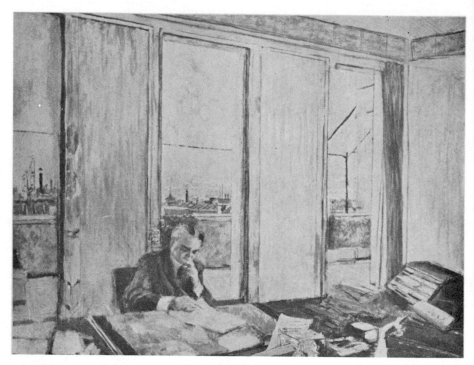

Charles Malégarie (1938)

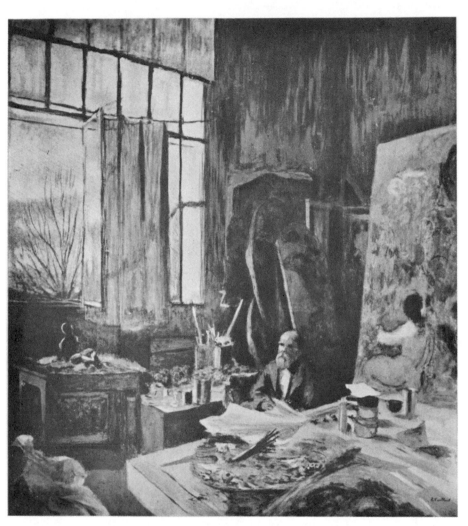

Ker-Xavier Roussel (1925, 1935)

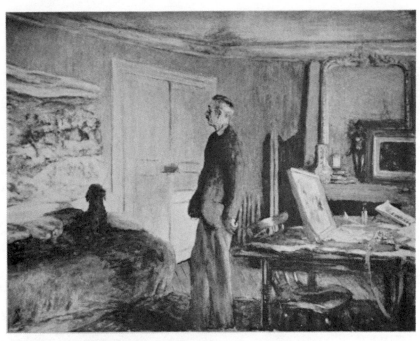

Pierre Bonnard facing his canvas (1925, 1935)

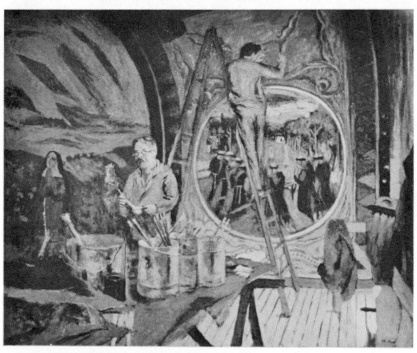

Maurice Denis decorating a chapel (1925, 1935)

Aristide Maillol at Marly (1925, 1935)

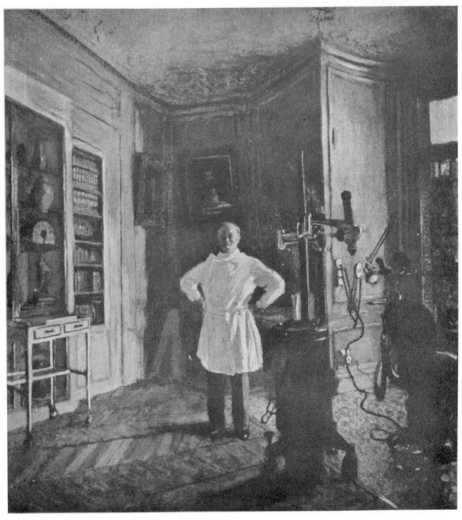

Dr. L. Viau in his dental surgery (1937)

methods for which they felt themselves indirectly responsible has never been better explained than by Maurice Denis in these lines *(De Gauguin et de Van Gogh au classicisme)* : " We contented ourselves, let us confess it, with hasty generalizations; as it became schematic, our art remained fragmentary. We have made too many sketches and too few pictures. We do not know how to finish ".

The Vuillards objected to tell the story of a man anxious to abandon his customary spells and charms. It was no mean risk he ran, differing so much from himself without heeding the familiar voices.

But he knew these risks. We would have looked in vain at the 1938 retrospective survey for the Giraudoux, Comtesse de Polignac, and Anne de Noailles portraits, which, since he had taken great care in the selection of his work, we must suppose had failed to satisfy him.

Many of the people who sat for him offered, it must be admitted, very few attractions from the plastic or temperamental side. By others he seemed to be frightened. While Lautrec played the madman in presence of Jane Avril, Yvette Guilbert and La Goulue, Vuillard appeared embarrassed in presence of Yvonne Printemps, Popesco, Dorny and Renouart. If he now began to paint directly from nature, it was because he knew he had nothing to hope for from the remembered and the unconscious.

The sensuous plays in his art too discreet a part for him to experience the animal delight of Rubens or Renoir in their fugitive models. The appreciation of movement, muscular force and tense passion, possessed to a high degree by Degas and which gives so much energy to the least turbulent works of Manet, Goya, David, Ingres and Gericault, he always lacked. Instinctively preferring the static even in presence of essentially dynamic persons—actresses—he reduced the subject to a minimum. Many a time and in every period, he tried to conquer the enchanted domain of childhood — to show a small boy lifting himself on all fours from a flowered carpet to explore the upper world, or a little girl riding a rocking-horse in a drawing-room, or any of the little people, singly or under the mother's care. (The little Bernheim-jeunes, the David Weill children). But these middle-class children, too civilized, too well-clothed, are far from possessing the unconscious charm of the children of the " squares " and the attics. They know they are under observation. At four years, they are posing for their portraits.

Two of Vuillard's latest portraits prove that in spite of appearances, he had lost none of his pristine virtues. *Doctor Viau in his dental surgery* (1937) is a marvellous symphony in grey and black where the precision of the painter equals that of the practitioner. The picture is spacious, airy, calm (though most of the objects suggest a struggle!) and alive, although it contains only one person, upright and motionless, but ready to spring into action. The unity of the colouring is assured by the tender Paris

light which coming through a window, caresses twenty surfaces of nickel, glass, aluminium and white lacquer.

The portrait of Charles Malégarie at his desk (1938) surpasses all Vuillard's other pictures of business men. His invention resides in the choice of the " marine " or seascape form of which he nearly always makes a success and which permits him here to unfold a view of sky and roofs, like a frieze, immediately above the model. Nothing could be better done than the atmosphere, with the pervading tones of grey and milky-white. Here the painter's sympathies again come into play. He does not feel himself in exile as in rich interiors.

Had he lived longer, would Edouard Vuillard have renounced these excursions into society and all these brilliant and somewhat laboured performances? Are we in a position to say that he was on the eve of reacting against his own reactions and breaking with the discipline and technique so recently adopted? Would the cry have escaped him, as it broke from Maurice Denis, the eve of his death, " Gauguin — think of Gauguin! " We are free to suppose, on the contrary, that, heedless of misunderstandings, he would have persevered with heroic obstinacy in the new way (6). His conviction, in any case, was that in executing these portraits he was applying the only method which would enable him in a future he hoped to be near, to undertake with completed knowledge and perfected weapons, works which till then he had approached only by intuition and piecemeal, namely, decorations on a large scale; the rest remaining in his eyes merely researches, preparations, exercises, a stage to be left behind him.

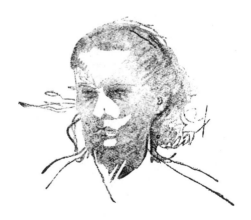

DECORATIVE WORK

Gauguin and the Nabis clamour for wall surfaces. — The examples of Puvis. — The first decorations : Jardins de Paris, for Dr. Vaquez and Clande Anet. — Comédie des Champs-Elysées. — Seascapes. Bois-Lurette. The Squares Vintimille. — The garden in Vuillard's work. — Commissions by the Théâtre de Chaillot and the League of Nations Palace at Geneva.

One of the most serious preoccupations of the Nabis and the Pont-Aven group was to restore to the painter his first mission — the adornment of the wall. Throughout a century, the bourgeoisie, fascinated by the Dutch lesser masters, seemed to care only for the ornament-picture, which, destitute of any precise purpose, passed from hand to hand like a jewel or a deed. Lacking commissions, artists ceased to take large views and measured out their efforts. Instead of relating the painted work to a whole, or of considering it as in itself a whole (a sum of reflections, observations, knowledge, and mental or manual experiences), they contented themselves with fragmentary productions, not always devoid of glints of genius. Some cared only for portraiture, others for still life, others again for landscape. Their field of vision was a limited field, a patch of ground explored by habit, exploited by the craftsman.

In former times, the Masters were indeed masters. The whole world, they saw as their province. Nothing which made the greatness of the poet or the philosopher was foreign to them. Yet they remained pure painters. Now, become the slaves of a manner or a type, they have most of them degenerated into petty druggists who exploit a speciality.

Walls! — the " Symbolists " of 1890 rallied to the cry. To raise it meant no little courage among men, helpless, blown hither and thither by every wind, without masters, without experience, knowing only that sloth must be vanquished and everything learnt over again by the daring. Vuillard often declared that he was less interested in the career of the artist

than in fathoming the depths of painting, meditating on its laws, exploring all its possibilities and all its resources. Very soon he felt it was not enough to cover a piece of canvas conscientiously and to copy as well as he was able some object presented to him by chance. Detached from all personal ambition, at this epoch he was " ready for everything " — a bold declaration in the mouth of a diffident man.

Opportunities were still to seek. Neither the state nor Maecenas was conscious of a mission. Puvis linking up with Poussin and recovering the sense of the universal, but admired for the wrong reasons, purely literary, alone found favour with the Third Republic, thanks to a misunderstanding. It was through Cottet, whom they met at Maillard's that our young men discovered Puvis' work and thought. They might easily have passed him by, thrilled, as they still were, by the examples of Manet and the Impressionists — in so many respects opposed. Vuillard, as we shall see, in the evening of his days, protested against the influence of Degas and against certain peculiarities; but his devotion to Puvis did not weaken. This admiration was based on moral and spiritual affinities, by a common love for purity, harmonies and calm rhythm.

Like those of most painters, Vuillard's enthusiasms were often somewhat paradoxical. At times they seem to be dictated by what we may call a complementary exigency. We find him thus envying Le Brun and Vouet (for whom he professed a special cult), their power of organization and their eloquence or as he put it, their " decorative facility ". This said, we may wonder whether he was made, as he believed, to cover vast surfaces. Circumstance and his fundamental good sense compelled him, most fortunately, to find a mean between Grand Decoration and easel-painting without leaving the realm of the intimate. It is in this last domain, uncontestably, that he satisfied the highest demands on himself, while remaining true to his more exquisite qualities.

The prodigal son, the dare-devil, the first of the band to cover a wall, instead of merely clamouring for it, was Bonnard. At the Indépendants in 1891 he was represented by a vast composition done in distemper. Next year, Sérusier was painting big panels in the studio of the sculptor, Lacombe. A little later, Vuillard was working with Sérusier's gang on scenery for the Œuvre. He was, as we have seen, the most fervent of Lugné's collaborators. Unfortunately, nothing remains of the *Rosmersholm* scenery which marked a definite turning-point in his life. Without it, he might never have learnt how to cover wide surfaces or the uses of distemper.

What has become of the six panels and the screen executed for Mme Desmarais in 1892, that year of feverish groping? We know of them only thanks to an article in *Voltaire* (7) and to the rough sketches, vigorous in tone, which the artist was careful to preserve. These present interiors in ochre, yellow and red, peopled by young women engaged in various occu-

On opposite page: The Housekeeper (About 1925).

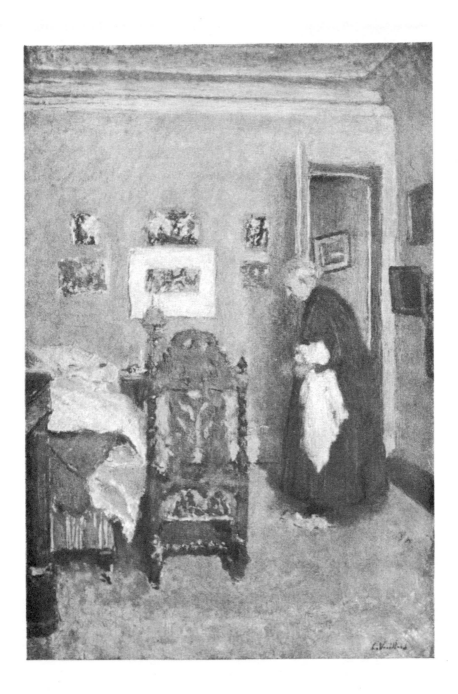

pations, treated with that combination of tenderness and lightness which characterizes many little scenes belonging to that period. Already, the linear organization, seen in the play of parallels (doors, plinths, floors), demands the importance, to be fully conceded in the pieces executed for Dr. Vaquez.

The sympathy extended to Vuillard almost from the beginning by the *Revue Blanche* procured him an order for nine large full length panels. (1894). On this occasion he borrowed his inspiration from the street scenes of Paris. Bonnard had already discovered a new aspect of the city in his *Orgue de Barbarie (the Street Organ)*, *Sortie de l'Ecole (Coming out of School)* and *Blanchisseuse (Washerwoman)* — he showed the street not as a public place but as an inhabited interior, animated and living, finishing often halfway up the walls and without a glimpse of the sky (8).

When he was commissioned by Alexandre Natanson in 1894 to decorate his home — an exceptional chance for a beginner — Vuillard chose public gardens for subject. This does not mean that he proposed to himself views of particular spots, such as his *Square des Batignolles*, *Place Saint-Augustin* and *Place de Vintimille*, executed later — he aimed at the freest renderings as one might present a forest scene, in other words, synthetic reconstructions or generalized landscapes. The line of hills discovered in the three panels acquired by the state in 1929, reminds one of the heights of Saint-Cloud seen from the path bordering the race-course. In the *Deux Ecoliers (The Two Schoolboys)* and *Sous les Arbres (Under the trees)* we can fancy we recognize the alleys of the Tuileries, which inspired the coloured lithograph, published soon after in the album of Painters and Engravers. In the panel acquired by the Princesse de Bassiano (anterior by some months to the Natanson decorations) the turns in the alley and the façades perceived between the chestnut trees make us think of the Parc Monceau — or of the Luxembourg! It matters little — many favourite prospects are combined; what we see is a re-created Paris.

The *Jardins Publics (Public Gardens)* are compositions on the large scale, most of them elongated in shape, and done in the medium to which Vuillard accustomed himself while painting his first sceneries. They are linked together according to the principles of symmetry. Continuity is assured by the horizontal lines cutting each panel in the middle. The three acquired for the Luxembourg *(L'Ombrelle, Conversation, Les Premiers Pas)*, though not belonging to a series, form one whole. About a third of each composition is occupied by a milky sky, two-thirds by a gravelled foreground reflecting the light and light passing shadows.

These golden foregrounds, so lively and striking, reappear in several other panels of the same series *(Les Nourrices, Fillettes jouant, La Promenade, L'interrogatoire)*; also in *Sous les Arbres* and the *Deux Ecoliers*, Here the upper part does not belong to the sky but forms a broad band,

woven in every sort of green and punctuated with flowers and leaves which are suggested by minor graphic elements and the use of the flat brush. While some parts obey the traditions of optics, others are governed by an arbitrary regard for decorative effect. Perspective and chiaroscuro are set at naught by line and colour. The aim is not so much fidelity to the subject as to present a general unity by a combination of conventional signs and a skilful play of analogies or contrasts.

The special charm of these decorations proceeds from so close a collaboration between the conscious and unconscious that it is hard to determine the part of either in the successful result. What little there is of theoretical is corrected by a marvellous taste, by tact, observation and an unfailing sympathy. Every generalization is based on elements observed. The first impression is never spoiled by deliberation or inclination.

These evocations of Paris differ from all impressionist experiments by the essential part reserved to the figuration. For Jongkind, Monet, Pissarro, Lepine and their successors (Marquet for instance), all that mattered was the sun. When they choose to mix the immobility of stone or verdure with the variations of the sky, any characters shown in the picture are seldom more than passers-by. But the public gardens of Vuillard are before everything else, open air *intimates* wherein the framework and the natural accessories inspire and impose new gestures and new attitudes, not on fleeting figures, but on the *inhabitants*. The group or the figure is received by the landscape which isolates it, shelters it, offers it wooden benches and iron chairs instead of beds or divans, sand for a carpet or a flooring, a sky for a ceiling, and growing instead of cut flowers.

Since these works are destined to adorn a wall and to assimilate with a flat surface, the persons are, so to speak, woven in with the background. This subordination is more difficult to admit in an easel picture, as Vuillard soon came to learn, but is unquestionably legitimate in a mural painting. All visual tricks are sternly excluded. These wall pictures owe their charm before all to the clever play of line and flat strokes, by the alternation of the full and the void, to the exclusion of everything indented or with a sharp relief. Rapidity of execution and unity of touch are facilitated by the distemper medium. At the same time its matt surface is without the aggressiveness of oils.

To people these compositions, a minimum of anecdote is sufficient. An old woman, dressed in black, seated under a red umbrella — three young women seated, side by side, on a bench — the back view of a little girl, watching the first steps of her brother — that is enough for the Louvre triptych. The " subject " of *Sous les arbres* is a game of hide-and-seek. In the foreground, a little girl in a black pinafore stands with her face

against a tree; the mothers sew and chat under the branches, while in the distance, parallel with the arcade of trees, are seen lengthened forms, sisters to those which adorn the allegories of Maurice Denis. Here, from behind, we see two schoolboys. Elsewhere, children playing at the feet of their nurses, animate the alley or are scolded by their mothers.

In another panel, similarly inspired and of the same period, which belonged to Thadée Natanson's collection, we see a servant in a light-coloured apron and a striped jacket, in charge of a group of children. The vista, slightly broadening downwards, allows us to see the other people ranged in depth in the background. The cream-coloured patina of the tall houses, with their vertical rows of balconies and shutters, is described through breaks in the foliage. These buildings remind us that parks and squares in Paris are just artificial oases or imitation woodland bordered by masonry. The right of the composition is held by the main group, made up by a baby in a tartan dress sprawling on the ground, a little girl in a black pinafore standing, and two small boys struggling; on the left, the gravelled path winds upwards, growing narrower, towards the centre. At that point a bearded promenader wearing a Panama hat, bends over a seated lady. Behind them, mothers and children, a variegated mass, animate the summer shade. Tender greens mix with darker greens and blues, modulation and correspondence is the rule. The splaying slats of a bench contrast with the stripes on a bodice and the dots on a skirt. No Japanese print is more subtly matt.

Here as in the Natanson murals, the familiar dominates — the children at play, the grown-ups chatting, the dialogue of garden chairs, have all been noted with the blandness and delicacy of a primitive. The houses seem to smile, the friendly alley and the tutelary chestnut take on a poetic signification. The little servant-girl in her white apron is raised from her subaltern rank to the foreground, in disregard of the ancient hierarchy. Before this, Degas had introduced the *nourrice* on to the race-course or into the Luxembourg gardens; but she in her theatrical uniform, evoked a wealthy environment very different from the *petit ménage*, with its cooking-stove, its washing and crockery and all its responsibilities concentrated in the capable hands of the *bonne à tout faire.*

Although Vuillard does not attain the hieratic style and conciseness of the painter of *la Grande Jatte*, we perceive in these panels a quality of silence, an order and a tempered brilliancy which time and again make us think of Seurat — due to the balance realized to so high a degree between the visible order of things and the organizing power of the artist, or to the modern characters being presented in a relatively static rhythm, or to the craftmanship shown in the separation of tones and the punctuation of dresses and foliage.

In 1897, Vuillard was entrusted by his friend, Dr. Vaquez, with the decoration of his drawing-room in the Boulevard Haussmann. Free to choose his subject, he forsook the open air and attempted a synthesis of all his earlier interiors.

No doubt, in another age, the artist would have been content to design cartoons, to be executed or at any rate interpreted by the craftsmen of the factories. How was it that, while thirty years later, Jules Chéret, Wilette, Odilon Redon, Jean Veber, Raoul Dufy, and Ch. Dufresne, were, each in turn, asked for designs for Les Gobelins (then directed by Gustave Geffroy), for Beauvais and for Aubusson, no one seems to have thought of the Nabis? (9) Yet, how great a stimulus that would have been for them... It may be that Vuillard, instead of turning to portraiture, might have devoted himself to what may be called *rus in urbe* studies, in the line of his *Squares* and *Vues de Paris*. All the aspirations, so far merely asserting themselves in the *Jardins de Paris*, might have found full scope. Instead of returning to a species of realism, he might have invented a language ever freer, and cultivated that spirit of transposition and enchantment which lends so much charm to the works anterior to 1900.

In the event, his painting will remain for ever chamber music. But whenever the occasion offers, we see him ready to forsake the easel picture and eager to undertake work on a grander scale. Still, it must be admitted he was of too sedentary a nature to stray far from modern dwellings, and in these he found his inspiration in executing the Vaquez commission.

The decorations inspired by the round of daily life are in the nature of reveries. This remembered, we find justification for turning a painting into a kind of mirror, wherein the woman at her embroidery and the man reading, on raising the eyes towards the wall behold, if not their doubles, at any rate men and women who are neither quite themselves nor other people. These flimsy creatures, transparent as phantoms, this society of furniture, stuffs, embroidered flowers and real flowers, rugs and disembodied books, have abandoned the material world for another, paler and more lasting, to be invested with an hieratic immobility and an extraterrestrial purity.

These four admirable panels have been conveyed under a bequest to the Petit Palais (1936), where they find a more appropriate setting. In these echoing spaces, trodden only by the stranger's foot, in these galleries where the walls are everything and it is only the walls that speak, where the visitors are observers not doers, there, assuredly, such evocations are in their true place and there they exercise the spell with which their creator furnished them. There we are not distressed or astonished by the devastating effects of time — the transitory takes on a decisive character, the old-fashioned enters into history, and to more eminent merit is added a documentary value.

In the Vaquez panels we see the culmination of the qualities in process of development since 1891. Vuillard did not allow himself, like so many official decorators, to be carried away by an extravagant imagination. He took care to assure to each composition, an organization of line and colour and a harmony regulating interior details. This symphony in four parts is governed by unity of construction, unity of light and unity of rhythm. The lines of the ceilings, bookshelves, tables and Persian carpets assert the predominance of the horizontal. These parallels continue from one panel to the next almost without interruption. The dominant colour is set by the wall-paper with its innumerable flowers diffusing their tints into the atmosphere — a violet sown with browns, ochres, carmines, ash-greens, which tints the entire scheme and proceeds from the heart of objects and persons. An even filtered light, from some invisible source, bathes the smooth matt surfaces and obliterates the third dimension, thus keeping imagined shapes from competition with the living. In any decorative fiction, it is the cardinal sin to confound two worlds and irreconcilable data.

Though painted in 1896, the Vaquez decorations do not appear to have been revealed to the public till nine years later. In December, 1905, the *Gazette des Beaux-Arts* called attention to their importance. It was André Gide whom Roger-Marx asked for that " promenade " round the third Autumn Salon, in which talk on art generally is varied by some commentaries of eminent lucidity. Having laid it down that in the reigning anarchy, it was incumbent on every artist to create for himself a new aesthetic and that too many pictures remained at the sketch stage, Gide made up his mind. He did not bore his reader by upward gazing at the skied pictures. His attention is engaged by two tranquil artists, as he calls them in opposition to tormented artists. " If it were not for M. Vuillard, I should stick to M. Maillol ".

He analyses our painter's work in these words. " I do not know what I like most here. Perhaps, M. Vuillard himself. I know few works where one is brought more directly into communion with the painter. This is due, I suspect, to his emotion never loosing its hold on the brush and to the outside world always remaining for him a pretext and handy means of expression. It is due to his speaking in a low tone, suitable to confidences, and to one's leaning over to listen to him... His melancholy is not romantic nor haughty, it is discreet and clothed in an everyday garment; it is caressingly tender, I might even say, timid, if this word were in consonance with such mastership. Yes, I see in him, his success notwithstanding, the charm of anxiety and doubt. He never puts forward a colour without excusing it by some subtle and precious withdrawal. Too modest to assert, he insinuates... No seeking for the showy, a constant search for harmony. By a grasp of relations, at once intuitive and studied, he

explains each colour by its neighbour and obtains from both a reciprocal response... "

The Vaquez panels may here be briefly described as follows :

The Piano — Three women are grouped round a grand piano which is overshadowed by a large bunch of flowers; one is playing, the others stand round her; in the foreground, a lady, wearing a light yellow dress with puffed sleeves, is seated at a table strewn with stuffs.

The Writing-table — In the background, a man, full face, is bent over his table, writing; in the foreground, a young woman, in a blouse of finely striped material, is making a dressing-gown in broad stripes.

The Reader — A silhouette is shown framed in the doorway; in the foreground, a woman, seated, turns the sheets of her newspaper.

The Library — Back view of a young woman, standing, her head slightly in profile, as she takes a book from the shelf.

The words woman and silhouette have been repeated, because we are concerned here with beings not strongly differentiated from each other, though they are not quite so much abstractions or quite so contemplative as the little sisters of *Conversation* or *Dans les Fleurs* or the " *demoiselles élues* " of Maurice Denis. These apparitions at least are engaged in definite work. They are not inactive angels, but they read, sew and embroider, and they have been religiously observed and studied in their every attitude. So much having been said, they retain only a semblance of life. Their flesh is diaphanous, their clothes have the air of a stretched fire-screen, they belong to the scenery. The light divided touch is suggestive of tapestry work. Once again, Vuillard recalls Seurat, though he does not proceed systematically by separated tones. (He did this, however, at the same period, in several easel-pictures). Entire areas are treated with a flat brush, and the point, playing on the smooth colouring, is only introduced as an element of vibration. Black and the neutral tones, far from being proscribed, assert themselves upon more resonant surfaces and constitute intervals of gravity and repose. Not less important is the lineal organization governing this profusion of flowers and details — there are flowers on the walls, the fabrics, the dresses; even the tea cups and the books seem about to blossom. Every device for varying the design of a wallpaper or a tissue has been resorted to — stripes, broad or narrow, specks, dots — not in competition with rich materials, after the manner of the Dutch and the Venetians, but, on the contrary, out of a devotion and a predilection for the dull, less obtrusive materials, for linen rather than silk, for cotton rather than brocade. We have spoken of the essential part assigned here to the coffered ceilings and carpets which form a kind of border to the upper part and to the foot of each panel and which bring out the values of human curves and the charm of so many objects governed by an interior order which respects an apparent disorder.

The refinement of tones verges on preciosity. But Vuillard avoids that pitfall, like the musician of *Serres chaudes*, of whom we are often put in mind by these mauves and lilacs mingled with blues, carmines and greens. Indeed, we may call them hothouses, these flowery velvety rooms, in which the personages seem hardly to breathe, action is slowed down, and the colours, even the shapes, are but allusions.

But, without renouncing these delights, Vuillard was bound to react against excesses of the period. He came dangerously near, as we have said, to being guilty of the precious. Happily, he had within him sure antidotes against theoretical subtleties and deformations, against contempt or forgetfulness of the true. His prudence and intellectual sanity sustained him in his resistance to factitious originality.

Throughout the capital year, 1897, he was preparing for the decorations which were commissioned by a new Maecenas, the novelist, Claude Anet. One of these panels, exposed somewhere about 1905 and retouched in 1936, represents a Family Gathering in a Norman Garden. *(Réunion familiale dans un jardin normand)*. It is an anticipation of the Bois-Lurette group. The two most important compositions passed into the hands of Princess Antoine Bibesco and were on view at the exhibition of 1937 at the Pavillon d'un Collectionneur. They are masterpieces. Vuillard never did so well, he was never to do better.

A garden bench, an ordinary bench — the wall of a small suburban cottage outlined to the left, against the summer sky. In a foreground of gravel and flowers, a couple seated. We stand wondering before the freshness of this vision. How is it that this static spectacle possesses an animation lacking to the Vaquez panels? Why is it that we are so deeply moved by a scene, utterly destitute of sentimentality, which shows us simply a Parisian woman with short hair, reading a magazine, and, on her left, in the foreground in the lower angle of the picture, a sprightly young man, bearded, bending with his knee thrust forward, playing with a kitten?

At first sight, nothing could have less of the mysterious about it than this retreating façade of stone and brick, with its rulings of closed shutters, than this garden table, than this day, than this couple. Yet, for all that, everything is arbitrary, abnormal, and surprising. Summer is substituted for the sun, which casts no shadow and brings no object into relief. Depth is suggested by the diminishing scale of the characters, alone. Traditional perspective is abolished and amazing liberties are taken with the data of experience. All sorts of contradictions are skilfully upheld. In the heart of a fine season and a fine day, we are bathed in a glaucous chiaroscuro; the people appear to be composed of the same substance as the landscape; the path is of the same colour as the flesh; a cloud is puffed out like a

dress; here, a fabric looks like a field; what seems to be a butterfly is a passer-by. This marvellous picture has the hues of moss and jade, of sand and orange. Three colours — green, dark red, and red ochre — are modulated. Green prevails, or rather a multitude of greens, different forms and densities — the bars of the garden seat, the shutter slats, the foliage of the climbing rose bushes, the slopes of the wooded hills. Innumerable greys become tinted with pink and lilac in contact with the green; they hover on the soil, on the sky and on the house and bring out the opulence of ten deep reds. These also differ among themselves. We have only to compare the woman's skirt, the bricks, the sewing on the table, the three-cornered cape of the passing woman, the tiling of a distant villa. Set in this area of muffled tones, the blacks and whites have unexpected power — the matt blacks of hair and of a passing figure — the white of the printed corsage, the white of the magazine page, the white of a summer suit and a servant's apron, and the white of the dappled sky overhead.

In this panel which excels its fellow (a woman lying in a garden arm-chair), Vuillard continually transposes, as if he were his own interpreter and had assumed the task of weaving this verdure with a limited number of tones, inventing a universe which is not intended to deceive the eye or the mind. The work belongs to the wall. For that reason, he has shunned the prominent, the brilliant and the hollow, everything in fact that might suggest the model. Every tactile suggestion has been suppressed. Never has any painting differed so much from statuary. There is no shape here you could go round — all action is on a plane, or more exactly, there is a juxtaposition of nearby and distant actions, those in the background showing as much vigour as those in the foreground. Detail is respected throughout and becomes ornament as in the Persian miniatures and Gothic tapestries.

We have arrived at the period when Vuillard, eschewing what might be called certain extravagances, obscurities and deformations, shows most charm, unexpectedness and novelty. Comparing the two principal figures, so strangely overlapping, with those painted by Degas or Gauguin, Vuillard's chosen masters, we notice that the spirit is entirely different. We are reminded by their familiarity, their suavity and their oddity rather of Toulouse-Lautrec (whose drawing, however, is sharper and more incisive). Tone down the static splendours of Gauguin, blend the hieraticism of Puvis with a little of the strange borrowed from Redon and a spice of Degas' severity, and you have this phantasy, *la Femme au Jardin*.

Since the same masters presided over the technical and spiritual formation of Bonnard, our thoughts turn also to him, especially as the young man, bent in three with the kitten, resembles him, and his style and language are suggested by the *Parisienne*, nervous but still, and the tiny dog gambolling among the flowers. In fact, here it is possible perhaps

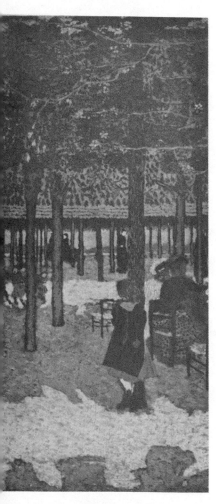

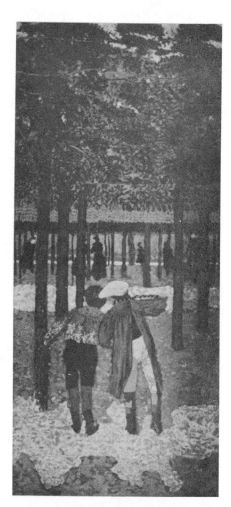

Under the Tree (1894)
Decoration for A. Natanson

The Two Schoolboys (1894)
Decoration for A. Natanson

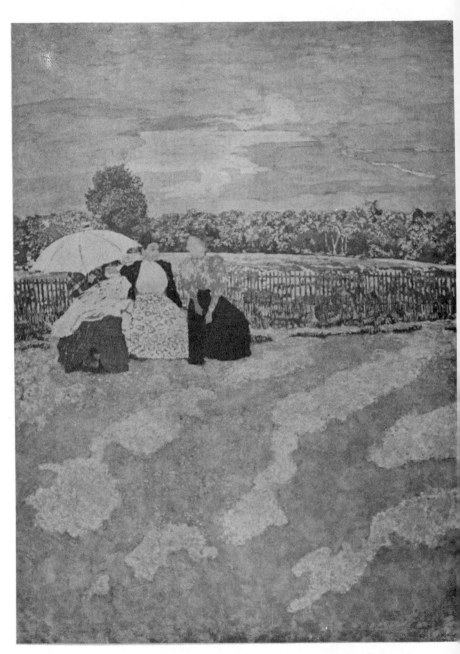

Three Women on a Bench (1894) — *Decorative painting for A. Natanson*

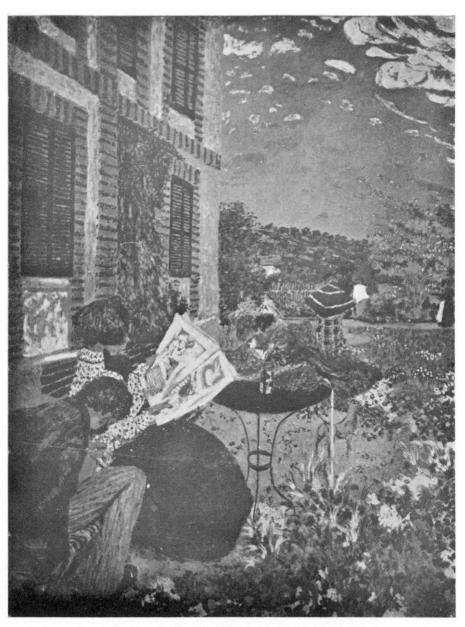

Woman reading in a garden 1898 — *Decorative painting for C. Anet*

131

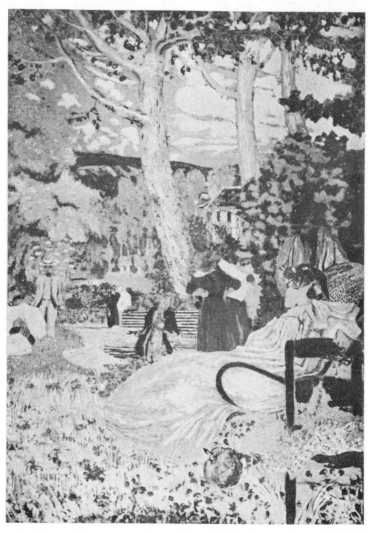

Woman seated in a Garden (1898) — *Decorative painting for C. Anet*

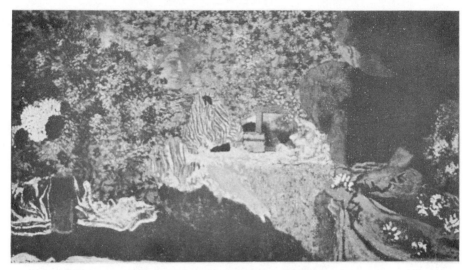

Among the Flowers (1895)

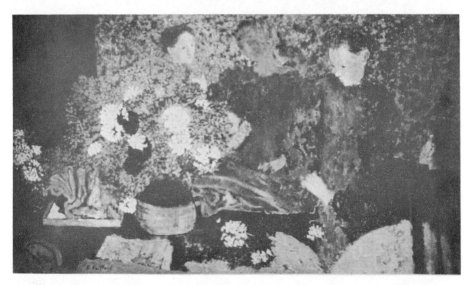

Conversation (About 1895)

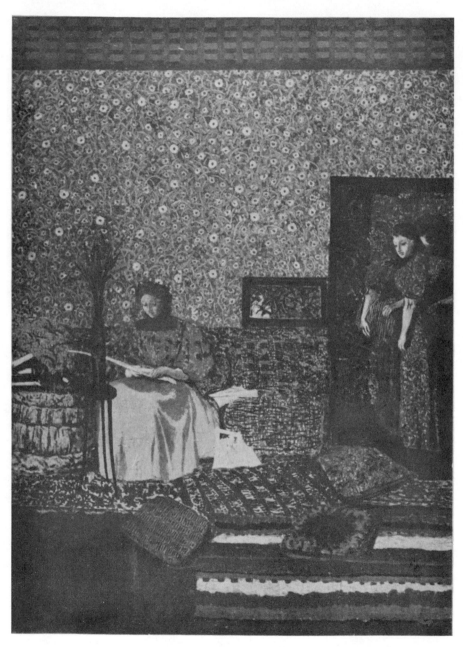

Decoration for Dr. Vaquez (About 1896)

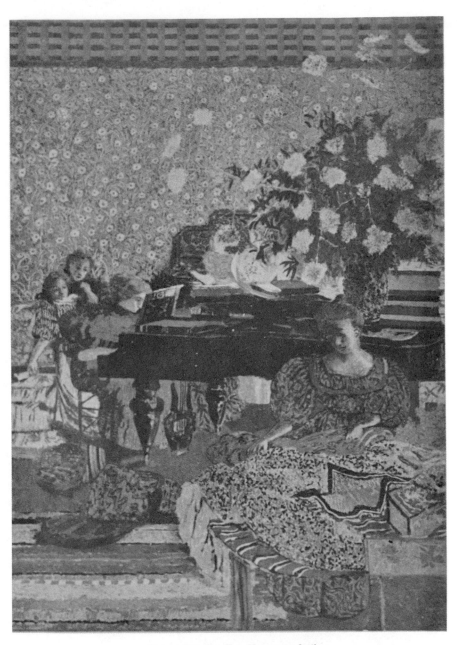

Decoration for Dr. Vaquez (1896)

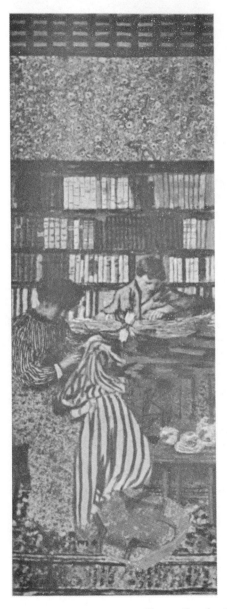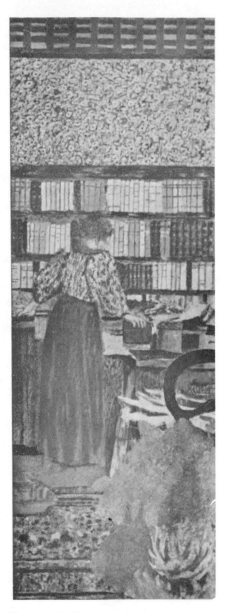

Decoration for Dr. Vaquez (1896)

to trace some slight influence of his. This refers to the drawing, not to the colouring which remains literally incomparable.

The same qualities are again found in the series of lithographs, published soon after by Vollard (1899). In these, the coloured inks — yellow-green, lemon-yellow, and reds, light as strawberry-juice — upon their white background describe, matt as in a fresco, a succession of interiors peopled with white or bluish stoves, hanging-lamps, crowded mantelpieces, and silhouettes of children and old people. Or we see little girls coming out of school and strollers in the country and avenues checkered blue and white by sun and shadow. Each of these lithographs is a tiny fresco. Not since Whistler, had the coloured print achieved such wonders. Nowhere has Vuillard's drawing shown itself more expressive or more completely emancipated from any system.

Very soon, in consequence of the crisis above mentioned, more than one childish intonation vanishes, certain *brusqueries* seem too daring, and we feel the same regret as upon the transition of adolescence into manhood.

Another of the Claude Anet panels is entitled *Déjeuner dans un jardin de Normandie*. This is a transitional work, akin in execution and subject to certain Monets, and still more by its sparkle and mobility to some Renoirs. A table is laid outside the house. Guests gossip round a check table-cloth which has not yet been cleared. To the left, a young couple (Bonnard and Mme Claude Anet), are about to walk away; he turns a smiling profile towards us, she is hatless and dressed in a long white gown. Coolus, seated, talks with Mme Hessel; at some distance from the table Tristan Bernard and Gaston Bernheim are seen. The women's summer hats and the men's " boaters " have for background a wall of greenery. Important retouching, forty years after, introducing a spaniel into the foreground and modifying the background, did not affect the charm and juvenility of this great composition, which is pervaded by a festival air by no means frequent with Vuillard. The arrangement is not so new as that of the Bibesco panels. Affinity with the Impressionists is more obviously announced. The young woman seated with her back turned has the sprightly grace of a Renoir; the couple standing, reminding us of the *Danse à la Campagne*, are less reticent than most of the artist's figures. The background belongs to the same family as the great rustic Monets, such as the *Déjeuner sur l'herbe* in the Frankfort gallery (10).

*

The two landscapes *Paysages d'Ile-de-France (Les Premiers Fruits* or *First Fruits* and *La Fenêtre sur les Bois* or *Window looking on the Woods)* inspired by the horizons of Etang-la-Ville (1899) have passed from Adam

Natanson's collection into Leon Blum's. They are of entirely different character. One attains a length of four metres, being with the *Bibliothèque* and the Geneva decoration, the largest surface covered by Vuillard. Executed in oil on canvas, instead of in distemper on cardboard, these works by their melancholy tonality recall various little pictures of the years 92-93; even the warm tones are dulled. A sunless day impoverishes the greens and maroons and depresses the whites. In this respect they are similar to works of Sérusier conceived as tapestries. They are not done exactly in black, but in dark green, as La Fresnaye and Segonzac used to do at their beginnings. Greens and the earth-colours prevail, the foliage is opaque, the sky itself of a leaden grey, as though smoky.

In *Les Premiers Fruits*, the centre is occupied by great masses of vegetation, relieved by small figures incorporated in the scene — a child in a pink pinafore, a peasant at his vine. Hills, suggested by those at Etang-la-Ville, close the horizon. We discover them again in the second panel *(La Fenêtre sous les bois)*, which is also diversified by human presence — a peasant returning from the fields, a woman watering geraniums at her window. The austere lighting, notwithstanding, these *verdures* with their measured horizons, their fields sewn one to the other, their little hollow roads, their masses emphasized on the flat work, reserve a character of suavity and familiarity. In this production on the large scale we recognize the painter's determination to avoid dispersion and picturesque entertainment, to tighten up his forms and define his contours.

As Thadée Natanson remarks with penetration in the notice of his collection, one of the peculiarities of *Premiers Fruits*, " is to juxtapose with various parts treated broadly, several ornamental details which have engaged the most meticulous attention of the painter, such as a bindweed in a field or the spotted kerchief of a field-worker in a belt of foliage ". Vuillard was conscious of the law of decoration — to preserve the flat appearance of the wall and to support the composition by means of powerful masses. He sought that support, which had somehow failed him in the *Jardins* acquired by the Luxembourg, in columns of tree-trunks and screens of foliage. Now, to emphasize the essentially decorative character of these large landscapes and to relate them to the *verdures* of the Great Age, he wrought them frames of leaves and flowers, as Puvis had often done. This problem of the " surround " which also vexed Bonnard, was never out of Vuillard's mind. We have noticed his ingenuity in the Vaquez panels in isolating each subject with a double frieze constituted by the coffered ceiling and flower-patterned carpet. Decorating the Palais de Chaillot, at a later date, he used arboreal architecture in a similar way, closing the composition right and left, to open it only on the distance.

La Meule and *l'Allée* date from 1900. They were shown in 1908, and retouched for the first time in 1938. As received by the Musée d'Art Moderne, under the Roussel bequest, they show signs of having been touched up a second time, *La Meule* to a less extent than *l'Allée*. More light has been thrown on to the hayrick, by the side of which a darkly-dressed man (Tristan Bernard) wearing a cap sits crosslegged, listening to two young women seated near him on the grass. The rick takes up a good half of the composition and enlarges the landscape while almost dwarfing the human beings. The scene recalls those calm moments experienced sometimes in the country when the townsman on holiday is drawn out of himself and enters into communion with the earth and sky. That impression was deeper before the women's dresses, together with the flowers and wisps of straw in the foreground, had been brightened. A subdued harmony and a colouring in gold and silver reflecting the overcast sky, procured a mild calm melancholy to a summer-piece such as one sees in Watteau. Once more, it is by the power of simplicity that the painter achieves his end (11).

L'Allée (or *La Dame au chien — Lady with the dog*) is less original, especially in its actual state. A theatrical something has been added to the young woman on the bench (Mme Hessel) and to the hound accompanying her. A violet on the cloak has a jarring effect in the midst of too strident greens. Was it necessary to accentuate the lights filtering through the branches? A preliminary study entitled *Sous-Bois* (Roussel bequest) is more appealing than the final version. It expresses Vuillard's liking for trees, the structure of which he came later on to study more profoundly in an admirable series of pastels.

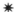

A period of eight years elapsed between these two landscapes and a whole series of panels, several of which were executed for Henry Bernstein in 1908. They are small — 1 metre 95 cms in height by 45 or 65 cms in breadth. Here again, the most has been made of the length. *La Rue (the Street)* is seen from a fifth floor, in the long retreating lines of its pavements, with its unsymmetrical buildings, its roofs, chimneys, balconies, and shops foreshortened. The downward thrust of the design and its animation is not without a suggestion of Bonnard's scenes, such as *La Rue* and the triptych of the *Ages de la Vie*, which Vuillard saw every day on the walls of the Rue de Naples. But the feeling is entirely different. There is no exuberance or dispersion, but a seriousness and an avoidance of the anecdotic require that every detail shall be generalized. The soft pedal is down. We may bracket with these tall panels, the *Tour Eiffel*, *l'Enfant au ruisseau*, *la Voiture d'arrosage* and the curious *Avenue du Bois de Bou-*

logne which is traversed by the diagonal of a pavement starting from below to rejoin the facing roadway.

In these, as in a series of Views of Paris, mostly still in sketch form (Salomon and J. Roussel collections), we must admire the felicity and decision with which Vuillard has reconstituted the diverse skies and the backgrounds of foliage and masonry, as well as the interest lent to foregrounds — street or pavements — the very emptiness and retreating lines of which palpitate under a tempered golden or silvery light. These distempers (12) are so small, resembling the leaves of a screen, without being related to each other, that they can only by a stretch of language be classed among decorations. That description applies more fitly to the five-leaved screen (Henraux collection), to be spoken of presently when we group round the *Square Vintimille* a number of compositions, the theme of which is not less important than that of the key work.

*

The years 1912-13 were in a measure decisive since they witnessed the birth of the two versions of the *Place Saint-Augustin, the decorations of the Comédie des Champs-Elysées* and the *Bois-Lurette* series. Distemper had no more secrets for Vuillard. Like a potter bending over his baking clay, he waited eagerly for the colour to dry and for the emergence of the tones. He knew the fascination of this material and its dangers. If he had a preference, it was first of all for a mattness not easily obtained from oil. Unceasingly, especially in rooms, whether the light is natural or artificial, reflections introduce intolerable contradictions into the heart of an oil painting. Varnish multiplies the glitter. The inequalities of a coarse touch make many a canvas look like a rough sea. All calculations are upset, accents are displaced, effects distorted. On a vast surface, naturally these evils are exaggerated. The use and even the difficulties of distemper protect the painter who from the beginning avoids all vanity of execution, all *brio*, and all showiness as the negation of his native qualities. In the two Place Saint Augustin's, and the Square Vintimille's, Vuillard attains the zenith of his career as painter and decorator.

One view of the Place appears to be taken from outside a café at the corner of the Rue de la Pépinière. At the foot of the picture are seen the usual little round tables, one with a syphon upon it, and overhead, in the top left hand corner, the thin diagonal section of an awning. The place is framed by the blocks of houses between the Rue de la Boétie, the Boulevard Malesherbes and the Boulevard Haussmann. In the distance are the upright lines of the plane trees, arc lights and kiosks ornamenting the thoroughfare. A cloudy sky, the blue showing through, bathes the frontages, the foliage, and the asphalt like watered silk. The shadows lie softly. The

square seems a piece of scenery, or rather a track on which circulate all sorts of vehicles, market-carts, dogs, cyclists, pedestrians and motor-buses.

Yet the picture does not appear overcrowded, because of the empty spaces left in the middle — the empty spaces, dear to Vuillard, and grey as only the Paris sky and asphalt can make them. Corot and Boudin come into one's mind. The sure touch shown in the receding perspective of the avenues, roofs, and balcony supports, together with the stability of the solids (a stability which the majority of the Impressionists could not arrive at), are reminiscent of Vermeer's View of Delft, of Canaletto and Guardi. The suggestion is strengthened by the humid atmosphere and slight evaporation common to Paris and Delft, as by the restraint of a hand careful to avoid any exhibition of its own skill.

This chef-d'œuvre was foreshadowed by the *Cour en Automne*. But in the intervening fourteen years, the artist had made countless discoveries and resolved so many problems, secretly, obstinately, never letting himself be discouraged by setbacks or carried away by praise. This is a classic work in every sense of the word. There is no artifice in the presentation. The syphon ingeniously placed in the foreground and the awning in profile, alone survive of the arrangement dear to Degas. The Japanese obsession has faded out. In the second *Place Saint-Augustin*, the arrangement differs little, but the foreground counts for more (overhead, the same line of awning, below the same chairs and tables). The trunk of a plane tree cuts the picture on the left. Two market carts are drawn up alongside the kerb. On the right, a young woman in a big hat, holds a rose in one hand and her bag in the other.

Vuillard's affinities with Boudin are manifested in the few seascapes he painted, notably in a series of distempers executed on his return from vacations spent at Le Pouliguen and Saint-Jacut (1908-9). Two belong to the Renand collection — the *Port du Pouliguen* and the *Moulin*. Others in a preliminary state belong to the Roussel bequest — the *Plage, Promenade dans le Port*, the *Cargo à quai*, etc. The light beige basis of the paper used for foundation and showing through the pastel and *gouache* lights (Vuillard like Degas fancied this combination), goes to maintain that blond, veiled harmony at which Boudin excelled — as often, too, Berthe Morisot, who is recalled by Vuillard's *Plage, Marée basse, Promenade dans le Port, Fenêtre en Bretagne, le Port par temps gris*, wherein a subdued pearly sky prevails over the fishermen's huts, the calm sea and the quay lined by patient fishing-smacks. These studies, often very much longer than high, were not worked up by Vuillard. Perhaps he thought them too hasty or without sufficient solidity to make them real compositions or what he called a picture. (The word for him had a special significance.

" See" he once said to me, of a great drawing by Théodore Rousseau, " that is a picture already! ") Yet a number of these sketches contain the most precious allusions to the immensities of sky and sea. They are syntheses immediately realized and admirable in their refinement and breadth of execution.

By the quality of the light, so much akin to that of Paris, the Norman coasts (dear to Jongkind, Monet and Boudin) often supplied him with inspiration. He spent several summers at Vasouy and Amfreville, in company with the Hessels, Tristan Bernards, and the musician, Paul Hermant. The villa Bois-Lurette at Villers-sur-Mer was adorned (1912) with seven rustic compositions which bring into play the civilized prospects of the Calvados, half-field, half-garden, impregnated with the smell of the sea. The sea, a mild violet blue, is seen afar off through bars or balustrades. The meadows are green, overhung by foliage. *Sur la Terrasse*, under cover of an awning, two young women converse. Or, a light meal is being served on the shore. Women are sewing in a high glass verandah. Here we have the dining-room and the light morning repast. It may be guessed how much Vuillard was able to make of Bois-Lurette, with its rustic furniture, of contrasting dresses, childlike figures and holiday attitudes. There is perhaps less of the element of surprise in these two panels, which do not exceed two metres in height, than in the garden scenes painted sixteen years before, for Claude Anet. Later retouching has imported rather sharper accents into these landscapes. The light, less filtered than usual, except in the interiors, goes to show, once again, that the summer with its contrasts and profusion of greens, disconcerted the painters of the grey, even in the Norman country. Only the Impressionists, and Corot with them, appear to have got the better of what the last-named called " *le grand tapageur* ".

Le Goûter (more properly, breakfast) escapes these reservations. By a trick familiar to Bonnard and Vuillard, three persons, of whom Tristan Bernard in the background is one, are seen in a mirror above the buffet which reflects another mirror. Their diminished images bear company with three persons at table. Cups, butter-dishes, sugar-basins, tureens and napkins, compose a subtle still-life. The shadows are of the morning. On the white table-cloth, every object weighs lightly. Colours and reflections are but half awakened. The living beings belong to a dream. The picture is infused, unlike other panels, with the sentimental experience of the painter. Vuillard is not merely a guest. We leave Bois-Lurette in his company, to seek other wonderlands.

The public was admitted to see these decorations in the course of the year 1913, at the same time as the first studies of the Comédie des Champs-Elysées. Upon the instance of Gabriel Thomas, Vuillard was called for the first time, along with Bourdelle, Maurice Denis, Roussel, Jacqueline Marval and Lebasque, to undertake the decoration of a public building — the theatre erected in the Avenue Montaigne by the Brothers Perret. Denis was entrusted with a cupola, Roussel with an act-drop, Bourdelle with the walls of a vast peristyle; but knowing Vuillard's possibilities and limitations, and that the more intimate the atmosphere, the more certain would be success, the architects allotted him the charming *foyer*. The architectural setting is thus described by Paul Jamot in a booklet consecrated to the Brothers Perret and architecture in reinforced concrete : " An oblique gallery serves as foyer to the Comédie theatre. It is on a level with the parterre; the audience from the boxes can make use of a large balcony facing the windows. The balustrade is ornamented by interlacing palm-trees. Thus, the elegant and animated throngs above and below offer a spectacle to each other. Above the balcony and above the doors and between the windows, are panels of various shapes and sizes decorated with the works of Edouard Vuillard. These present life indeed, but life with which artifice is naturally combined, since it is the life of the theatre. " " Vuillard " continues the writer, is equipped for this work by his familiarity with the uses of distemper. Distemper, as it seems to me, is to interior decoration what the fresco is to monumental decoration — the one fits in with wood, the other with stone and stucco. "

The decoration of the foyer is composed of two panels, about two metres high by three broad, facing the windows — *Le Malade Imaginaire*, symbolizing the classic repertory, and *Le Petit Café*, symbolizing the modern. Between the windows, two smaller panels illustrate *Faust* and *Pelléas et Mélisande*. Over the doors, are shown *An Actor, An Actress making-up*, and several still-lifes *(Guignol, Flowers)*.

The *Malade Imaginaire* and the *Petit Café* are the outstanding pieces. In them Vuillard for the first time describes action, action of which, it is true, he is not the author. His visual memory, like that of Degas, enables him to re-create in full daylight the peculiarity of the stage, where footlights and limelight supply a substitute for sunlight and, unnoticed, effect transpositions as arbitrary as any painter's. These painted versions of scenery amount, therefore, to a representation at the second remove. Vuillard has followed the example of Degas, who always took pleasure in depicting the Opera dancers in training, ballet rehearsals and performances (French and Russian), *Mlle Fiocre dans la Source, Sémiramis*, etc... Earlier still, Daumier had mixed actors and spectators together in the *Drama*, without conveying of the stage and auditorium much else than a bewildering study of the chiaroscuro. Vuillard saw in the theatre a world of magic and

metamorphosis where all sorts of problems were presented and solved. Instead of the model, he saw the actor, conditioned by the text and the light. Doomed to repeat the same words and gestures, night after night, he poses naturally, obeys the author while pretending to be free and is no more in fact than an instrument.

Vuillard was far from being a dramatist. He was a designer of shades and an accurate observer of determined gestures and attitudes; but he had little taste for action. This, it must be confessed, handicapped him as a decorator. He lacked all that the genius of Giotto, Pietro della Francesca, Uccello, Tintoretto, Rubens, Boucher, Tiepolo, Delacroix, Puvis, even Pietro di Cortona, Guido, Lebrun, and Van Orley, achieved in this field. And yet even in youth, he was irresistibly drawn towards larger canvases, wherein he might expand, although it was precisely in confined surroundings that he was most successful. But the theatre is a confined atmosphere where an open air scene is really but an interior. In seeking inspiration from the drama for the decoration of a foyer, Vuillard followed a long tradition. Great would have been his embarrassment if he had been called on to create a subject, to emerge from the role of spectator and from his common round, and to put in motion a troupe of gods, heroes and allegorical figures. He much preferred the scenario to be furnished by the author and the playwright. So it came about that Gœthe and Maeterlinck supplied him with the only love-scenes he ever painted.

We borrow from Paul Jamot the description of the scene drawn from the second act of the *Malade Imaginaire* : " Cléonthe, his head well thrown back under his wig, sings while strutting and making a leg, dressed in a magnificent red suit — fair, delightful, impertinent, priggish. M. Diafoirus, his feet towards the fender, turning his back to the audience, is hardly visible, while his son, Thomas, perched on a high stool, dark and slender, sees without understanding what is passing. As was done in the first instance by Degas, the lower edge of the picture is cut to show the heads and instruments of the orchestra ".

Paul Jamot is right in mentioning Degas, although the feeling in Vuillard's picture is quite different. He was ravished by the interplay of costumes against an architecture of canvas and boards, fascinated by the tricks of a false light, coming from below or from the sides, which distorted shapes and gave an unreal lustre to the varnish. He resumed each part and fixed the minute of action. The result was a charming transposition of a transposition of life, far removed at every point from any literal interpretation.

Between a dramatic work and a painting, there exist many analogies. The art critic borrowing from the stage vocabulary, speaks constantly of scenes, actions, scenery and figuration. Every painting is, of course,

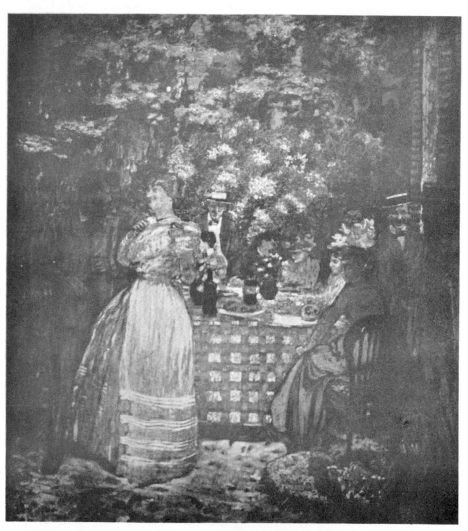

Lunch in a Normandy Garden (1898-1936)

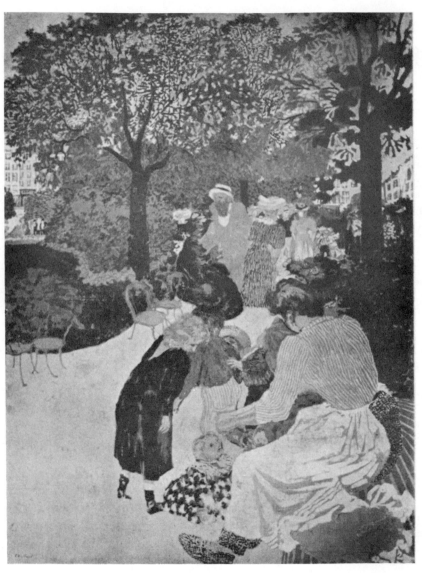

Public Garden (1894) — *Decorative painting*

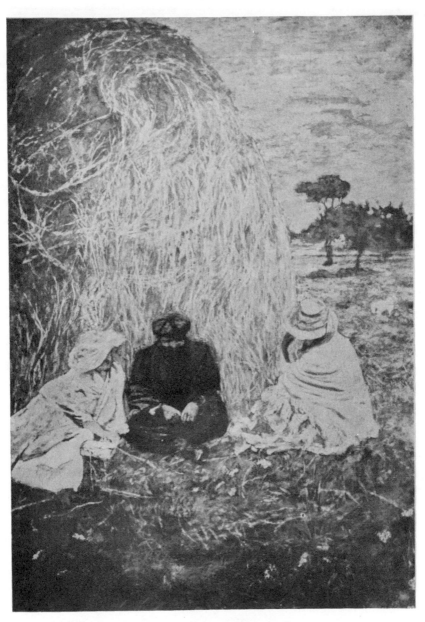

Under the Hayrick (1900, 1938)

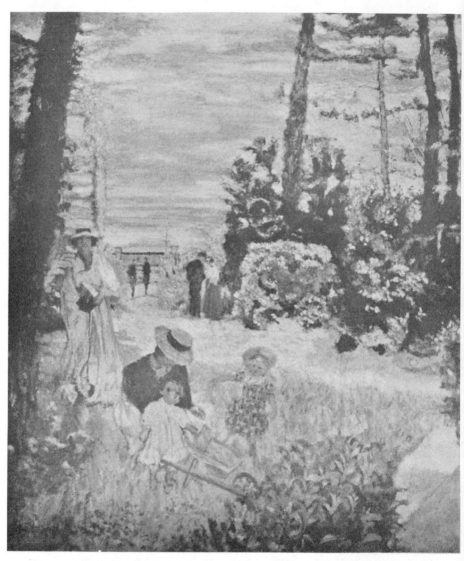

In a Normandy Garden (1898, 1936) — *Decoration for C. Anet*

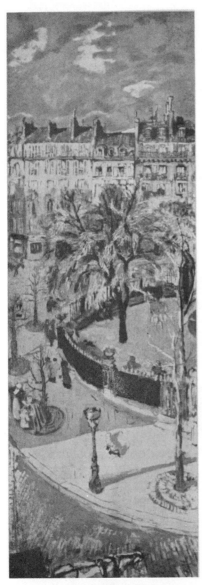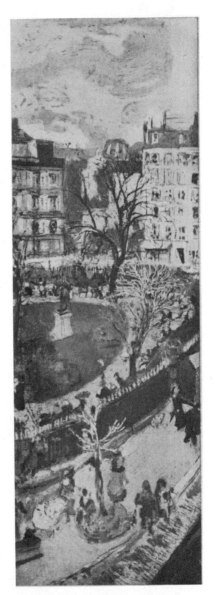

Square Vintimille (1908) — *Decorations for Henry Bernstein*

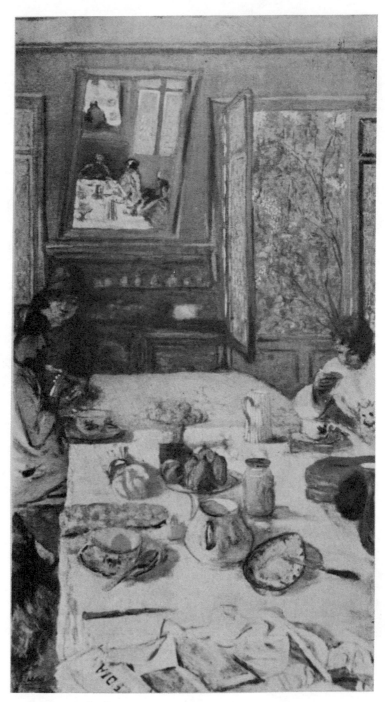

At Tea (1913) — *Decoration for Bois-Lurette*

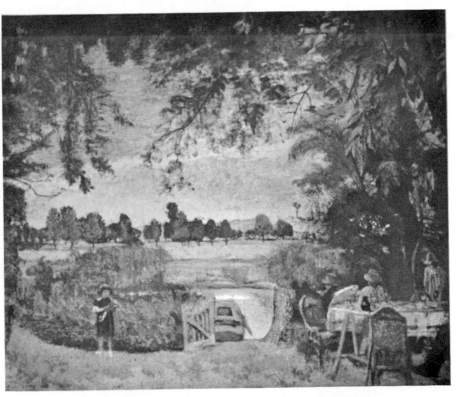

Tea by the waterside (1913) — *Decoration for Bois-Lurette*

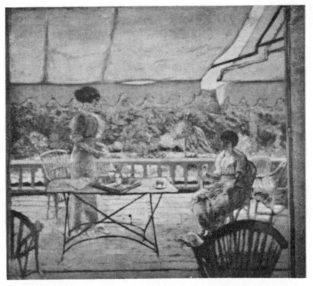

Two Women on a Terrace (1913) — *Decoration for Bois-Lurette*

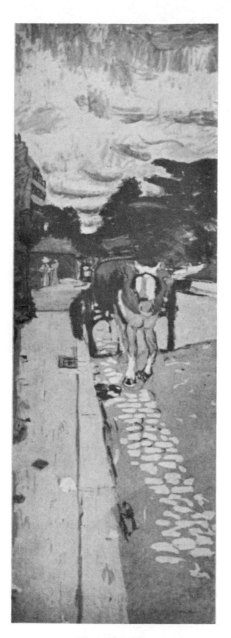

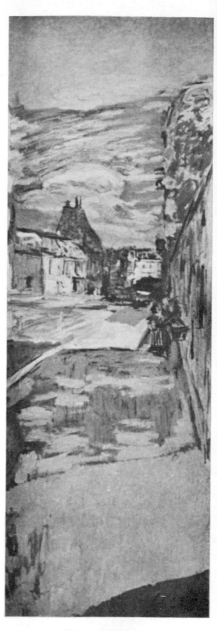

View of Paris
Decorative scheme for Henry Bernstein

View of Paris
Decorative scheme for Henry Bernstein

a spectacle. But here we are concerned with the spectacle of a spectacle, and it is the task of the painter not to communicate the illusion of real life, which is the business of the actor and the producer, but to explain that this is the rendering of a representation — of a purely artificial performance, in an unreal light, an unreal enframement, assisted by disguises and made-up faces. To this Vuillard applied himself; not only by framing this fictitious window revealed by the act-drop and evoking an auditorium by means of two rows of inclined heads, but also and above all, by stressing the attitudes, by startling high lights on the faces, by extravagances in the drawing, by means of a colour which is dissonant and sometimes false, but loyally and captivatingly false.

The *ingénue* and the singing *jeune premier* (Germaine Defrance, Bertin), gorgeously arrayed and exuding love, are in contrast with the angular and funereal Diafoirus (Desfontaines), an Argan not less sombre, the *Malade* disguised as a spectre (Vibert). In front of one of the wings, a young· servant is posed like an artificial rose. High lights, here and there, relieve Thomas' collar, a pen on a writing-desk, Cléonthe's hands, a cotton bonnet, the calf of a leg, the nails in an armchair. These devices are the dialogue, the painter's retorts and reparties. He takes pains to emphasize the structure of the fireplace, to bring all these grey fields lit by the footlights, into harmony, and to contrast their nudity with the ornamentation of a glittering ceiling. This is very great art.

Not less charming is the interpretation of Tristan Bernard's light masterpieces. Once again to quote Jamot — " The exaggerated luxury of a fashionable café is brought into comparison with the solid and discreet elegance of a bourgeois interior of the seventeenth century. The unbalanced lines twist and turn in a medley of colours. The yellow of nougat is associated with the pink of a galantine. An architecture of comestibles! " The black coats of the men are set off by the brilliant gowns of the women. Couples are seated at overloaded tables. Young men, coquettes in decolleté, old men with long whiskers make up a menu full of humour and spice.

The meeting of Faust and Marguerite and the fountain scene of Pelléas are far from possessing the same intensity. If the landscape and the mauve of Mélisande's dress strike us as artificial, I know it is to remind us that it is moonshine and the dress is an actress's. Though closer to Molière than to Maeterlinck, paradoxical as it may sound, Vuillard is intimidated by Gœthe. The intimist, inspired by comedy and not by drama, and dreading grandiloquence, has painted these scenes as scenery. On the other hand, he is his old self again in two charming medallions, representing his old friend Lugné Poë and Suzanne Després making up, as also in a *Guignol* and two floral pieces.

The Bois-Lurette and Comédie decorations came as a surprise to many critics who had not seen the *Jardins Publics* nor the Vaquez and Claude Anet panels. By this time, the authorities ought to have been aware that Vuillard should be entrusted with designs for the Gobelins or Beauvais. That idea did not penetrate official intelligence. The problem of wall decoration was in Vuillard's very blood. He had never ceased to dream of tapestries and wall-papers and to express his admiration for the craftsmen whose business it was to interpret the cartoons of Van Orley, Oudry and Boucher. Had he been commissioned by the state, no doubt he would have remained faithful to the spirit of transposition, developed to so high a degree in work done for his friends.

This transposition is less evident in the Théâtre des Champs-Elysées. There we see, according to Pierre Hepp's expression, a reaction against " le compromis tapissier et le japonisme à bout de rôle "; but, to cite the same critic who translates Vuillard's thought very accurately and more or less in his own words, what the painter aimed at was " translating what had been merely fugitive indications into formulas, and devising a rhetoric for himself ". This last was certainly his ambition. Given the opportunity, his victory would have been certain. But for want of walls and commissions, he had to beat a retreat. Portraiture monopolized him and therein he sought to satisfy his classical aspirations. Portraits offered consolation for the decorative work which passed him by; they expressed his scorn for a public which would have condemned him to repetitions and shut him up in easel-painting as in a gilded cage.

Meanwhile, he amused himself with compositions which frequently never went beyond the preliminary stage, but which by their size and number tell of his hankering after wide surfaces. Not much importance can be attached to the great oval executed in 1917 for a tea-room, reflecting its bustle and glitter, but the same year witnessed the birth of a masterpiece — the *Square Vintimille* (Kapferer collection).

That particular spot had long been for the artist *un lieu de prédilection*. We notice it for the first time in 1895 in *le Square aux nourrices (The nurses' square)*, which he overlooked from the top of the Rue de Calais from 1908 till he went there to live, twenty years later. Earlier by nine years than the great picture in the Kapferer collection, a five-leaved screen, a ravishing work very oriental in conception, belonging to the Henraux collection, surprises us by the red tints of a chestnut tree in flower against the green. The 1917 picture differs little except that the execution of the design shows a still surer hand.

The secret of this notable success lies in years of familiarity with the scene, strengthened by daily communion. For this urban landscape is a

portrait, only to be compared with the portraits of the few people whom Vuillard most cherished and in whom he never ceased to discover, whether they were absent or present, an inexhaustible source of meditations and conclusions. In this tiny square, similar to so many others, with its railings, its paths, its bushes, its imprisoned chestnut and plane trees, its lamps and its statue, all Paris is resumed as a son's affection is resumed by the traits, similar to so many others and yet incomparable, by that immense and limited universe, which is the face of the mother.

To describing it in a light which resumes all lights and is so to speak the eternal light, enriched with every singularity and accident, Vuillard has devoted what was best in him. And as always happens when such a communion is achieved, whether it be the portrait of his mother or of the little Montmartre square, it is his own portrait the artist has drawn.

Into the final design has entered a circumstance which upsets the normal scene or more exactly brings out the contrast between the natural and the human elements, between the serene play of the light on the vegetation and the turbulence of the foreground, showing a roadway under repair. On the observer's side of the garden wall of stone and iron, a huddle of objects — spades, tubs, wheelbarrows, sieves, funnels, bags of cement, paving-stones, joists, tarpaulins, palings — oppose their planes and values, whilst, directed by a foreman, a gang of labourers, bending over their work, explains the meaning of these pacific barricades. Here is an organized disorder, a symphony of cold and chalky tones, delightful in their harmony and diversity, an unexpected explosion of animation; the whole giving full value to the friendliness of sky with house, of tree with path and of path with statue, to the glamour of a day like so many other days, to the prodigies of the fine season, to the warmth of the greens suspended in space, to the pleasing brightness of the repainted house-fronts.

This square has in itself nothing remarkable. Its name has no particular significance. The surrounding houses are of no special style. Only children and old pople resort here to enjoy a little fresh air and the illusion of the countryside. No painter had hitherto chosen it for a subject; nor would Vuillard, had it not been the garden he saw from his windows, the garden of his life, on which he had seen thousands of suns rise and set. It is enough for us that it assumes unwonted proportions and is invested with a poetry lacking to the most famous sites (14).

The two long panels of the Bernstein collection, several sketches of which are in existence, form one picture cut into two leaves. In intensity, maybe they surpass the great Kapferer panel. The square is seen in fine winter daylight, which mixes its gold with the grey tints, refines the articulation of the trees and shrubs, opposes the cold green of the lawn anb the

dead black of the railings to the sunlight caressing the roadway and the housefronts. The landscape vibrates from the ground to the sky, thanks to the design and colour, and the whole possesses the resonance, although the theme is so different, of the finest Canalettos. Not in the Place de la Concorde, not in Notre Dame, not on the quays of the Seine, does he find inspiration, this man of sedentary habits who makes discoveries only in the usual and everyday things. He is only at his ease in certain rooms and with familiar faces; outside particular districts, he is no more than a visitor. When he ventures abroad, he still seeks the protection of the walls.

These squares, with their blocks of houses, their usual furnishings, their ceiling the sky, are so many rooms. As lovingly as he defines a doorway, a wainscot, a retreating corridor, or a pattern on the wall, Vuillard analyses the modulations of the shutters, the light projections of the balconies, the irregular profiles of the attics and chimneys, or the changing shadows on the floors of gravel or asphalt. As he excels in setting a table with napkins, glasses and nosegays so he studs the Place Saint-Augustin with carriages and passengers and the Place Vintimille with arc lights and benches, the statue of Berlioz, groups of people and buildings.

By means of blended colours — light, almost friable, tints, messengers of harmony and stillness, ochres, ash and slate blues — Vuillard sets the Ile-de-France before us. He suggests a moist and temperate space, to which violence and harshness are foreign; haziness together with excessive precision. He is lifted above the impression or the anecdotic by a creative memory which liberates him from literal imitation and enables him to reconstruct everything in the religious calm of the studio without being disturbed by the movement of wayfarers and the inconstancy of the sky.

The little picture in the Renand collection dates from 1920. A woman in black, seated by her child in white, is shadowed by a chestnut tree. This time, we are in the centre of the garden, on a level with the ground or the bench. But there is the same harmony as in the large pictures. Through the foliage we perceive the houses, gilded by the calm light of Paris — the light which impregnates the pink-grey soil as it does the grey housefronts and so many of Vuillard's interiors and studies of his mother at work by the window, harmonizing with the silvery grey of hair, the ambered grey of a hand or a cheek, the lovely grey of a glance. The matt blacks and banal ironwork of a balcony are relieved against a background which seems quite close or against the inequalities of a neighbouring wall. The street or the yard has the air of a second room or of its prolongation. This interpenetration of the interior and of the open air is not effected only in the innumerable scenes painted in the Rue de la Tour, the Rue de Calais and the Place Vintimille. We have only to look at the part played by the landscape in such commissioned portraits as Bénac's (in which may be

distinguished on the right that marvellous glimpse through the window of trees outlined against a background of masonry), as Dr. Viau's, and as Malégarie's, where the bristling roofs of Paris are shown through high windows like a frieze against the cloudy sky.

Belonging to Vuillard's own neighbourhood, may be counted three pastels in gouache suggested by the *Demolition of Number* 28 *Rue de Calais* (1909) (Roussel bequest) and above all, three sketches in size-paint *(La Petite Place and Le Sacré Cœur)*. From the interior of his room, he has painted an exceptional *nocturne* — the window is wide open, the facades are splashed with gold, on a flaming red sky funereal rectangles are traced (15).

✳

We have insisted on Vuillard's sedentary habit of life. So, among his landscapes, we find few corresponding to his portraits of the fashionable world. Ill at ease even in Paris outside his own neighbourhood, he was all the more a stranger in the course of his occasional travels — to Holland, Spain, England and Italy — where he had not the time to get into communion with new horizons. Nevertheless, while enjoying the hospitality of friends in the country, he procured himself the illusion of home. He established a kind of harmony between himself and the scene. These exceptional conditions were found at Valvins, where he painted *La Maison de Mallarmé*, two or three times, in the subdued harmonies which recall some works of Degas; also during his long stays with Thadée at Villeneuve-sur-Yonne (1897-99), in that Burgundy, so dear to Sisley, where the sky is as kind as in the Ile de France *(La Barque en Automne)* — at Honfleur, again, on the Channel coast *(Barques et Vapeurs)*. More exceptionally, still, in 1900, he found himself, in the course of a visit to the South, painting *la Terrasse au bord de la mer à Cannes, Mont Chevallier* and the *Jardin au soleil* and, further north, a view of Lausanne. But he felt himself very much more at home in the neighbourhood of Paris, notably at l'Etang-la-Ville, where he often used to go painting in company with Roussel. Here he achieved his view of Saint-Germain-en-Laye (1900) and the lovely landscape in the Carle Dreyfus collection — where the silhouette of a house opposes a view of flowering orchards and distant hills to the mattness of a roughcast wall.

✳

We shall close this parenthesis devoted to easel landscapes by returning to compositions on the large scale. Gardens are the theme of several : Norman gardens (Villiers, Villerville, Villa des Etincelles), the Vaucresson

gardens *(Clos Cézanne)* and the Parc des Clayes. A garden-even uninhab-
ited, tells of man; a parasol, an arbour, a rosery and a garden path, even
deserted, suggest a presence.

The Clos Cézanne is happily composed (1924), with its framework of
arches and background of sunlit verdure, its tall rose bushes and sky like
watered silk. Athis and Mme Hessel are shown on two benches, facing
each other across a gravel path. This is one of the rare compositions in
which summer triumphs, dispersed and many coloured. In spite of retouch-
ing (1937), the canvas preserves its harmony.

Many intimates and large portraits are framed in verdure, onwards
from the portrait of Mme and M. A. Natanson (1907) to *The Woman in
white with a child and a dog* in a sunlit garden, a vast and sonorous distemper
(A. S. Henraux collection), *Mme Kapferer and children, Mme Roussel and
children, the children of David Weill, Children in the garden* (Roussel
bequest) etc. Vuillard supported his portraits with high masses closing
the composition. A tree introduces an element of quietude and dignity
even into the most homely background. Surveying these well laid-out
parks, we sometimes find ourselves regretting those gardens of the *début* —
familiar gardens, studded like the meadows with simple figures and tangled
elements. But that should not render us insensible to the solemnity
characterizing the productions of ripe age, as sincere as the audacities, the
turbulent charm and the unexpectedness of that earlier time.

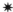

Trees are a very important element in the decorations which, very late
in the day, were commissioned by the state. The credit of helping all
artists, yourg or old, capable of participating in the revival of mural
painting, belongs to the director, Georges Huisman. The exhibition of
1937 will no doubt be renewed, thanks to the assemblage of painted and
sculptured works which decorate the Chaillot theatre and the new museums
in the Avenue de l'Alma. Admittedly, the architecture of these edifices
is in the most questionable taste, but the monumental statues of Maillol
and Despiau and the decorations of the new theatre, show that a coherent
programme was arrived at, in spite of obstacles. The results of this
programme, which exceeded the scheme of the exhibition, were submitted
to the public when the work commissioned by the state was put on view
at the Ecole des Beaux Arts. No decorator worthy of the name was
forgotten. Vuillard, Denis, Bonnard, Roussel, Dufresne, Dufy, Boussin-
gault, Waroquier, Moreau, Brianchon, Oudot, Chastel — they were all
there. Some, put at the foot of the wall, admitted their limitations.
Others, without achieving a complete success, were encouraged to do
better. Youth could ponder what examples to follow or not to follow.

The beneficent state had no reason to regret having provoked the competition.

The Théâtre de Chaillot, unfortunately, offered only badly lighted spaces to Vuillard and his colleagues. Wide though the corridors were, they did not afford the spectator a good point of view. Nothing seems to merge these great panels in the wall. A frigid atmosphere pervades this colossal and inhuman palace. Bonnard's composition is a fairy scene but the statement is confused; Roussel, however, is in his best mood; as to Vuillard, his is a great square mural in which the greens borrowed from the numerous Les Clayes pastels serve as a background to the " idea " of the persons grouped downstage. I say stage, although this is not, like the Champs Elysées panels, a definite representation, but pictures a ballet imagined by the painter.

For the first time, one might say, we see him here entirely obedient to his caprice. More exactly, an indistinguishable action is introduced into a fancied landscape of great trees and sunlit perspectives, forming a natural backcloth. In the green shade of the foliage, we descry strange shapes. Is this one Scapin or Figaro thinking out some prank? Where are they going and whence do they come, these dancers with tiny butterfly wings, one of them on tiptoe? Vaguely we perceive a symbolical ape, admiring himself in a mirror beside a mossy basin. This fountain separates two groups — on the right, Titania with her ass, on the left, a little marquis, very much of the Dehelly type, leans towards an ingénue (Agnes, perhaps, or Celimène). Two hamadryads, growing like terminal figures out of their trees, flank the sides of this rustic interlude, which is lit by unseen footlights in the foreground.

Vuillard had no genius for allegory. But the feebleness of his purely imaginative creations is redeemed by their effortless blending into this symphony of greens, the darkest and the most tender, which at the summit become ornamental motifs, free patterns, clusters of foliage. The work is in the best tradition of mural painting. It is at once a composition, airy and enclosed on all sides. It is a flat scene solid as the wall and an entertainment with no pretentions to reality.

Vuillard, at all events, appears to have been satisfied with this work. He looked on *la Comédie* as a prelude to other compositions, to be enriched by means of formulas which he had recast, a vocabulary and a rhetoric — to quote his own words. He soon had the opportunity. He was entrusted with the decoration of a large surface in the assembly hall of the League of Nations at Geneva (17).

La Paix protectrice des Muses (Peace protecting the Muses) — this title might have been borrowed from Delacroix or Puvis. It was of Puvis that Vuillard often thought when, so near death and perched on a scaffolding, like the masters of old (a fact which filled him with pride and anxiety), he

fought against fatigue and difficulties of every kind. On so large a scale was the composition that he was only able to execute it piecemeal. Not till it was put together at Geneva was he able to judge it as a whole. For the first time he dared to resort to allegory and go outside his repertory, borrowing from his beloved Lesueur the divine figuration of the Hotel Lambert, and dwelling on the august summits of Parnassus — he, a dweller on fifth floors in Montmartre, the painter of household suppers!

The colouring generally is suave. To fit his frescoes to the edifice was the chief preoccupation of Puvis, who, it is said, always kept by his side, a specimen of the masonry he was decorating. Such, also, was Vuillard's care. Soft tones prevail here — light tunics, ground, a limbo of clouds from the midst of which, the presiding figure of Peace scatters benedictions on the field below. In the centre are three Muses, seated and draped, after the manner of Puvis. Euterpe stands with one hand on her theorbo, with the other beating time — somewhat stiffly. We have a back view of a slim and somewhat colourless Clio. Thalia is even more conventionally rendered. The best part, undoubtedly, is the colonnade of trees, before which passes a procession of youth. There we find the true Vuillard, much more truly than in the mythological emblems which he describes without much conviction or with the tinsel furnished by the property room. This is not his style. This rarefied air isn't the atmosphere of his home. To put life into these fictions, he would need the gift of illusion which he does not possess. Unfortunately what he cannot extract from memory and experience, he tries to borrow from history, from Poussin or Lesueur. Surely, it was too late in the day for him to expatriate himself. Nevertheless, he must have exulted in the execution of this great commission. He had dreamed so long ,with eyes fixed on the Great Age, of escaping from his own, of risking all and sacrificing his normal aptitudes to higher requirements. Was he satisfied with the result? Satisfied, perhaps, he never was. I believe, all the same, he was pleased to have sojourned with the gods. The palace of the League of Nations was indeed a palace of illusions and the subject selected by him was soon to possess a tragic irony. And there Vuillard in his turn offered sacrifice to the noblest and most generous of illusions — to escape from the real, to exceed the limits of one's own strength, to achieve the impossible.

Death forbade other attempts which without doubt would have been enriched by the experience of *La Paix*. In the winter of 1940, Vuillard was working on a large decoration inspired by a visit to Les Clayes. The writer showed him some of Théodore Rousseau's designs and he praised the powerful structure of the ground, trunks and branches. To the walls of the studio were attached several full-length compositions begun at Les Clayes, among them *Le Jardin hivernal au Paon (Garden in winter and peacock)* and *les Pintades (Guinea-fowl)*. He commented now and again,

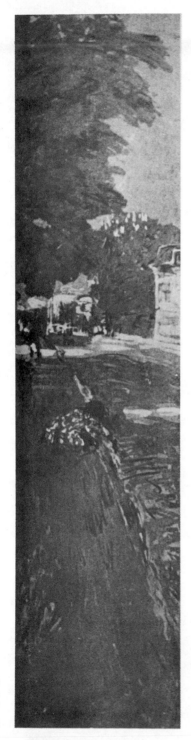

View
of Paris

*Decorative
scheme for
Henry
Bernstein*

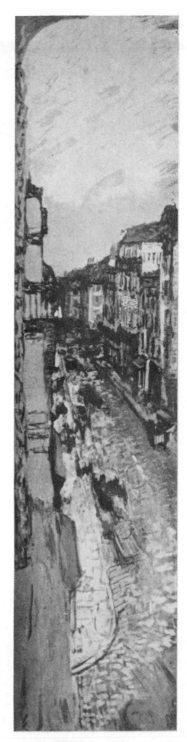

View
of Paris

*Decorative
scheme for
Henry
Bernstein*

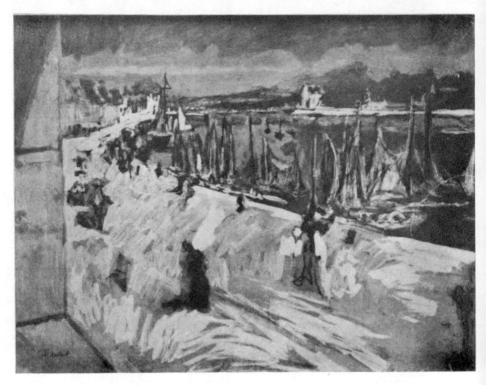

View of Le Pouliguen (1908)

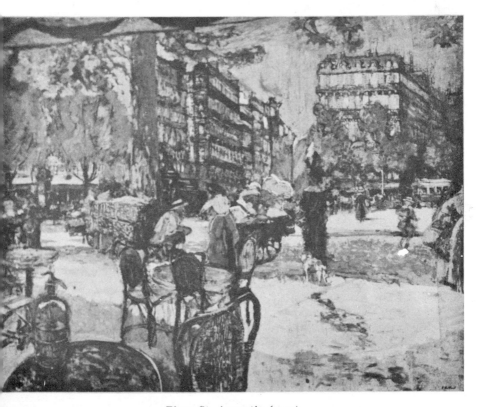

Place St. Augustin (1913)

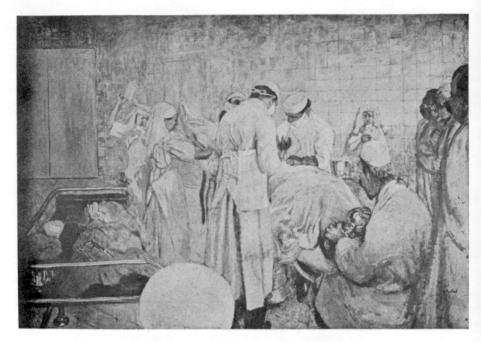

Dr. Gosset in the Operating Theatre (1912, 1936)

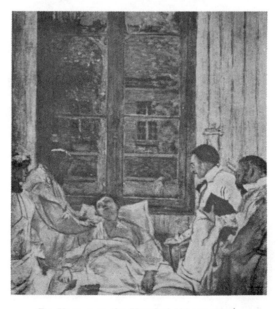

Dr. Vaquez at the Hospital (About 1921)

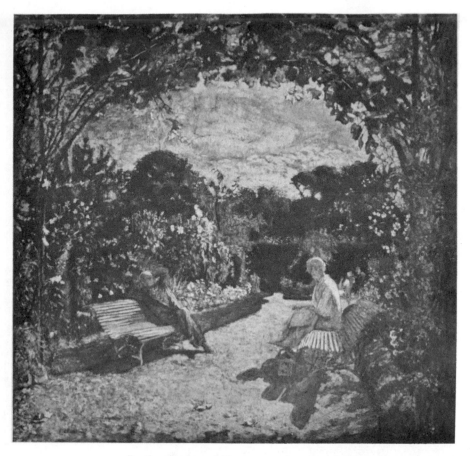

In the Garden at Vaucresson (1923,1937)

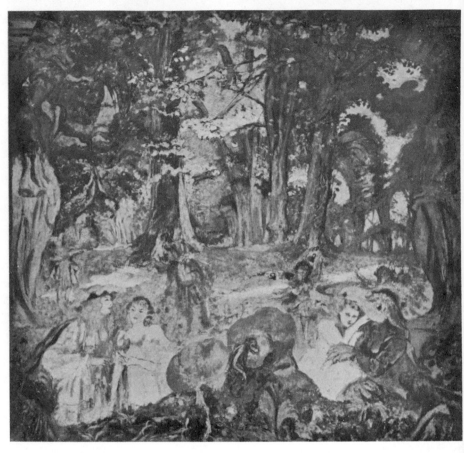

Comedy (1937) — *Decoration for the Palais de Chaillot*

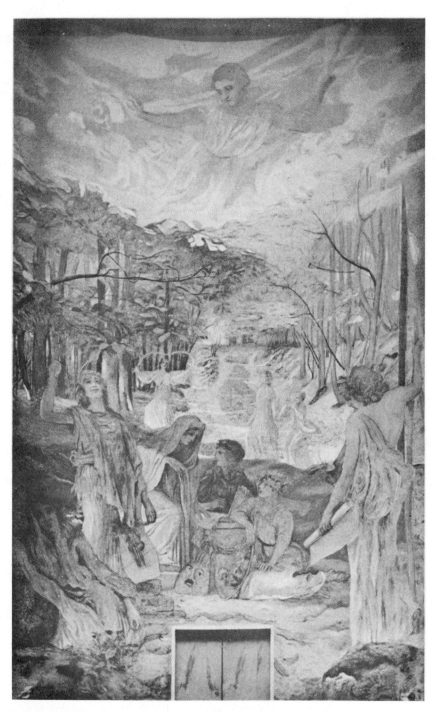

Peace protecting the Muses (1938) — *Decoration for the Palace of the League of Nations*

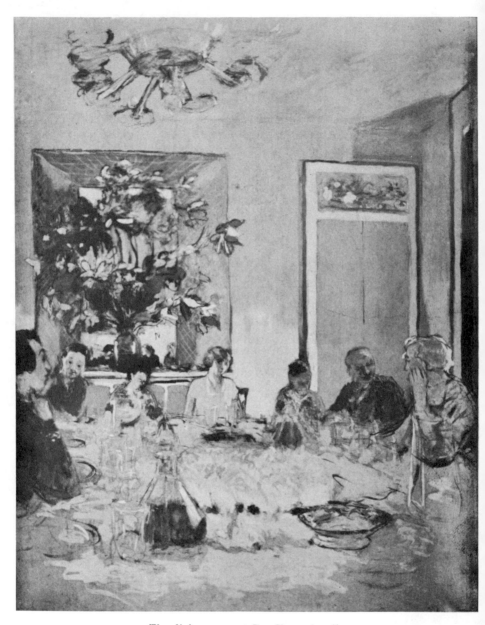

The dining-room at Les Clayes (1938)

On opposite page: Le Petit Café (1913) *Decorative panel for the Comédie des Champs-Elysées.*

On opposite page: Le Malade Imaginaire (1913) *Decorative panel for the Comédie des Champs-Elysées.*

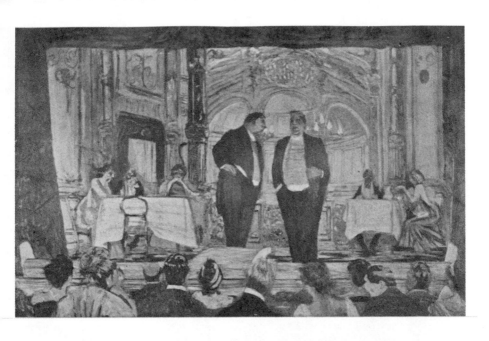

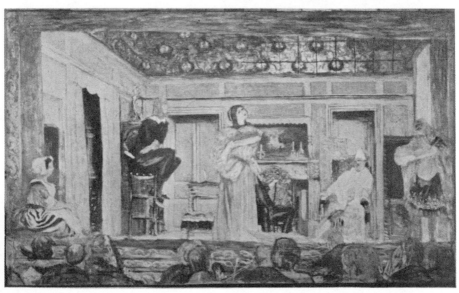

with a sad vehemence, on the errors and weakness of our time, of Puvis, of Lebrun, of Maurice Denis' last book on religious art. Seated on an old divan, his leg bent back, from time to time his hand went to his side or nervously stroked his beard. His heart already gave signs of failing. The approach of the catastrophes which threatened France paralyzed his work and thought. He closed his eyes, shook his head and fell into a profound melancholy. To that he succumbed some months later, far from Paris. Whatever Giraudoux may say, he was a war casualty.

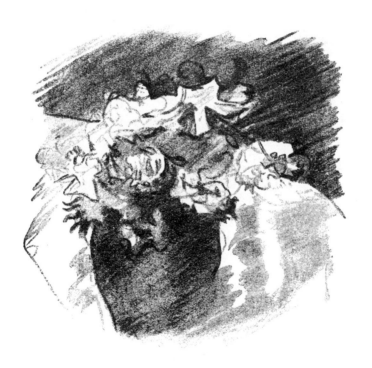

VISUAL MEMORY
AND
ORGANISATION
OF THE
PICTURE

The revolt from copying nature. — Handling the work. — The completion. —
Vuillard's methods. — Sketches, pastels, engraving. — Foundation materials. —
Paintings in oil and distemper. — The principle of harmony. — Return
to the visual world.

Upon entering the Académie Julian and the Beaux-Arts, Vuillard and
Roussel expected a discipline, a direction, and a method favourable to
the development of their talents. They little knew into whose hands had
fallen the once sacred mission of transmitting a tradition or realized the
indifference of all the schools of art, private and public. The vulgarity and
the meanness of these places would soon have disgusted them with painting
had they not as by a miracle, found saviours — Gauguin, in the first
instance, through the medium of Sérusier, next, Maurice Denis, who, in
spite of his youth, was able to make clear all that which his friends saw
only confusedly. At the age of twenty, Vuillard was delivered from the
torpor of the schools. The most diverse problems were feverishly discuss-
ed, all sorts of solutions contemplated. False axioms and prescriptions
were utterly rejected.

It took them no more than six weeks to discover that never a useful
counsel would come to them from the lips of Gérôme. With the exception
of Gustave Moreau, none of the professors, or rather functionaries, dreamed
that his one business was to be a connecting link, a bridge, between his
pupils and the masters of the past. For these craftsmen, without brains or

faith, painting had but one object — to imitate blindly appearances, to give the illusion of relief, and to impart depth to the form. They daubed and daubed — they copied as they copy to-day (methods, alas! have not changed much) works of the worst period, stale by repetition and spoiled by the lighting. Professional models, posing as in a Comic Opera, presented their anatomy as the ideal. The students went on drawing without ever asking themselves what is a form or a contour, without ever suspecting that the hand has the right to choose between different methods, one as legitimate as the other, or between different " styles " in use since the Stone Age. To paint, according to these teachers, consisted solely in the application of a set of formulas. It was to do this or to do that without any assertion of the student's personal sentiment. The chemical, mathematical and physical part of the art, which at least might have formed the basis of instruction, was not less neglected than general culture and spiritual formation. Geometry which presides over the different modes of composition, the science of proportions and numbers, the choice of material to work on, the art of preparations, the laws of the complementary, the peculiarities of each technique, the notions of warmth and cold—how could this be taught by the dodges employed by Gérôme?

Instinctively, Vuillard realized from his earliest efforts, the sense to be given to the words *value* and *composition*. His wise frequentation of men and things — as Degas said in speaking of the Louvre — helped him. Above all, in himself, he discovered very soon a fund of pre-existent truths, which enabled him to resist all tyranny from outside and disorder within. Honest and lucid, even when impassioned, proceeding steadily and prudently, he was not to know, as so many others knew, any tragic conflict between his sensibility and his reason. Organization played a great part even in his earliest still-lifes. But he felt he must define and fathom what was as yet sketchy and guessed at. The fermentation of art during the period 1890-95 and the intellectual orgies to which his comrades abandoned themselves, helped him to get over ground quickly and at thirty years of age, to arm him with an intellectual and a manual method.

✳

A capital difference is to be noted between the still-lifes antecedent to 1890 and to those that follow. The schools — and for that matter, the Impressionists — held that the work began in front of the model — the object, figure or landscape, as the case might be. There could be no success without verification at every point. In revolt against this servitude, the great spirit who formed Cazin, Bracquemond, Fantin, Legros and Rodin, had enjoined a teaching based on the cultivation of the visual memory. Influenced, no doubt, by some unknown disciple of Lecoq de Boisbaudran, Gauguin decided that he would do without the model. He denounced

the *Copiez bêtement* which was then all the rage. " Even in presence of nature " said Gauguin, " it is our imagination that makes the picture... The artist is discovered by the quality of his transfiguration. Observe, " said Gauguin, "then paint from memory and correct the real perspective in order to make it believable. " Surely, that was the method in the great ages. Ingres has written : " Paint without the model — you must remember that your model is never the thing you wish to paint, neither in design nor in colour; but you cannot do without him. If you go on painting not after nature but after your model, you doom yourself to slavery and your work will show it." And Ingres often quoted Poussin: "It is by observing things that the painter progresses, rather than by copying them. "

If we are to believe J. E. Blanche, Degas, while staying at Dieppe dissuaded Sickert from following nature, while Whistler and the Impressionists said exactly the contrary. Cazin, Lecoq's pupil, almost always painted only from sketches. To quote Denis : " It was on a cigarette-paper that Cazin at the deathbed of Gambetta noted the traits which enabled him afterwards to paint the great tribune in full detail and with scrupulous accuracy. "

For the insurgents at Julian's, Gauguin was the hero of the resistance and the liberation. They knew by what means, Puvis, one of their own gods, while adoring Nature, learned to escape her dominion — how Odilon Redon finding the Impressionists *trop bas de plafond*, and inspired by Bresdin, sought in reality only a leaven, to be sustained by what he called imaginative logic. In the same way, Cézanne has said that we must not copy light but find an equivalent for it.

So these young men came to feel themselves delivered from the odour of the model and its concomitant meannesses in the schools. To work from memory became the first article in the new credo. Since visual memory, like other memory, must be cultivated, why had it been left for half a century fallow? There, indeed, we have the origin of the decadence in our arts. Take away the support of the real from the majority of our contemporaries and they will be thrown off their balance. No revelation helps them — neither design nor colour is registered in the dark room of memory. Technically, they are beings in the literal sense, to whom the present alone is experience, who believe only what they see and what they touch. At times they give forth marvellous echos, but like all echos they are bound to reply immediately to the summons of the subject.

Vuillard was privileged to possess in the supreme degree the gift of preserving the precious sediment deposited by things — an imponderable substance which is a forecast of the picture itself. The rapture of living by the eyes, of assisting at harmonies, at the innumerable contrasts of tones, lines, shades, far from becoming extinguished at the fall of the day

or the bend in the road or with the flux of time, goes on and on and is re-born free from accident and every impure element.

At first, Vuillard drew his inspiration directly from a face or a fortuitous collection of objects. The day came when he realized that these when no longer visible, remained at his command; that he could not only evoke their peculiarities or general characteristics, their lasting or fragile aspects, but that he was able to invest them with a second life and project them outside himself conformably to laws and rules and make of them the enduring creations of the mind, instead of creatures of chance and improvisation.

This new method did not indeed enlarge the field of his experience. It permitted him to remain always more constant to the things he loved. It demanded more and more capacity for visual pleasure, a preliminary attention, a condition of receptivity, a state of grace sustained by exercises and unbroken communion. Lugné-Poé in his Souvenirs represents Vuillard as " always reflecting on and attentive to the colour of silence and the tone of the shadow ". Every one who approached him, noticed how deeply he was absorbed by the essential activity of the artist — the registering the situation of objects, the relations of tones, lines and values, comparing, opposing, connecting, limiting, suppressing, exalting, dissociating and confounding. Never was he more attentive than when he appeared distracted or enjoying leisure. It is too often forgotten nowadays that the decisive moment in artistic and literary creation, is not when the hand sets to work but when the mind conceives and discovers.

How many artists, like hunters in ambush, wait for the moment when the image shall present itself and some unforeseen quarry shall emerge from their conscious or unconscious to capture their skill! They lie in wait for an idea or an event. Their discoveries surprise them. Not so, Vuillard. The customary was his domain. He took his stand on things of everyday, on experience, that is to say on an interior reality already captured, on the things seen before and lived before. He knew how that stretch of wall received the light, what line this perspective took... how dense was that solid, the sympathy of one shade or inflection for another. All this was written in his mind. He could paint it all in the dark with his eyes shut. He needed to call on nature only for some confirmation, some detail, to fill some gap in his memory as the novelist at moments needs to recall a word or act of real life. Vuillard's was a closed world, limited, certainly, but always available and always new. It was always new, for to live, for him, was to compare a perception with an anterior perception and to note differences too subtle for other eyes. His subjects are repeated as one repeats the gestures of love and friendship, the explanation of which is loyalty.

VISUAL MEMORY

There exist several versions of a canvas showing Mme Hessel and her daughter seated in their dining-room in the Rue de Naples. At first sight they might be confounded. Looked at attentively, it will be seen that the light plays differently on the objects, faces and walls, that the jug and the bottle have no longer the same density, that the reflections are displaced, that a slight change of standpoint has modified the proportions and perspective. Anything apparently copied from life had been transformed and reinvented. (18).

✳

Vuillard's memory retained only a limited order of facts or sensations. It was highly specialized; above all, a memory of colours. Hostile to movement, agitation, to tragedy as to gaiety, a stranger to passion and to all that might upset his balance, Vuillard very seldom went contrary to his nature. Even to the last, he does not seem to have suffered by his limitations. In them consisted his modesty and circumspection. Stoical in manner, concerned to deal only with the things belonging to him, he was satisfied with a field which he cultivated intensively.

We must the more insist on the voluntary, organized and considered character of the work since everything in it that is charming and subtle is conducive to misunderstanding. Vuillard's smallest picture satisfies the mind by its stability. We find in it none of those hesitations, those timid approaches, so common among painters who blur, subdue and elude, under pretence of creating an atmosphere. Here the refinement of the vision is not all. These calm appearances and this mask of suavity hide the mind of a master. The lay-out demonstrates the sway of a skilful system of verticals, horizontals and obliques. Vuillard's concern for organization recalls that of Seurat, though it is less dogmatic than that seen in the *Poseuses* and the *Grande Jatte*. The painters do not seem to have known each other. Vuillard afforded hardly more than a glimpse of his work at the Indépendants; Seurat died in 1891 and only became really known at the Revue Blanche Exhibition, nine years later, but profound affinities are to be discovered in their vision and in more than one characteristic.

This lucidity in the handling of a composition often passes unnoticed. To declare a work exquisite is but to content oneself with a vague expression. Vuillard's taste was undoubtedly unerring. His eye was endowed with a marvellous receptivity. But we must not forget that all these harmonies which appear to have been simply noted as he went by, were recovered and re-created in the active laboratories of memory where the real is decanted, sensation purified and imitation, far from being the jaded rival of the object, becomes the translation of a transposed truth.

This effort of transposition Vuillard accomplished with so little emphasis

and such care to hide his own merits and his profundity that superficial judges like Henri Focillon have sometimes failed to recognize how greatly he and his friends esteemed their art. Glancing through the reviews of the past thirty years, we see what rank a certain school of critic assigned him. They set up against him, Matisse and Picasso, oblivious that long before these painters, the Nabis were thinking out the words *synthesis* and *composition*, to discover in the end, how much that is vain enters into theory.

There was rejoicing among fashionable and anecdotic painters when in 1920 Vuillard was rejected *because of the subject*. The judges vaunted Cézanne, Seurat, Signorelli, Paolo Uccello, Ingres and Poussin, hoping thus to advertise their profoundness. They were blind to the fact that the reticent master of the *Femme au Bol* and the *Place Vintimille* (the *intimiste* as he was amused to call himself) concealed beneath his placid manner the pangs which tormented Cézanne, and an ambition as noble as that which moved Degas and Monet, opposed, as it was, to any dedication and scornful of any concession to the modes of the day.

Yet it was once believed that Vuillard's pictures were the products of improvisation! This seemingly facile painter is so hard on himself that he often returns, thirty years after — and not without risk — to works of which he perceives only the faults. At his home in the Place Vintimille, I have frequently examined pieces of furniture, cupboards stuffed with sketches and drawings which covered the floor. Vuillard was frightened by this accumulation of works which had been left in suspense, so many possibilities which he had neglected. He flung up his short arms despairingly. Sometimes he asked me to hold some forgotten piece before his eyes. In an old file, I came upon a host of small pastels, unfinished, and was surprised after touching these marvels, to find nothing but grey dust between my fingers. The artist had preserved these studies as of autobiographical interest only and was alarmed lest they should one day be put in circulation. Selling was as much an ordeal as it was to Degas. None of his works seemed to him finished. One is reminded of Bonnard, the eve of an exhibition, armed with a tiny paint-box falling like a foraging insect upon his pictures and touching them up, all at the same time.

These methods are possible only when one has the gift of proceeding, not without nature (the source of all things), but after an interior model. They are possible only if one is provided in one's mind with a fund of forms and colours and so rich a capital of relations that one can draw upon it at will at any moment. Nevertheless, when too large a gap exists between the mind that executed and the mind which revises — between the sensibility of yesterday and that of to-day — it is hard for the painter to find his own foot-prints. He is lost while thinking he is treading the old path.

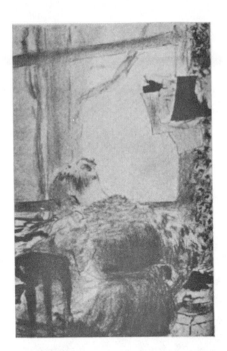

The Dressmaker (1895)
*Lithograph
in colours*

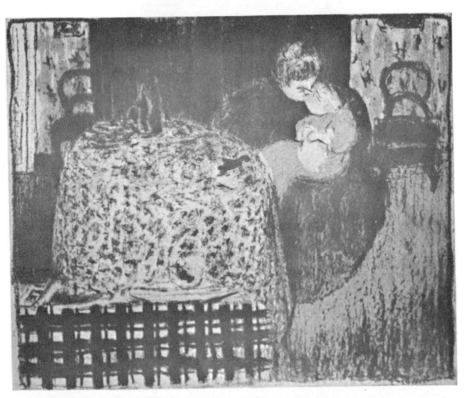

Motherhood (1900) — *Lithograph in colours*

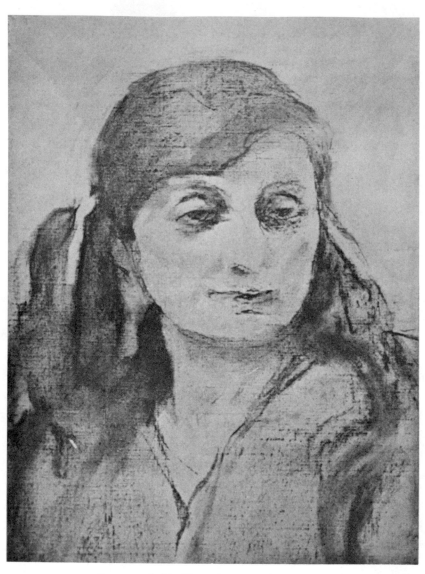

Countess de Noailles (About 1932) — *Sketch*

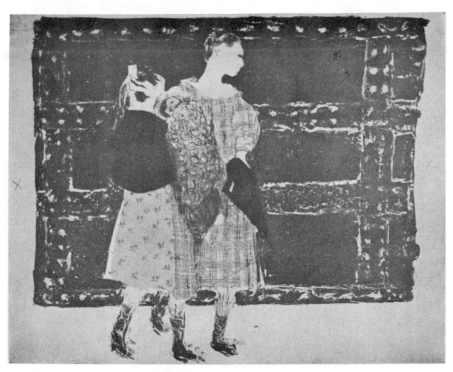

The Two Little Girls (1899) — *Lithograph in black*

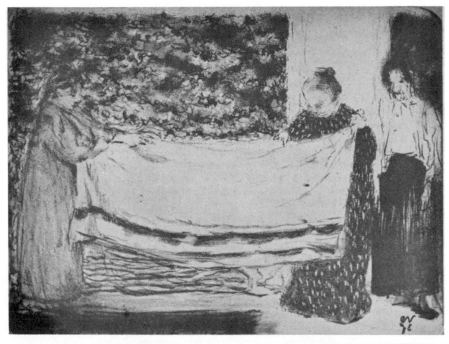

Folding the Linen (1893) *Lithograph in black*

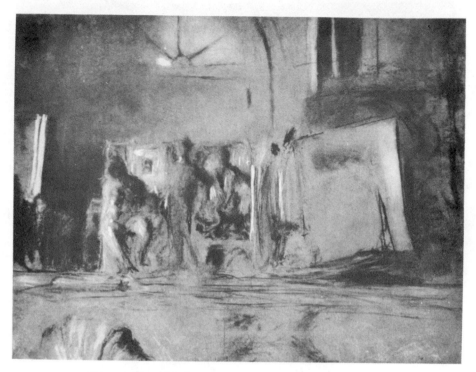

Chimneypiece with Statuary at Maillol (About 1937) — *Pastel*

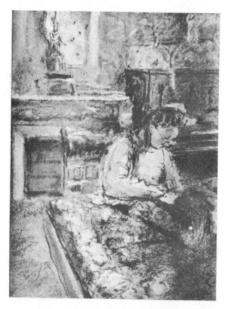

M^{me} Vuillard writing — *Pastel*

And that is what happened to Vuillard, as it happened to Roussel, especially in the latter years.

The will *to finish*, that is to say, to carry a work to its absolute completion without leaving anything to hazard, never ceased to sustain him and his associates. In abandoning theories (as he did for a brief interval), eliminating all details, and emancipating himself from the fascination of resemblance, he was not moved by a desire for conformity or to simplify his task but by a species of asceticism and in order to penetrate more secret truths. It would be erroneous to believe that the charming little panels of the Revue Blanche period because they have an elliptical aspect, meant less effort than the still-lifes which preceded or followed them.

To finish is not to execute slowly, to manufacture difficulties, to encumber oneself with details, or to polish and re-polish. Art is not merely a game of patience or a game of skill. As has been wittily said, many pictures supposed to be finished have never been begun. On the other hand, a summary and elliptical aspect is not necessarily, as too many imagine to-day, a guarantee of depth and originality. When certain critics pretend that the Vuillards posterior to 1930 are finished, this word is used in an unfavourable sense. It is insinuated that these pictures are over-refined, that they are overloaded with idle details and that they are a return to the worst conventions. This meticulousness in reproducing everything is set down as a mere display of skill. To this misconception, we shall return later on.

Attention may be called to another psychological error. Rather than admit that a great artist, in spite of diverse fluctuations, may remain faithful to himself, critics are prone, in order to simplify their work, to distinguish epochs which they compare with each other. They hold, for instance, that the Corots, Boudins, Marquets and Vuillards, from a given date, have lost the virtues of the earlier Corots, Boudins, Marquets and Vuillards. At times, the bias works the opposite way : the last Degas and Renoirs are to be preferred because their treatment is freer. That artists' inspiration has been known to fail, that promise has not always been fulfilled, that vision has become dimmer, is incontestable. But in the case of spirits as lucid and as incapable of any pettiness as Corot, Vuillard and Boudin, it is only with all reserve and respect that we can consider what are called their faults. We must beware of period catchwords and reactions which were once necessary but which have become reflexes and, in their turn, conventions. It mattered little to Vuillard, the resistance encountered towards the end of his life in this or that quarter. In fifty years he had seen so many changes in artistic opinion that he could not be astonished to find himself misunderstood at seventy, as he might have been at thirty but for the opposite reasons. The same thing happened to Degas, when Tou-

louse-Lautrec was set up against him, and to Claude Monet who was always being compared unfavourably with Cézanne.

We return to Vuillard's methods of composition. Whether it was the matter of an interior, a landscape or a figure, the essential was registered and reconstituted within himself. If he undertook a portrait, he observed his model at length and sought to discover the conditions under which he was most at his ease and most in harmony with his environment — as, Nanteuil said, at his ordinary *brio*. He impregnated himself with his reality and simultaneous or successive realities, with his character and his characters. And when he was out of sight, he found him again in his own mind in the silence of the studio.

Then would commence a long series of operations — notation of the general atmosphere, establishment of the governing lines of the composition, the choice of a dominant harmony. This was the embryo of the picture. " I have got hold of a little idea " the painter was accustomed to say. The little idea was the particular angle from which the scene was to be taken, the part of space most favourable to the life of the person, and the colour element which called out his qualities. Of these initial searchings after harmony and arrangement, we often have the evidence in a succession of small pastels (cf. the numerous studies of the portraits of the Comtesse de Noailles, Mme P.-E. Weil, Miche Marchand, Mme Henraux, Missia and her niece, Bénac, and others). Soon the painter will pay another visit to the model, question him and look about him, but to the model's great surprise, he will behave pretty much as an ordinary visitor, producing no paper or pencil or any of the impressive apparatus of the artist.

Afterwards, Vuillard would verify his observations by means of written notes. His notebooks are curious, different from any others. They contain a collection of general or local data, separate elements similar to Corot's notations of values and to Barye's measurements from the skeleton, not given in figures but almost so — a shoulder joint, the angle of an elbow, the retreating line of a ceiling, the profile of a chimneypiece, the foreshortening of a hand, a fold of cloth, a detail of structure or lighting, the nucleus of a chiaroscuro. These jottings were taken down from life. The notebook would come into service when Vuillard in his studio looked at his initial sketch in pastel so far empty of details, and emerging from the stage of the dream and gestation, proceeded to the execution. Individuality then came once more into its own, and the picture assimilated a selection of partial verities which he brought into harmony (20).

Practically all his great compositions were effected in this manner. Later on, Vuillard if he thought it necessary might ask the model to pose in his own milieu or at the studio. Even after these re-touchings, he

couldn't be sure the work would satisfy him. He would put it out of his mind, then take another look at it, forget it again, and wait till it acquired an independent existence of its own. But he was never quite sure that his work could not be corrected *ad infinitum*, like Valéry's sea, and begun all over again.

<p style="text-align:center">✳</p>

While the fragmentary sketches are innumerable, he has left, like Manet and Monet, very few drawings of the whole which foreshadow the future picture. More of a painter than a draughtsman, attracted by harmonies more than by oppositions and by rhythms more than by movements, he put little into his drawing. His stroke *en grisaille* is short and precise as though he feared to release the pathos of the chiaroscuro and the contrasts of colours. The pastel with its light touch, the brush which caresses, these were his chosen instruments, preferred to the point sharpened like a dagger. For engraving, he always selected a thick pencil which glided over the smooth stone and lent itself to colouration. His engraved work is a manner of painting and his best etchings have been printed in several tones.

His compositions with the pencil or the pen are rare, so we are better enabled by his mezzotints to analyse the peculiarities of a nervous drawing, more suggestive than assertive, which reminds us of Whistler and Berthe Morisot *(Lucien Fabre)*. The greys dominate, blended often by means of the scraper—an artifice dear to the colourist who is fond of half-tones and modulations. The high-lights of the wash impart transparency to the scumbling. Forms and backgrounds interpenetrate. In more than one of the Œuvre programmes and Revue Blanche prospectuses, the tools have called forth the shadow of a shadow or suggest a silhouette. Sometimes, moreover, as in Bonnard's work, the title is itself an ornament and the stylized script interplays with the picture.

A convention as old as the centuries requires that to give importance to the sitter, he must stand out detached on a smooth or monochrome background. He must occupy a void from which all intrusive elements have been banished. Space must be cleared of all contradictions and all competitive features. A special and in one sense, an abstract site is created. Vermeer of Delft, the greatest of intimists, showed his models against bare walls, simplified the rooms and cut down the accessories to the essential. Le Nain and Chardin did the same. The isolated personage or the group commands the picture, establishes the harmony and subordinates the object to the will of a master.

For Vuillard, on the contrary, a background was never an arbitrary field of paint designed simply to show up the foreground. It appears in his works of the period 1892-98 (for instance, in the Vaquez panels) so

<p style="text-align:center">183</p>

much mixed up with the characters that it might be said to be the leading feature. This background presently, little by little, became less assertive, but was never altogether divorced from the action. Even when a room contains only a minimum of furniture, pictures and the usual accessories, the flowers on the wall-paper or the carpet lend an element of vibration to the space. Vuillard was not frightened of overcrowding. He allowed his lines to contradict each other and to destroy what there is of dullness and artificiality in symmetry. He liked to mingle actual objects with their reflections and made great play with the mirror which favours all sorts of mystifications, exchanges, interference, and penetration. This disorder was kept respected and well under control and lucidly organized. It was justified by profound plastic and sentimental reasons. If we study the spot occupied by a person, the distance that separates him from the wall or surrounding object or the relations of the chair with the table and the table with the window, we shall see that they are never fortuitous or conventional. The necessary stability of a flat surface like a table is not incompatible with the mobility of some human evidence or the trace of the gesture which has put the napkin near the cup and the bread by the plate. But action in general is suggested only by indirect allusion. It is the objects which are enjoined to tell us of their masters and to describe to us their habits and likings, the human beings remaining much more discreet and effaced.

Vuillard's designs are made of these allusions. He is respectful of the tacit pact and relations between the elements. His work abounds in whisperings, thrills and small excitements. We do not use the adjective small in a scornful sense. Here, every impulse is contained and restrained, even the impulse of the crayon or the charcoal. But fine and brief though the indications may be, what a power of suggestion, what intensity lies in them! The exceedingly rare states of certain lithographs in existence (for example, the *Coutourière* of the Revue Blanche, the portrait of Paul Léautaud and six plates from *Cuisine*) bear witness to Vuillard's scruples and repentance. Yet, nothing can be more decided than these indications. In Lautrec's engravings, colour often appears like a simple high-light or a flat brush stroke. Vuillard's lithographs are essentially a painter's lithographs, and even in the mezzotints such as *l'Intérieur au Paravent*, it is always as a painter that he handles the pencil, the wash and the scraper.

The twelve plates collected under the title *Paysages et Intérieurs* (1899) are miracles of tact, finesse and instrumentation. If ever the expression chamber music could be applied to visual work, it could certainly be to these. The unexpected resides not only in the design and perspective *(L'Intérieur à la suspension*, the three *Chambres aux papier rose)* but in the restrained selection of tones — half-tones and quarter-tones — mouse-grey, slate-grey, strawberry and cyclamen pink, plum-violet, moss-green,

withered leaf, lime-tree yellow, colourings which bring out the whites amazingly and by their matt quality suggest distemper. The contour, also coloured, joins with the light flat strokes of wash the better to assure the interpenetration of stain and contour and the communion of planes, persons and foundations, The Japanese print, by which Vuillard like Lautrec has profited, alone affords such subtle gratification. Vuillard had not the wonderful simplifying style or the expressive force of Hokousaï or Outamaro, but his chromo-lithographs exhale a dreamy quality, an allusive charm and a magical pathos which few European coloured prints, other than Whistler's and Bonnard's, could procure us (21).

✳

Vuillard often found expression by means of pastels. One of the earliest, belonging to Maurice Denis, represents *Deux femmes assises dans un bois* (1891). But it was in the course of the year 1897, in 1907 and above all, subsequently to 1920 (particularly in 1923) that he made use of this medium which yielded Boudin, Monet, Manet and Degas, Odilon Redon towards the end, and Ker-Xavier Roussel, such varied and sumptuous effects. It was a common thing with him, in sketching out his decorations, his intimates, or his portraits, to jot down his designs, general or partial, in pastel. He could thus see the whole organization in advance. With the assistance of these notations of the scheme, he was ready to reconstitute the coloured atmosphere, the setting and the figuration.

But the pastel was not for him merely a means to an end, but an end in itself. *Lysès, Sacha Guitry, Giraudoux, Jacques Laroche enfant à sa table de travail, l'Enfant à la chemise écossaise,* and *la Famille de l'acteur Robinson* — admirable studies of the painter's mother (such as *Mme Vuillard cousant à sa fenêtre,* with the lovely reflection in a glass panel of the buttercup armchair, *Femme agée écrivant, Femme en noir lisant à la lumière de la lampe,* etc.) a thousand scenes taken by surprise during the vacations at the Clos Cézanne and Les Clayes *(Les joueurs de bridge, Dames causant sur un divan, Musique à quatre mains, La partie de cartes, Jeune femme et enfant dans un boudoir rose, Femme en bleu versant du champagne),* and a series of nudes, were all done in pastel. With these must be numbered several works belonging to the later years, such as a number of bouquets and still-lifes *(Tasse à vin près d'un bouquet de marguerites* — P.-E. Weil collection, *Table servie* — former Dorville collection, *Cheminée du Peintre Place Vintimille* — exhibited in 1940 at the autumn salon) and the small portrait *Vuillard aux lunettes.* In these he finds no better inspiration than in the monochrome and related values. The spell is broken by the intrusion of the resounding reds, madders, yellows and violets. He likes to show the blue-grey background or the dark maroon of the paper between the high-lights. The finest pastels are lightly touched without any attempt

at giving them that thickness and consistency which Manet and Degas achieved by cross-hatching and heavy applications.

Particular mention must be made of the studies executed between 1933 and 1938 at the chateau of Les Clayes, which were used for its decoration. A few steps away from inhabited rooms, Vuillard discovered the profoundness of the woods, the blue which plays between leaves, the tenderness of moss, the patina of bark, all the religious mystery of these green mansions where gold, blue and green have the refulgence of stained-glass. Several notations have the splendour of Odilon Redon's pastels. Others executed earlier, at Saint-Jacut in 1909, thanks to their chalky quality and the softness of their greys and golds, resemble rather seascapes by Boudin and Claude Monet.

Vuillard began by painting in oil on canvas. In 1891 he changed his technique. Oil, too shiny and thick, as a means of linking up colours, was replaced by medium. Here the example of Degas after 1879 was followed, as shown in the picture *Devant les tribunes*. Instead of canvas, Vuillard preferred an unprepared pasteboard which absorbed colour. His choice is that of a painter who eschews brilliancy. The grey or grey-ochre board gives the tones, above all the cold tones, an unexpected lightness, distinctness and charm; it is friendly to black, the dark tints and maroons; and its own tint, often left exposed, plays in a minor key between the painted parts. These foundations, dull if you wish but promoted to the rank of the precious tones, vibrate deliciously by analogy and by contrast. Grey (and even greyish) ceases to be " the enemy of good painting ", as Delacroix called it. Its worth had been demonstrated already by Corot, Puvis and Degas. The last had said " Vuillard can make a bunch of sweet peas out of a dusty bottle of Chablis. " His fancy for sad tones induced in him the franciscan virtues, a kind of enrichment by poverty.

Meanwhile, he and his friends broke with the Impressionists and drew away from Gauguin. For them, the essential object of painting was not to obtain the maximum of luminosity. They nearly all of them, adopted the cardboard which gave their compositions a subdued charm. No impastings caught the light; the brush, soaked in medium, glided as on a porous wall. Until 1914 Vuillard chose these little rectangles, the cost of which is insignificant, which can be cut to any shape and which dry quickly without dullness. Later on, when the use of this material had become vulgarized, he discovered its disadvantages. Led away by an easily established play of harmonies, too many artists contented themselves with sketches. André Gide, Paul Jamot, and Fosca called attention to this danger. Vuillard, without abandoning the ordinary board altogether, took to working on canvas or a specially prepared board.

＊

Upon his entry into theatrical circles in 1893, Vuillard, still quite young, acquired the use of a material of which he grew fond — size — paint or distemper; it was congenial to his qualities, helped him to avoid direct imitation and to count more and more upon his memory. Bonnard had been one of the first to employ it in a series of panels exposed in 1891 at the Indépendants. One of the earliest of Vuillard's distempers is the *Café au Bois de Boulogne* contemporary with the Rosmersholm scenery (1893). This was followed by the first decorative panels for Natanson, Vaquez and Claude Anet.

Used by decorators in their large-scale works, painting with the *colle* offers many advantages. The colours are matt and without reflections; they are not falsified by artificial light; and they dry rapidly, which facilitates re-touching. The colour powder is contained in small phials and mixed with the medium dissolved in hot water. The drawback is that it is easily spoilt by damp or grease. It tends to crackle. But though more vulnerable in this respect than oil paint, once on wall or canvas, it is no longer at the mercy of chemical reactions and it keeps its freshness.

In youth, Vuillard dreamed of a sort of intimate fresco for the domestic interior, of a decoration not done on the wall but on detachable panels lodged in the woodwork. His large compositions are for the most part, distemper paintings — the *Paysages de Paris* (collection Bernstein), the *Places St Augustin* and the *Places Vintimille*, as well as the decoratiõns of the *Comédie des Champs-Elysées* and *Bois-Lurette*.

The use of the *colle* drove Vuillard to the use of light hues. This substance offers an initially cold foundation whereas cardboard calls for harmonies of a sombre warmth. In the first *Jardins Publics* and succeeding works, lilac, tender greens, exquisite beige, and blue-greys compose a lovely effect wanting in the previous pictures painted in oil. Harmony with the architectural enframement is immediately established thanks to the consistency of a medium akin to plaster and stone.

The use of distemper becomes general in portraits starting with that of one of his most charming models, *Marcelle Tristan Bernard* (1914) which constitutes an innovation. The difficulty of conveying cumbersome material to his sitters' abodes forced him to work practically.

Like Degas, Vuillard often mixed his mediums, gouache and pastel with distemper, as in the *Jardins Publics, Paysages de St. Jacut, les Enfants au jardin*, and the *Frises décoratives* (Roussel bequest). But these complications had only one purpose — to assure the maximum of concentration, finesse and simplicity. We have admired his success in compositions where larger brushes can design masses, cover vast surfaces with rapidity, and go over the work again without fear of fatiguing the colour. Although thirty

years old, the Champs-Elysées decorations have preserved their freshness entire, while many contemporary painters have seen their flowers wither. In the Roussel bequest which includes a number of preparatory panels for the *paysages urbains* of the Bernstein collection, we perceive the decisive direction of the brush. A few flat tints, of extreme refinement, already suggest the essential, and help to avoid a profusion of details which afterwards gave rise, especially in regard to portraits, to much misconception.

✳

A lover of silence and serenity, Vuillard tends to exclude turbulence, if not joy, as a disturbing element. His genius lies essentially in his faculty of differentiating tones and kindred values. The moment he puts two touches in juxtaposition, he gives proof of a confidence and an originality that what in others would have amounted to no more than charm, taste or ingeniousness, in him achieves the profound.

His precision recalls the greatest poets of the nuance. One thinks of those plays of alliterations and assonances which give to the verses of Vergil, Racine and Verlaine, their mysterious cohesion. As vowels and consonants call and reply, one to the other, in virtue of secret affinities and sustain the sentiment, so kindred tones are exalted by their neighbourhood and friendship. There is a sensuous rapture in their differences which are never disputes. And far from so delicate an exercise leading, as might be feared, to effeminacy in the form, the design is the stronger. Finesse is metamorphosed into power.

We must not speak of rare tones, in the usual meaning of these words. Vuillard never needed jewels of price or rich stuffs. His palette was constituted of sad whites, smothered greens, hushed blues and browns, faded pinks and yellows, matt blacks. As will have been seen, it is necessary to qualify every colour by some adjective which dulls or gives it a patina : whitish blues like old faïence, greenish whites like the guelder or Christmas rose, the pinkish white of shells, the ash white of the birch bark, the violet blacks of the bearskin, mushroom blacks, moleskin blacks, steel blue, slate blue, asphalt blue, green of lichen or of moss, light reds of old brick or tanned leather. Even the brilliant colours have no more than their minimum of gloss. Vuillard entered into no competition with the sun. To suggest a wall or a road bathed in sunlight, he did not use whites, lemon, or chromes, but light contrasts so subdued as almost to be greys.

His light has a milky quality and a pleasing opaqueness. He shows its organizing presence, whether it rests on a wall, on a moulding, a dress, a floor, a vase or an eye. He resorts to no literal imitation of that gold or silver sheen brought out by the daylight and reflected by objects as by mirrors — to none of the devices in which the late disciples of the Dutch have specialized. Compared even with Vermeer, that most discreet of

188

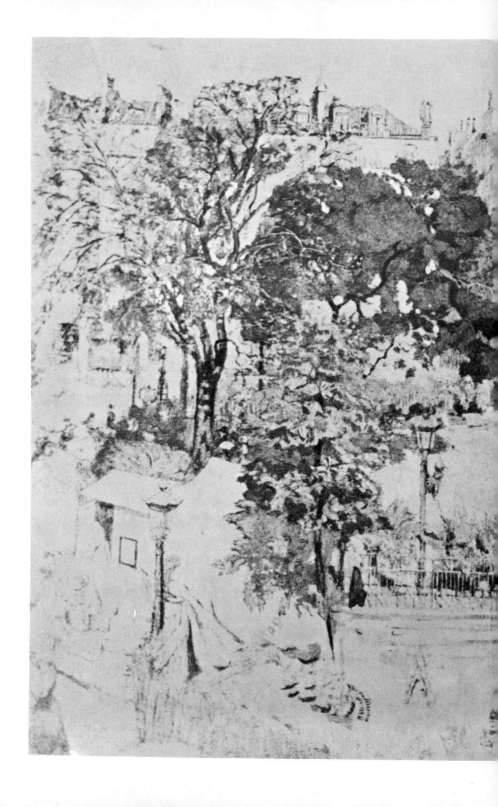

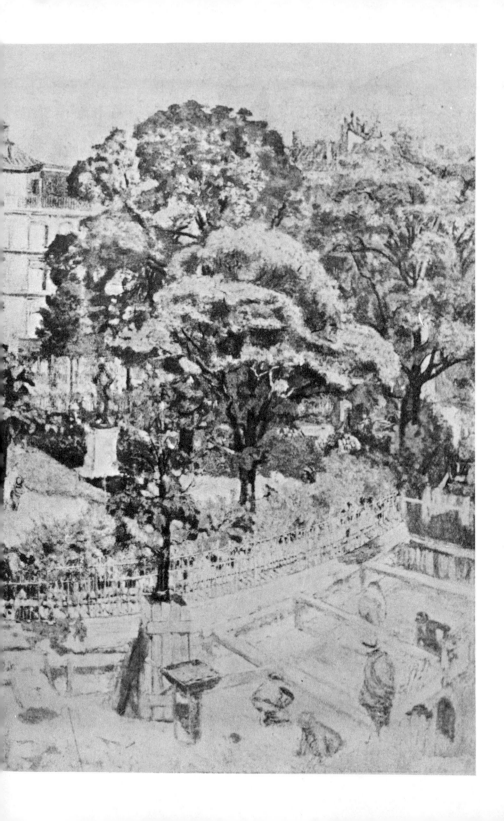

enchanters and the most respectful of silence, Vuillard is always true to the minor key; he tempers the seasons, deadens footsteps, and passes the light of day as through invisible curtains. The window is never an opening for the light — it is a part of the interior decoration. Nature is always treated as the complement of man, the open air as an extension of the home.

Every value, every colour, is so much abated that an impression almost of mystery results, although no event, external or internal, is allowed to trouble the serenity. In this respect, Vuillard's art has affinities with Puvis'. This economy and dread of violent efforts and shocks lend unexpected force to the least affirmation, sonority or gesture disturbing the zones of silence and tranquil spaces where habit grows. Vuillard's glory and courage lie in his having restored pictorially their charm and importance, not only to the everyday and usual but to the commonplace, the dull and sometimes even to the tiresome.

$*$

This said, all his paintings were not treated in the same manner. As far back as 1900 but especially after 1920 and in the latter years of his life, he kicked against his own predilections, indulging, particularly in smaller works, in an excess of prettiness; he showed more application in his technique, less of the unexpected in his methods of composition; here there was crowding, there turbulence. At the risk of doing violence to himself and losing some part of his charm, he listened more and more to Maurice Denis. He shied away from patched-up syntheses, the facile arbitrary, and the deliberately strange which had invaded painting.

He was anxious under the weight of enormous responsibilities. Early in life, he had found a perfect balance between his will and his talents. It may be that at thirty he was more sure of himself than at fifty. Many great painters of the 19th and 20th centuries have, in fact, arrived very young at their zenith, and never done better afterwards, despite their efforts and their technical and aesthetic scruples. It cannot be said of Manet or Monet, as it can be said of Cézanne and Degas, that their conviction was strengthened by time. The victories of their youth, like Vuillard's, were the decisive ones.

Coming under the influence of Bonnard and Roussel as regards colour, about 1900, the painter became interested in other *milieux*. He gravitated towards a more realist design. Formerly he could have said with Mallarmé, " I have always proceeded only by allusions "; formerly, while he attenuated and stilled, he reserved an important part to the indeterminate zones, to vague spaces, to the *flou* contrasting with the general focusing. He found a point of view outside the centre, he deliberately sacrificed entire parts. He interpreted instead of imitating, he recognized no hier-

archy of objects, he rejected harmonies and tones repugnant to his nature. Consciously or otherwise, he wiped out all that he did not like. But now he might be said to be in sympathy with the world at large. He places on the same pedestal things he has venerated since his infancy and the things he met with yesterday. He bends with indulgence — but that is not the same as love — over objects which he does not know by personal experience or memory, and over attitudes without any revelation. He enumerates more than he analyses. His patience is hardly distinguishable from resignation. But it is with native sympathy and restraint that he executes these inventories without ostentation.

If as André Gide says, " the qualities which it pleases us to call classic are chiefly moral qualities ", if classicism is " a harmonious bundle of virtues, the first of which is modesty ", then Vuillard never approached nearer to the grand traditions. His wonderful memory he retained, never did his hands obey him more loyally, and at no time did he possess more skill (in the great sense of the word) — so we see him resolving a thousand difficulties with the patience of an ascetic. No problem of perspective embarrassed him. Like the Primitives, the Florentines, the lesser Dutch masters, Chardin and Manet, he applied himself to catching lustre, reflections and the texture of a stuff. He lingers over the description of things, formerly transfigured, under their most traditional aspect. He spares us nothing, not a frame, a watch-chain, a ribbon. He paints things without interfering in their arrangement. He effaces himself, he accepts, as a passive observer whom nothing rebuffs.

The deformations, the singularities, even that reticence which delighted us — all these he now avoids as if they were mere formularies. To simplify the colour register, to flee contrasts and dissonances, appears to him a concession, an inadmissible improverishment in view of the infinite complexity and variety of the plastic elements. His case was the opposite of that of Manet, Monet, Degas and Van Gogh, who starting from a more or less life-like reproduction of appearances, went on to wider and wider syntheses. Of course, it was because he had begun by practising what we may call the discipline of liberty that he yearned later in life for the discipline of authority. He revolted as vigorously against discoveries, made and since vulgarized by his generation, as he had revolted, forty years before, against the contrary conventions. It was thus that official circles for a moment came to suppose that he was making advances to them and had passed over, repentant, to the conservative ranks. A number of critics were thus deluded, particularly at the time of his admission to the Academy — a gesture made solely in order to restore to that much decried institution, its original greatness and mission.

It must be emphatically stated that Vuillard's relative retrogression in his declining years was not due to any unworthy motives or to vanity. His setbacks were due to his temperamental incapacity to enrich his repertory as much as he desired, to amplify his means of expression (always somewhat frail), to speak in a louder tone and attain the universal.

What was it that upheld him in his new attempts? First of all, that sense of stability and balance which never deserted him, even when the composition condemned him to banality. The linear organization in which he excelled, and his natural talent for design continued manifest in the absence of the poetry of chiaroscuro which formerly created an illusion of lyricism. But it was precisely the lyric gift which he lacked. Now, when he illumined his interiors with uniformity, leaving nothing imprecise, we listen in vain for whispered secrets. In many recent portraits, his feeling is wasted on trifling objects or a fragment of landscape. The portrait of Berthelot, remarks Albert Flament, is that of an inkstand. In Simone Berriau's, what counts are the piano and hangings. Renouart? — a dressing room, a gown. Printemps? — an armchair. The Comtesse de Polignac, lost among her accessories, was seen, said Giraudoux, only through the wrong side of a spy-glass.

It was not only the composition that seems to have quietened down. Colour, although livelier and more scattered, has fewer surprises. The object affirms its existence and resists destruction. The tree knows itself to be green, the lampshade orange, the blotting-pad pink. Everything — the colours, the objects, the background — after an epoch of disguises and devices, is seen to be no more than it is. The logical mind of France plainly reasserts itself. Behold us far from the spirit of Verlaine — gone is the reign of the " nuance " and of the indefinite joined to the definite. Evolution had taken another course with Bonnard. In him dwelt the spirit of fancy; forgetful of the traditional aspect of things, he looked on the external world as only a point of embarkation...

In the last Vuillards, many tones, up till then proscribed, sharp, terrible and violent, reds, violets, greens, crude yellows, orange, associate as they please, intrude, into the society of choicer colours and at times invade earlier canvases almost to the extent of spoiling them. We protest in the name of Vuillard himself, but the future may decide that it is we who are wrong.

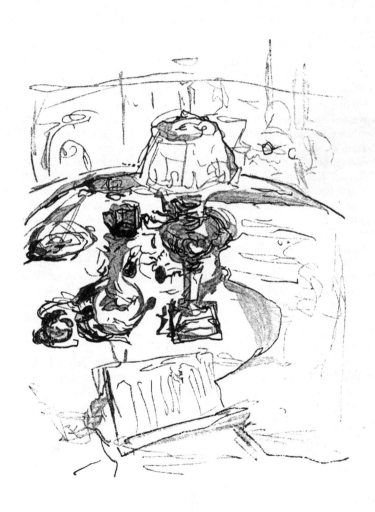

The Cook (1899) — *Coloured lithography*

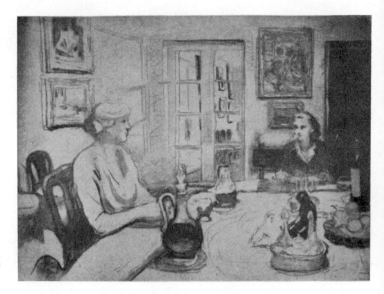

The Dining-room,
Rue de Naples
(About 1935)
Drawing

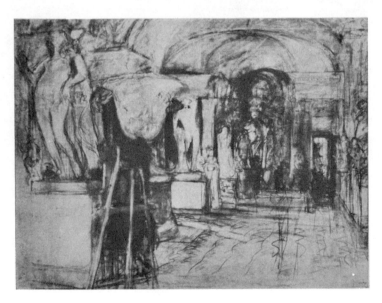

Gallery of Anti-
ques at the Lou-
vre (1920)
Drawing

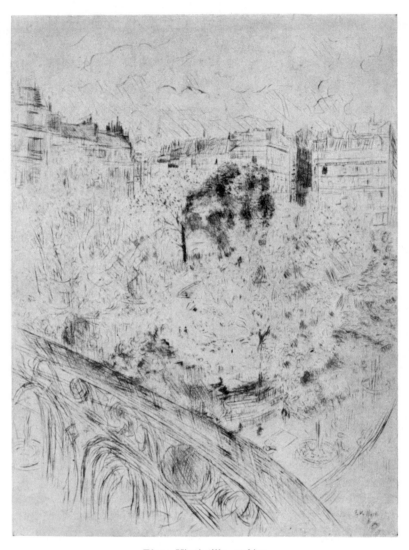

Place Vintimille, *etching*

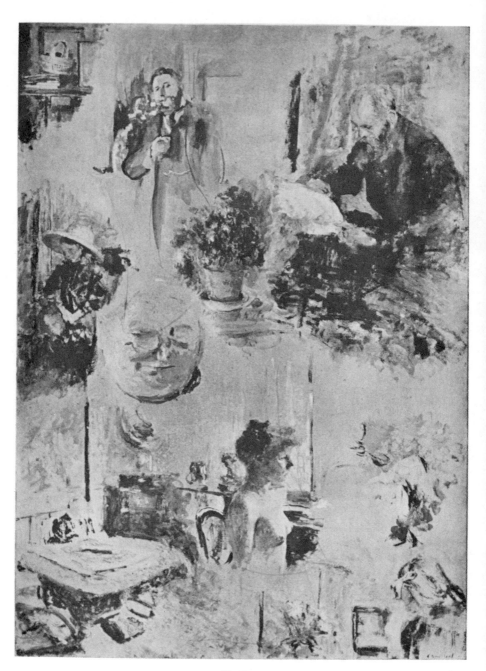

Studies.

VUILLARD
HIS
GREATNESS
AND HIS
LIMITATIONS

*Unity of Inspiration — Force and finesse — A static art — Flight from the
model — Departed happiness.*

Regardless of future reaction to Vuillard's work, we shall attempt to
place him, to define at the same time his significance and his limitations, to
trace his affinities and his discoveries, what he has ignored or neglected.

We must, in the first instance, admire in his work its character of unity,
the permanence of the same qualities, the same charms, the same dominants
and the same subjects. Between one picture and another, as between one
period and the other, there are few sensible differences, so much was the
artist swayed by the same emotions. To his work might be applied Proust's
appreciation of Vermeer : " We have here ever the fragments of the same
world; with whatever genius they may have been created, it is the same
table, the same carpet, the same woman, the same and only beauty ".

There are artists whose genius has several faces, who are torn by temp-
tations, whose allegiance is divided between opposite things. Others again
respond to only a few appeals and can express themselves only when a
theme awakens an echo and pursues them implacably. No more than
Vermeer, Teer Borgh, Canaletto and Boudin, was Vuillard a universal
painter. He was early in the day convinced alike by his intelligence,
natural inclination, and a species of moral and physical discretion, that
certain domains must remain forever closed to him. He renewed himself

by fathoming the laws of his art and the demands of his own nature. There is something miraculous in his innate sense of balance and harmony, in the refinement of his perception and his precision in the analysis of tones. This subtleness and decision enable him to steer between the two pitfalls which so often await painters enamoured of detail — dispersion and dryness. A sure conception of the whole guides him in the organization of those worlds of lesser things which are his pictures. Never does he demand theoretical solutions from indolence or abstract reasoning, those two masters of the arbitrary. He proceeds with extreme economy, infallible tact, a great severity towards himself, and a profound distrust of the approximate and everything that is not sufficiently tried and matured.

The thrill which he communicates goes under the skin. Let us make no mistake — the essential qualities of his art come from the depths. He is never vague, in the sense of uncertain of his choice. He is never insipid, for that would imply a lack of concentration — nor mannered, for that would imply the untrue or a parody. Should his inability to go beyond his powers, or change his register and repertory, be charged against him as poverty of invention? Nay, rather, let us call it courage, this refusal to pretend, as his will to remain always in harmony with himself was truest wisdom.

From his first still-lifes we see the strengthening of his predilection for monastic greys, subdued harmonies, and whispered colloquies between values, even when the objects were of the most ordinary. The atmosphere which bathes these objects so far escapes banality and vulgarity that the first painter of whom we are put in mind is Chardin. Before long, as the result of short but painful inward struggles, this quality of harmony finds more vehement expression. The absorbent cardboard, substituted for canvas, preserves the unity of the painted surfaces, while the medium used as vehicle gives a painting basically in oils, the mattness of a fresco. So Vuillard, thanks to his theatrical scene-work, comes to learn the uses of distemper. Everything, in the conception as in the execution, conspires to prevent the juxtaposition of an excessive number of objects, colours or rhythms.

<p style="text-align:center">✳</p>

In cold fact, every picture is silent since it addresses only the eyes. Yet there is many a picture which one can call noisy and which acts like an explosive. The evocation of battles, rapes, and martyrdoms is not alone in awaking tumult by association of ideas. There are conflicts of colours and lines sufficient to produce vibrations so violent that they seem to belong to the auditory world.

Vuillard nearly always eliminates movement, he reduces gestures to a minimum, and when he describes anyone, he surprises him in a static

attitude. His field of action is limited by a wall or a garden. His rooms are lit by an even light. Daylight and shade interpenetrate more than they contrast. A chiaroscuro, by no means tragic, approximates the actors to the setting and the usual furniture, and is not an element of separation or divergence. It tempers, it equalises. Indeed it hardly is a chiaroscuro but rather a moderate atmosphere where the high lights are dimmed, the shadows lose their emphasis and the reliefs so little accentuated that in the earlier works (which are most in our mind), living beings have no more substance than phantoms and real objects than painted objects. In time to come, differences between these silhouettes will appear. A warmer light gilds the interiors or the landscapes, though the mystery of the composition remains.

This mystery is inseparable from a power of concentration which is evident even in the hastiest sketches. I insist on the word *power*, for this is not the same thing as that easy *pleasing*, which many artists give proof of in the beginning and lose when they attempt to go deeper. Vuillard's art must not be confounded with that feminine painting with which luck as much as taste has to do. It is exquisite, in the etymological sense of the word : it implies an incessant selection; the instinct is controlled by an exacting will which leaves nothing half done. Many a time has Vuillard abandoned a study because it seemed to him that he had started it without that concentration which could alone guarantee its consummation. The moment he perceived that his natural facility, which was great, was getting the better of his controlled inspiration or that the conception was tainted by vanity or indolence, he stopped and threw up the work.

His most cursive notes, his pastels, and his crayon drawings, alike surprise us by the tension of the stroke or the touch and by their sureness. In these respects, this man of the 19th century showed himself at one with the Primitives, in spite of his subjects and because of his purity of intention and methods of execution. The word *faith* best expresses the confidence that sustained him.

It may surprise some that we should prize so highly those small pictures which at first sight do not seem greatly different from the " anecdote " pictures of many lesser masters. But, as has been said above, Vuillard does not remind us so much of the intimists and realist painters of Holland, Flanders and 19th century France as of Lesueur, Le Nain, Chardin and Corot. Without achieving their pathos, he is spiritually of their family and for the same reasons, he is great.

The more calm and denuded Vuillard's canvas, so much the more has it cohesion, power and plenitude. Thus, without indulging in regrettable generalizations, we are entitled to argue that there is less resonance and richness, in spite of their size and brilliancy, in more than one of his " society " pieces, possibly on account of the subject or crowding. Vuillard,

by nature and inclination sedentary, is less at his ease than Renoir or Bonnard, in dealing with warm tones and in his excursions into prosperity. The sun was too bright for him, youth must be transposed to a minor key and all excess eliminated. Was he, after all, somewhat lacking in vitality? Our incapacities, our fears, all that our temperament refuses, weigh as much as our preferences. To know an artist you have only to note the words or the colours which he does not make use of and the images which he avoids.

There is nothing sensual in Vuillard's painting. The act of painting is equivalent to the act of possessing since it means touching, caressing, dominating. The painter like the sculptor, handles the form, tastes its fullness, its resistance, its sweetness. Sensations — tactile, thermic, olfactory, auditory — are associated with the visual sensation. The Venetians, Rubens, Boucher, Goya, Renoir, a whole race of voluptuaries, have the air of conquerors, and even when not dealing with the human idol, exhibit the assurance of conquerors or simply of proprietors. For others, painting is something less material. It excludes the disorder of passion, it is before all, friendly. Not coldly, not passively, but with all sorts of attentions, precautions and decencies, they approach appearances as if they feared to alarm them. Nature, as seen by Giotto, Fra Angelico, the Master of Moulins, Lesueur, Puvis, Fantin and Vuillard was ever something dreamed of. Painting was for them in the nature of a contemplative act.

Faced with the human enigma, Vuillard maintained the same attitude of discretion and respect. He fixed the limits of the portraitist. He does not, like Raphael, Rembrandt, Goya, David, Ingres or Degas, sit down before this fortress which is his model; nor does he interrogate him, still less imprison him. Of a number of portraits it may be said that the notion of the setting comes first — the person is only an object among others. Very often, the model stands or is seated or extended in only a very slightly dynamic pose. The face betrays little internal movement, the mouth and eyes as little. No attempt is made to get inside the model and tear out his secret, nor any guess at it. Vuillard would not be inquisitor or judge with his closest kin or friends, he did not feel authorized to make revelations. Frankly, we can but regret at times this excess of reserve and prudence. Indulgence has only to do with people without indulgence, like Forain and Charlotte Lysès. Vuillard was wanting in the intuition, the daring and the foreshortening of the great analysts. His indifference to some of his models is sometimes equal to that of the French court painters of the 17th and 18th centuries. He differs from them and from the English in that he never condescends like them, to brio or sentimentality.

One cannot accuse him of tepidity. He was all good-will, all sympathy. But that good-will and sympathy had only one purpose — to define certain

relations, sustain a balance, invent here and there entertainments, all the livelier because they went hand in hand with so much gravity and repose. Endowed with little imagination and rootedly attached to a certain order, Vuillard when the Symbolist period had passed, took thought again and went back to the traditional arts of perspective and chiaroscuro. It would be inexact to say he returned to realism, for there was too much transposition in it. But that transposition resides less in the ingenuity of the design and the artifices of presentation than in what might be called the statement of values, or more simply, the organization of the canvas. He no longer looked on the unexpected as an essential merit, as it had been in so many small pictures painted between 1891 and 1900. Another instance of his scrupulousness is afforded by this return to the usual aspect of things.

Yet, when all is said, Vuillard of all his circle, remained the most deeply impregnated with impressionism. We will make this clear. Each of his canvases is organized in every part, constructed, logical and executed with a faithful regard to rule and to the exclusion of the fortuitous. He remains impressionist because all his effort is consecrated to an assemblage of small incidents and accidents and because he seldom attains (except in his decorative work, landscapes and portraits) to that power of generalization essential to the classic spirit.

Any of Vuillard's interiors assumes a transitory character when compared with *La Dentellière* or *La Liseuse*. The artist, one feels, has not pinned down a day or an hour of life but merely an instant, and in the disposition of objects there is something less fatal, in the attitude something less essential and in the expression something less precise than what one sees in the works of Vermeer. The privilege was not Vuillard's at all times to call a halt to time and to achieve in his evocation of the individual and the daily round, that synthetic force, one might almost say solemnity, possible to Velasquez, Louis Le Nain, Chardin and Renoir.

What was lacking in him? More cautious than his associates, he seldom attempted to escape from his own limitations. Bonnard, impulsive and less disciplined, charged headlong in the most diverse directions at the dictates of his fancy or his instinct, and his daring often found its reward. Building, also, on the commonplace and unmindful in his ingenuity of everything already expressed, he discovered strange and wonderful countries even in boudoirs and dining-rooms. Maurice Denis may have lost too soon his early freshness, but he might well be proud to have rediscovered the ambitions of the great epochs. Submitting his fiery imagination to the teachings of Poussin and Chardin, Roussel executed vast mural symphonies, fitted to be translated into tapestry — he awakened godlike populations and with them, the great rules and rhythms. He needed but a little more concentration in his efforts and most of all, the opportunity

to assert himself. Vallotton like Ingres, hiding fire beneath the ice, attempted to restore relief and vigour to the form, even at the risk of coarsening it. We must not reproach Vuillard whose charm lay essentially in his loyalty, for having feared to take strange paths and for never having dared to give a body to the dream — and by dream, I mean, for example, Renoir's when he painted the portraits of Samary and Mme Charpentier and his great nudes.

However much we may admire him, we cannot fail to regret that with such great endowments — and no one since Degas and Lautrec could boast so many — Vuillard should have maintained the like reserve. What superb themes this admirer of Rembrandt was worthy to undertake! What then restrained him? — was it fear of the subject, a dread of ridicule, a want of confidence in himself?

These creatures of the *salon*, these card-players, these people reading, lying down, seated at the table, whom he painted and re-painted without satiety — we can but wish they would look us for once in the eyes and tell us of their sorrows, their anger, their memories. No! they are content to assist at the spectacle of their daily life, to be creatures of the instant, doing nothing, confessing nothing. Never lovers embracing, never a mother fondling her child! We might suppose they fear anything that could trouble the even tenor of their days.

It is an inexplicable paradox that this industrious worker and grave man should have devoted a good part of his life to representing idleness, to the exclusion of passion, suffering or sadness. He paints mirrors but no woman looks into them. The flowers are gathered, the lamp is lit, the table set. Nothing happens or rather everything happens in the future or the imperfect tense. Silence takes the place of the story, memory does duty for events. Vuillard said, it is true, " I was never more than a spectator ". Courage, man, we are tempted to cry, put questions to your sitters, get them with their backs to the wall. He shakes his head, he blushes and goes back to his station.

Much of his decorative work proves to what a degree of excellence he can attain on a surface scarcely exceeding the average proportions of a picture. It's a small orchestra. But if he sought for a breeze of inspiration to make him free of a vast space and to give us the summary of his experience, he sought in vain. On the eve of the struggle, his fears drove him to preparation and supplementary precautions—he remained at his post, on guard, unassailable...

He was, I suspect, the first to suffer from this want of breadth, the more so in that he knew himself to be quite near the goal and that very little ground separated him from his chosen divinities.

GREATNESS AND LIMITATIONS

Let us add — and add it quickly — he failed relatively as all our great painters have failed since Delacroix. In their turn, Manet, Monet, Renoir, Degas and Gauguin, all, in a sense, abdicated. Many a master has paid too dearly for entrenching himself within acquired certitudes. Vuillard when protesting against an excess of praise, was comparing our period with the grand epochs of art, where in a favourable environment, painters and sculptors had not to learn everything over again but sprang from the earth fully armed. He regretted the time he had wasted in youth, for want of a sure technique and a method. He knew that a second life was needed to realize what he had glimpsed at, and to go beyond the little world he had so ably and diligently built up with pure hand and heart.

But narrow though it be, his is an enchanted and enchanting world. We know very few others so representative of a time on which humanity already looks back with regret and which we shall not see again, so representative of all connoted by the word *bien-être* when taken in other than a wholly voluptuous sense — the pleasures of retirement, of habit, of participating in a harmony, of the charm of living.

With the passing of the years, many much-vaunted works that have exercised greater fascination and stimulated more imitation will be revealed in their vanity, approximativeness and imposture. Formulas which seemed new but turned out to be only formulas, will have lost their powers of attraction; but the intimates of Edouard Vuillard, full of contained emotion, and meditated in all their parts, will not become outmoded. Their quiet charm and striking merit will be perceived. They will survive, that is certain, because they proclaim the present and are turned with all gravity and conscientiousness towards the eternal.

1940-1945.

THE END

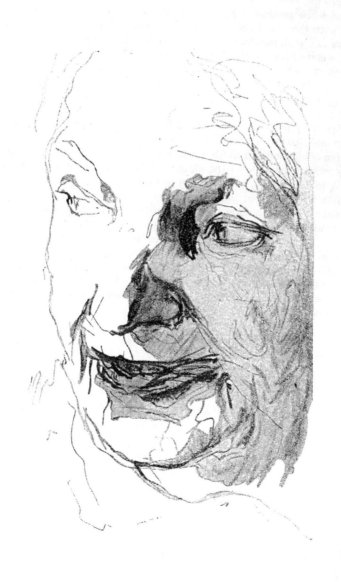

NOTES

(1) Among the portraits of the painter when young we may cite *Vuillard reflété dans une glace encadrée de bambou, Vuillard debout une palette en main,* and other portraits of a lighter kind such as *Vuillard au chapeau de paille* (about 1891). Throughout life, he was accustomed to study his face in the glass *(Vuillard debout dans son atelier, Vuillard se lavant les mains dans son cabinet de toilette,* etc.).

(2) André Gide says in 1896 in his *Feuilles de route,* " I know now why I am bored in Rome. I don't find myself interesting here. "

(3) We may also instance a fine portrait by Roussel *(circa* 1933) and the sculptured bust by Lacombe, that conscientious interpreter of the Nabis.

(4) One of these belonged to the painter Mouclier, a friend of his youth, whose name, already pretty well forgotten, was recalled by an exhibition in 1938. Mouclier was one of the first to draw inspiration from domestic scenes which he interpreted with skill and reverence. Vuillard said he owed much to him. Mouclier's art presently took another direction. The affinity between the two painters did not long endure.

(5) *Les Nourrices* (one of the earliest Square Vintimille's), *la lampe à abat-jour vert,* and certainly, *A l'Opéra* (where the parallel curves of the *baignoires* and the *premières loges* are variegated with black coats and light-coloured dresses) are nearly contemporary. To 1895 belong the two charming studies inspired by the low-built flower-decked house of Valvins, like a sorrowful rose on the water's edge, the place where Mallarmé meditated entrusting Vuillard with the illustration of *Hérodiade.*

(6) See The Organization of the Picture.

(7) Roger-Marx writes : " In the first place, we must admire the Symbolists for not condemning themselves to one particular line. They attacked all kinds of material, they showed themselves by turns painters, sculptors, potters and lithographers. Gauguin's case, far from being exceptional, was constantly repeated. M. Vuillard is the author of six pieces of the freshest inspiration and the highest ornamental originality. We shall not desist from reciting all that decorative art is entitled to demand from artists who are increasingly attentive to the rhythm of a line, to the qualities of an arabesque, to the alternations of calm and movement, of the full and the empty, in the establishment of a composition. " (Rogers - Marx, *Le Voltaire,* Oct. 1st, 1892).

(8) So far Vuillard had rarely executed Parisian compositions. The catalogue of the Arts Decoratifs only mentions the *Café au Bois de Boulogne* (1893).

(9) In 1923, the *Bulletin de la Vie Artistique* opened an enquiry for contemporary painters fittest to compose designs for tapestry. We called attention to Roussel, Braque and Signac.

(10) The left part of the picture was afterwards detached. It represents some young women with children playing at their feet.

(11) Defining what constitutes the centre of interest and *raison d'être* of a picture, Vuillard remarked *à propos* of Claude Monet's *Debâcle,* that there lay precisely what ought to be called *a subject* in painting. In the *Meule* (so different from Monet's *Meules)* there is a subject not hitherto treated.

(12) *La Bibliothèque,* a much larger decorative piece (4 metres by 3), commissioned by the Princesse Bassiano, suffers a little from dispersion.

(13) The revival of the *Illusionniste* by Sacha Guitry about 1917, inspired large-scale sketches where the stage is seen, this time, from the wings, as in Degas, who allowed great impor-

tance to the props and architecture of the setting. These plans, unfortunately, were abandoned.

(14) From 1935 dates another great study (Roussel bequest) with the Sacré-Cœur in the background. We must also mention several drawings and the striking etching which first appeared in the collection *Paris* (1937), then in 1944 with four unpublished copperplates in *Le Tombeau de Vuillard* by Giraudoux.

(15) Should be considered in conjunction with this small piece painted *circa* 1936, *Une Rue, La Nuit*, and *Place du Palais-Royal* the effect of which reminds us of nocturnes of Paris by Bonnard and Marquet.

(16) A large foliage-piece, painted in 1918, with a chestnut-tree for centre, belongs to Georges Bernheim. The salon of Les Clayes was decorated with a vast distemper (painted in 1923 and re-touched in 1937) which affords a view of the Clos Cézanne through a tangle of branches occupying two-thirds of the composition. Of the same date is a long band (2.53 metres by 0.75) entitled *Petite fille donnant à manger aux poules*.

(17) Previously, Vuillard had executed a large decoration, the *Galerie des Antiques au Louvre*, for the Bâle gallery. He makes a marvellous symphony in ochres of statues, vases and stone vaultings in perspective. As might be expected even in these solemn places consecrated to antiquity, the intimate note triumphs. In the foreground is a copyist's easel and in the background, a few visitors introduce a note of mortality among the ancient gods and heroes.

(18) The same change might be observed in the portraits of Anna de Noailles, and with certain *scènes familiales* or *Place Vintimille's*. Vuillard photographed the successive states through which many of his pictures passed (notably, *Portraits d'artistes*, *Gosset opérant*, and *Bénac*) and shows us the ease with which in the course of execution, he was able to modify the design, perspective, light and even the choice of elements.

(19) We have emphasized the

affinities with Degas often enough. We might even suppose Duranty was speaking of Vuillard when in 1876, he describes the methods of composition dear to Degas and his friends, and defines their point of view: "No more will we separate the person from the background of his interior or from the background of the street. No one ever appears to us against neutral, empty and vague backgrounds. Around and behind him are furniture, chimneypieces, wall hangings, a partition which express his fortune, his class, his trade..." And further on : "Our point of view is not always in the centre of a room with its two parallel lateral walls which recede towards another at the back; it does not always pursue the lines and the angles of the cornice with mathematical regularity and symmetry; nor is it always free to suppress the considerable developments of the bare floor in the foreground; it is sometimes very high, sometimes very low, losing sight of the ceiling, grouping objects down below, cutting across the furniture at random... If you take any person, either in the room or in the street, he is never in the centre of the canvas, in the centre of the setting. He does not always show himself in his entirety; sometimes he appears cut halfway up the leg, sometimes at the waist, sometimes longitudinally. The detail of these bisections would be infinite as would be the indication of all the scenery. "

(20) Such a method is the opposite of the *fa presto* practised by those to whom Vuillard has been compared : the regular purveyors of the Salon and professional portrait-painters. It is likewise opposed to the method of making a portrait by substituting on the plea of plastic exigencies an arbitrary conception for analysis and observation. Looking through the "log" of a portrait often adversely criticized like Bénac's, we find no less than twenty sketches for the short plump hand resting on the table and as many for the desk accessories, the folds of the coat, the profiles of the mouldings, the sculptured ornaments and the landscape. The least detail of the face is set down with a keen zest in its lighting and particular

situation: the inclination of the nose, relief of the mouth, colour of the forehead, etc. But, we insist, these were only signposts and elements of control which were to permit the painter to work tranquilly far from the model. To make up shortcomings, to correct errors at need, and failures of memory, Vuillard, like Delacroix and Degas, had recourse at times to the dark room. He was often seen carrying a Kodak. For that matter, he liked to photograph his pictures in process of execution in order to compare the successive states.

(21) *Cuisine* apart, Vuillard did not illustrate books. Mallarmé thought of entrusting him with his *Hérodiade*, but nothing came of the idea. A few stereotype sketches are found in *Prélude* and *Toi et Moi* by Paul Géraldy. The Nouvelle !Revue Française expected that Vuillard would illustrate *Du côté de chez Swann*. What hand could better have expressed the world of Proust?

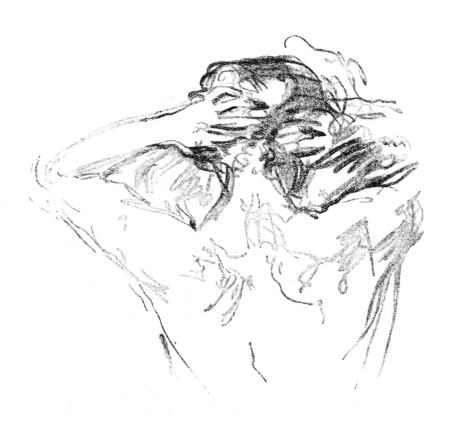

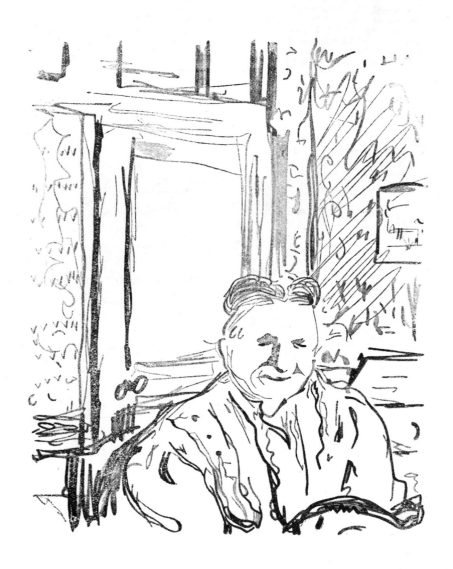

BIBLIOGRAPHY

BOOKS

A. AURIER. *Œuvres posthumes* (1893).

J.-E. BLANCHE. *Les Arts plastiques sous la IIIe République* (1931).

CATALOGUE *de l'exposition E. Vuillard au Musée des Arts Décoratifs* (1938).

MAURICE DENIS. *Théories* (1912).
— *Nouvelles Théories* (1922).

B. DORIVAL. *Les Etapes de la peinture française contemporaine* (1943)·

R. ESCHOLIER, *Le XXe siècle* (1937).

H. FOCILLON. *La Peinture du XIXe et du XXe siècle* (1928).

G. GEFFROY. *La Vie Artistique*, tome 2 (1893).

J. GIRAUDOUX. *Le Tombeau d'Edouard Vuillard* (1944)·

L. HAUTECŒUR. *Littérature et peinture en France du XVIIIe au XXe siècle* (1942).

R. HUYGHES ET G. BAZIN. *Histoire de l'Art contemporain* (1935).
— — *Les Contemporains* (1939).

P. JAMOT. *Les frères Perret et l'architecture du béton armé* (1927).

A. MELLERIO. *La lithographie originale en couleurs* (1898).
— *Le mouvement idéaliste en peinture* (1896).

A. LHOTE. *Parlons Peinture* (1933).

LUGNE-POE. *Acrobaties, souvenirs et impressions de théâtre* (1931).

R. REY. *La Renaissance classique au XIXe siècle* (1931).

C. ROGER-MARX. *La Gravure originale de Manet à nos jours* (1939).

A. SEGARD. *Peintres d'aujourd'hui*, tome 2 (1914).

P. SÉRUSIER. *A. B. C. de la peinture* (1921).

CH. TERRASSE. *La Peinture française au XXe siècle* (1939).

V. VERKADE. *Le Tourment de Dieu* (1926).

L. WERTH. *Quelques peintres* (1923).

REVIEWS AND PERIODICALS

J. BABELON. *Les donations Vuillard* (Beaux-Arts, Dec. 1941).

G. BAZIN. *Lautrec raconté par Vuillard* (A. de l'Art, April 1931).

G. BAUER. *Vuillard et son temps* (Conférence inédite, June 1938).

F. CARCO. *L'amie des peintres* (Figaro, Oct. 1942).

R. COGNIAT. *Vuillard aux Arts Décoratifs* (B.-Arts, 29 April 1938).

P. DU COLOMBIER. *Vuillard* (B.-Arts, 1942).

R. COOLUS. *Edouard Vuillard* Mercure de France (Jan. 1934).
— — L'Art vivant (May 1938).

M. DENIS. *Préface de l'exposition Gauguin et ses amis* (Gal. B.-Arts, 1934).
— *Préface de l'exposition de l'Ecole de Pont-Aven et les Nabis* (Gal. Parvillée, 1943).

F. FOSCA.	*Edouard Vuillard* (A. de l'Art., 1920).
W. GEORGE.	*Le peintre des intérieurs animés* (B.-Arts, 29 April 1938).
A. GIDE.	*Promenade au Salon d'Automne* (Gaz. des B.-Arts, Dec. 1905).
A. HEPP.	*Edouard Vuillard* (Le Divan, April-May 1912).
L. HOURTICQ.	*Un poète de l'intimité* (Illustration, Jan. 1939).
HUGELSHOFER.	*Bonnard et Vuillard à Zurich* (Formes, 1932).
P. JAMOT.	*Le Salon d'Automne* (Gaz. des B.-Arts, Dec. 1906).
J. DE LAPRADE.	*Vuillard d'avant-guerre* (B.-Arts, Feb. 1938).
T. LECLÈRE.	*Edouard Vuillard* (Art et Décoration, Oct. 1920).
A. LHOTE.	*In memoriam Vuillard* (N.R.F., Mar. 1941).
H. MARGUERY.	*Les lithogarphies de Vuillard* (L'amateur d'Estampes, Oct. & Dec. 1934).
ROGER-MARX.	*Les Indépendants. Les Symbolistes* (Le Voltaire, 29 Aug., 1 Oct. 1892, Mar 1893).
—	*Le Salon d'Automne* (Revue Encyclopédique, 1904).
C. R.-MARX.	*Portrait de Vuillard* (Formes, Mar. 1932).
—	*Vuillard ou la féerie bourgeoise* (Extrait d'une conférence inédite, B.-Arts, 3 June 1938).
—	*Les lithographies de Vuillard* (Arts et Métiers Graphiques, Dec. 1934).
O. MIRBEAU.	*Préface de la vente Thadée Natanson* (1908).
T. NATANSON.	*Un groupe de peintres* (Revue Blanche, Nov. 1893).
—	*Sur une exposition des Peintres de la Revue Blanche* (A. M. G., Nov. 1936).
—	*Sur Edouard Vuillard* (A. M. G., Nov. 1938).
LUGNÉ-POE.	*Avec Edouard Vuillard* (Candide, Jan. 1938).
H. PUVIS DE CHAVANNES.	*Un entretien avec Vuillard sur Puvis* (Renaissance, Feb. 1926).
P. VEBER.	*Mon ami Vuillard* (Nouvelles Littéraires, April 1938).
E. VUILLARD.	*Les Envois des pensionnaires de l'Académie de France à Rome en 1938* (Bulletin de l'Institut).
—	*Les Envois des pensionnaires de l'Académie de France Rome en 1939* (Bulletin de l'Institut).

LIST OF
ILLUSTRATIONS

Hors-textes

PRINTED IN PARIS
1946.
by the Imprimerie
Studium 3774.

Blocks by
Deberny & Peignot

PHOTOGRAPHS

MAURICE POPLIN, Pages : 26, 39, 71, 74, 113, 114, 115, 120, 129, 132, 148, 163, 164, 180, 194. — SYLVESTRE, Page : 29. — ARCHIVES PHOTOGRA-PHIQUES DES MONUMENTS HISTORIQUES, Pages : 31, 103, 130. — ALFRED DABER, Pages : 34, 35, 36, 57, 70, 119, 145. — VIZZAVONA, Pages : 57, 71, 73, 75, 76, 87, 88, 98, 99, 101, 109, 110, 146, 162, 178. — MARC VAUX, Pages : 72, 151. — BERNHEIM JEUNE, Pages : 98, 150. — ILLUS-TRATION, Page : 104. — GIRAUDON, Pages : 134, 135, 136. — PH. CARDOT, Page : 193.